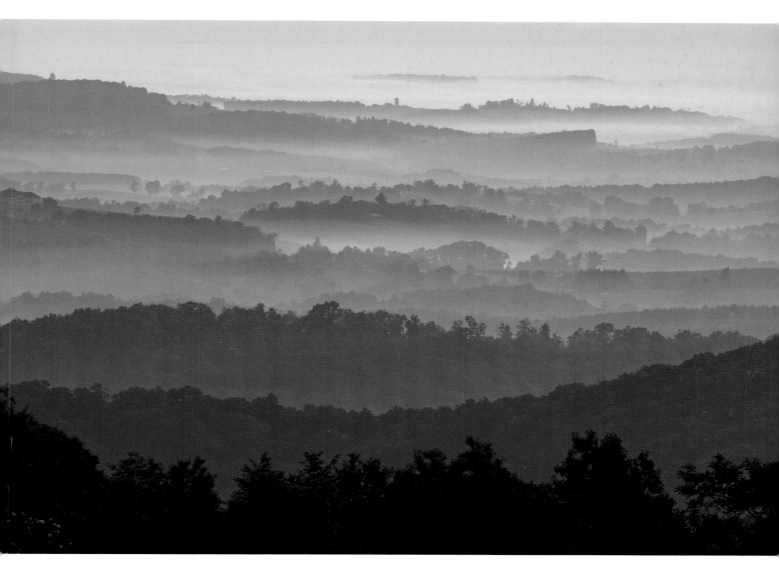

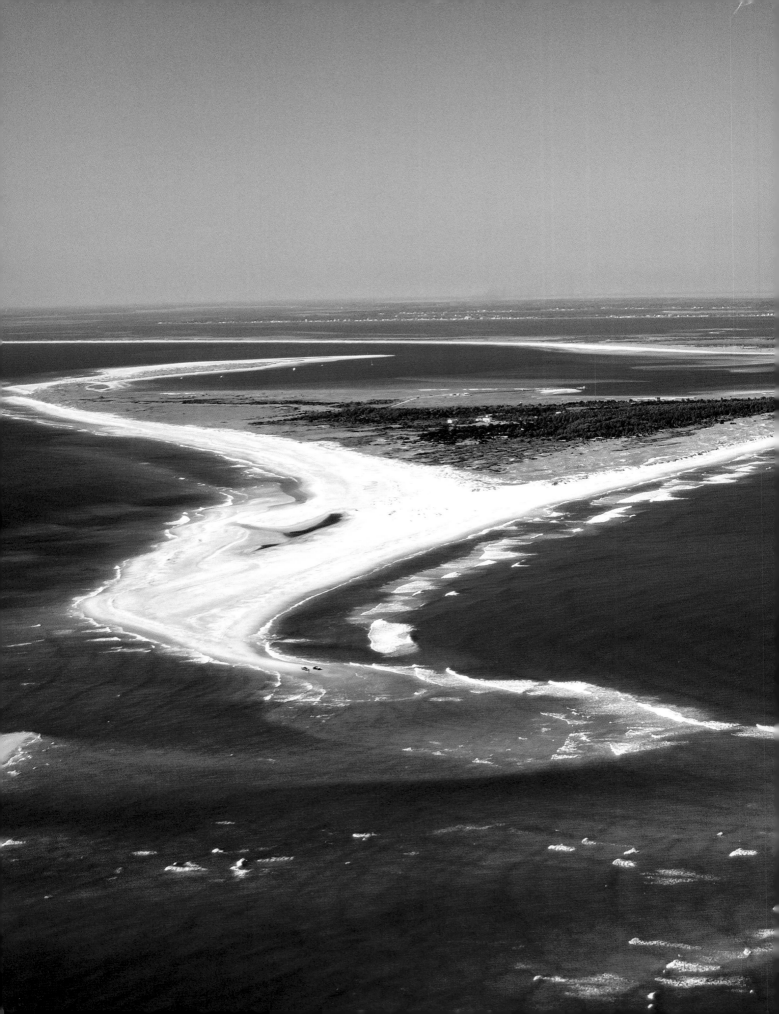

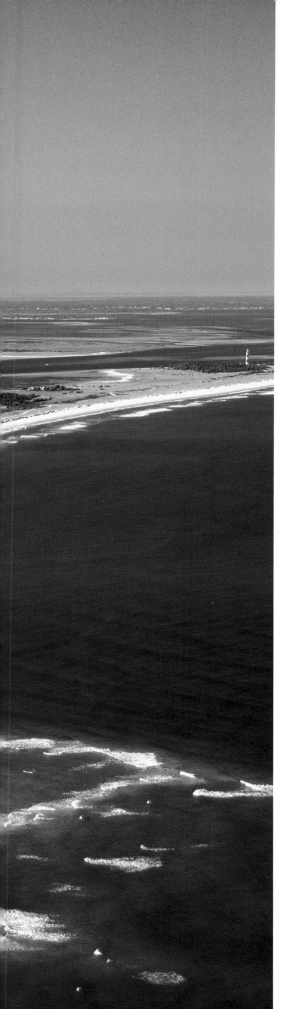

Backroads
of North Carolina

YOUR GUIDE TO GREAT DAY TRIPS & WEEKEND GETAWAYS

BY Kevin Adams

Voyageur Press

DEDICATION

To my sister, Alecia, for her determined encouragement over the years.
And for the joy of watching her make it to the top in all the ways that matter.
And to my brothers, Steve and Laurie, for always having the answers to my questions
and for making me feel that I could accomplish anything.

First published in 2009 by Voyageur Press, an imprint of MBI Publishing Company,
400 First Avenue North, Suite 300, Minneapolis, MN 55401 USA

Voyageur Press titles are also available at discounts in bulk quantity for industrial
or sales-promotional use. For details write to Special Sales Manager at
MBI Publishing Company, 400 First Avenue North, Suite 300, Minneapolis, MN 55401 USA.

To find out more about our books, join us online at www.voyageurpress.com.

Library of Congress Cataloging-in-Publication Data
Adams, Kevin, 1961-
 Backroads of North Carolina : your guide to great day trips & weekend getaways / Kevin Adams.
 p. cm.
 Includes index.
 ISBN 978-0-7603-2592-6 (sb : alk. paper)
 1. North Carolina—Tours. 2. Scenic byways—North Carolina—Guidebooks.
 3. Automobile travel—North Carolina—Guidebooks. 4. North Carolina—Pictorial works. I. Title.
 F252.3.A33 2009
 917.5604'44—dc22
 2008025056

Edited by Danielle Ibister
Designed by Chris Fayers
Maps by Patricia Isaacs, Parrot Graphics

Printed in Singapore

FRONTISPIECE: The Blue Ridge Mountains.

PREVIOUS PAGE: Cape Lookout National Seashore. **INSET:** Catawba rhododendron.

OPPOSITE: Old fishing nets and crab pots along the coast.

NEXT PAGE: Nose-End Rock along U.S. Highway 221.

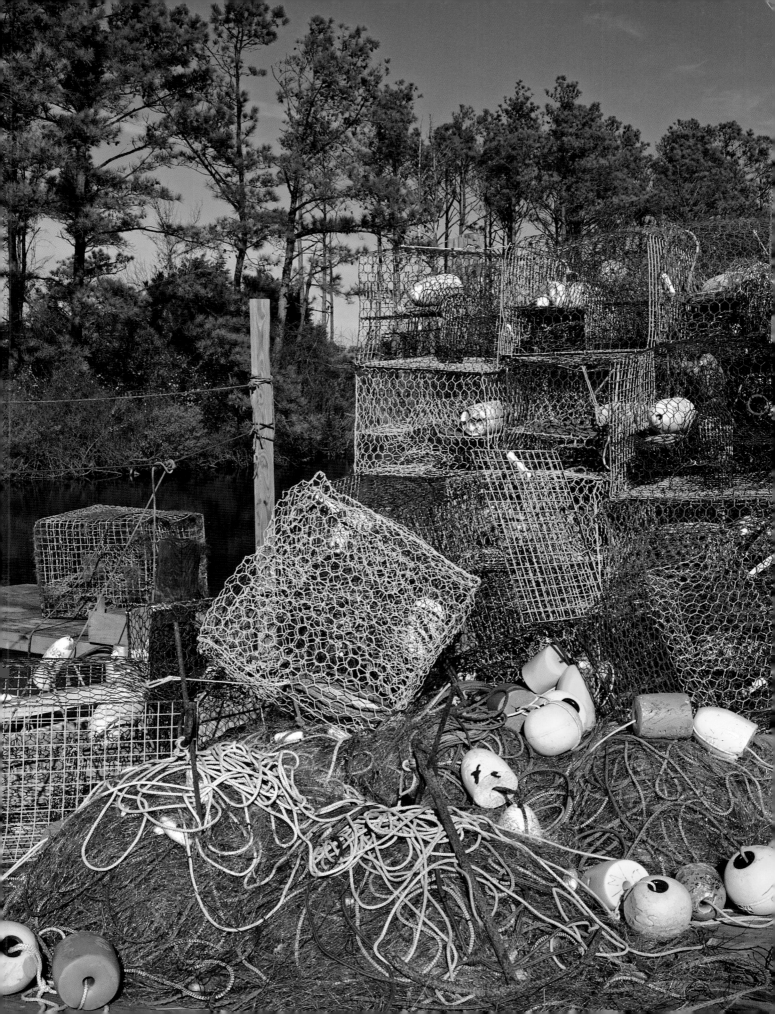

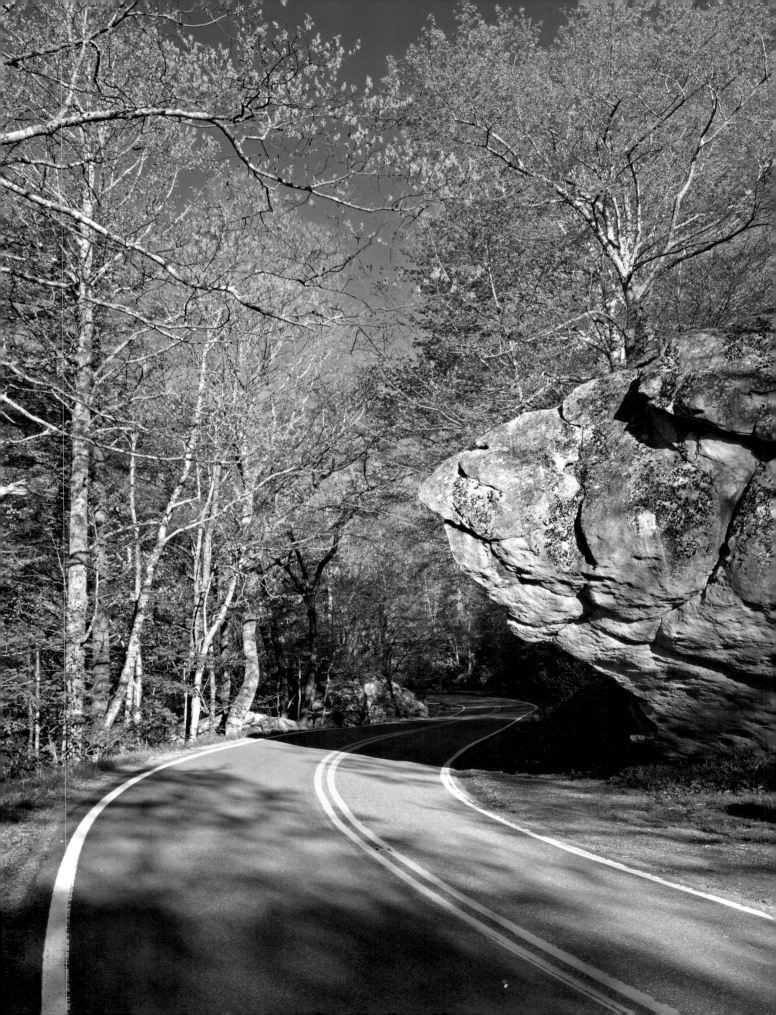

CONTENTS

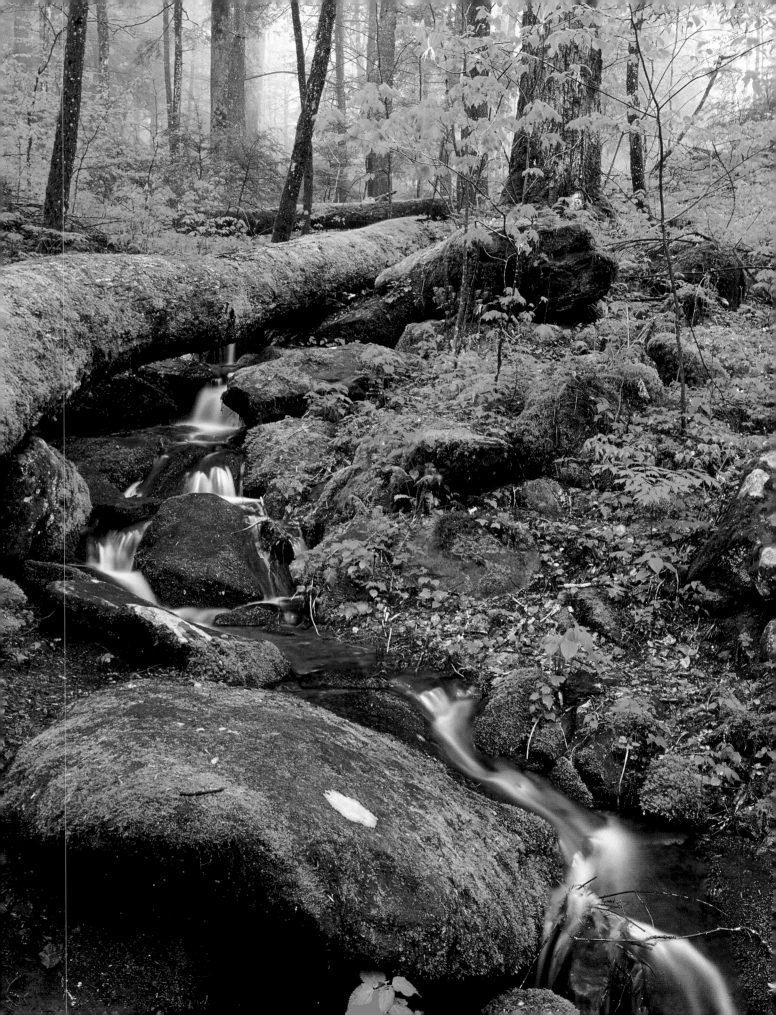

INTRODUCTION

At sunrise during winter, thousands of snow geese fill the skies over Pocosin Lakes National Wildlife Refuge.

OPPOSITE: Spring in Joyce Kilmer Memorial Forest has the verdancy of a tropical rain forest.

Goldenrods and asters grow at an old barn in western North Carolina.

L et me see if I have this right. I'm writing a book about North Carolina, highlighting thirty or so backroad routes that exemplify the state's storied history and scenic beauty—and I'm doing it all in 160 pages? Have I lost my mind?

Don't I know that North Carolina has the second-largest road system in the nation? And that most of these qualify as backroads? Or that the state's rich history extends all the way back to the colonial era, when North Carolina became the first state in the union to authorize its delegates to vote for independence from Britain? Or that North Carolina witnessed decisive battles during the Civil War and, later, man's first flight in a powered machine? Or that North Carolina's physical geography ranks it among the most biologically and aesthetically diverse places in America? Surely I remember that miles of pristine beaches and barrier islands line one end of the state, while rugged mountains tower on the other end?

I have lived in North Carolina for nearly half a century, during which time I have seen and experienced enough of my home state to fill a library of books. The idea of attempting to cull all of these attractions down to fit into a 160-page book was tough at first. But I finally decided to make this book a showcase for my beloved Tarheel State. Although I would have preferred to have had room for 1,000 pages and 750 photographs, I am confident that even the most seasoned North Carolina traveler will find something new and exciting in these pages.

I chose the routes based on scenic amenities, interesting history, general nature, and, admittedly, some of my quirks. I don't like heavily

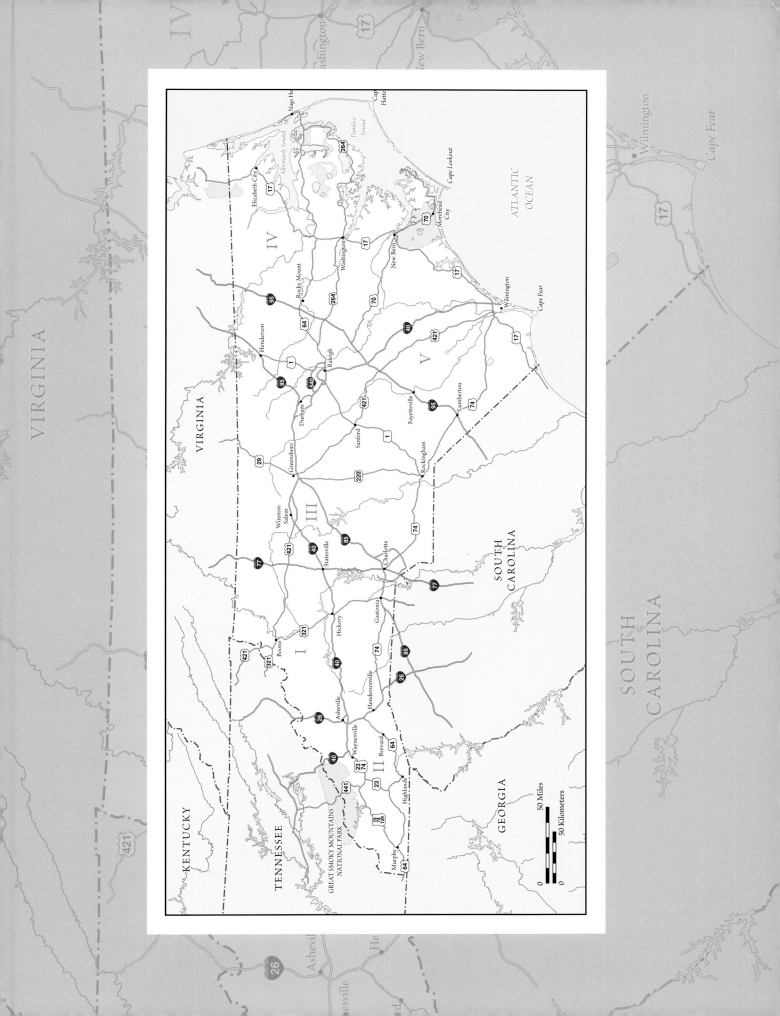

populated areas, but in some cases I felt it appropriate to include them, such as with Wilmington in Route 29. I refused to include the road from Cherokee to Clingmans Dome in the Smokies, even though it offers exceptional scenery; I've been caught in enough bumper-to-bumper traffic on this highway to skew my judgment forever. Yet I included the Blue Ridge Parkway, even though it receives the most visitors of any unit in the National Parks system. The parkway is not crowded during most of the year, and with some 250 miles of the roadway in North Carolina, you can find relative solitude somewhere at any given time, even during the height of tourist season. Besides, part of the appeal of the parkway is that it provides access to many other scenic areas, many of them little visited.

Each route includes driving directions and an overview of its highlights. The distances stated in the directions are rounded to the nearest mile. Because it is impossible to describe all of the excellent features of any one route, I try to provide descriptions that will entice you to seek out more information. Unexpected discoveries await you on every route. While therein lies part of the appeal of driving a backroad, there is some advantage in doing a little research ahead of time. At the very least, bring along a good road map. The maps and directions provided in this book are meant only as a general guide. I recommend DeLorme's *North Carolina Atlas & Gazetteer* as a primary road map.

The routes range in driving length from 15 to 180 miles, but mileage often does not indicate travel time. You can drive any route in the book in a half day or less, but why would you want to? The shortest route, on Roanoke Island, would take about thirty minutes if driven straight through, but it would take a long weekend if you experience all it has to offer. Most routes are best driven at certain times of the year, and some require you to visit at several different times to reap their benefits. For instance, wildflower season in the mountains runs from mid-March to October. You should take a road trip in April to see the spring ephemerals and another in midsummer to see the showy roadside species.

As if this isn't enough for you to digest before you hit the road, consider one more thing. On nearly every route, there are connecting side roads that offer sights every bit as good as the one you're traveling. This is especially true in the mountains, where practically every road is a "scenic byway." Don't be afraid to explore off the main route.

My lifetime of exploring North Carolina from the mountains to the sea has provided me so many sights, experiences, and memories that I will never be able to express them all. I am hopeful that in *Backroads of North Carolina* I have provided you with the spark you need to begin your own journey of exploration across the Tarheel State. I promise you that you will never become bored with North Carolina.

Time to hit the road.

OPPOSITE: The 1910 "Old Red Bridge" crosses Spring Creek in Hot Springs.

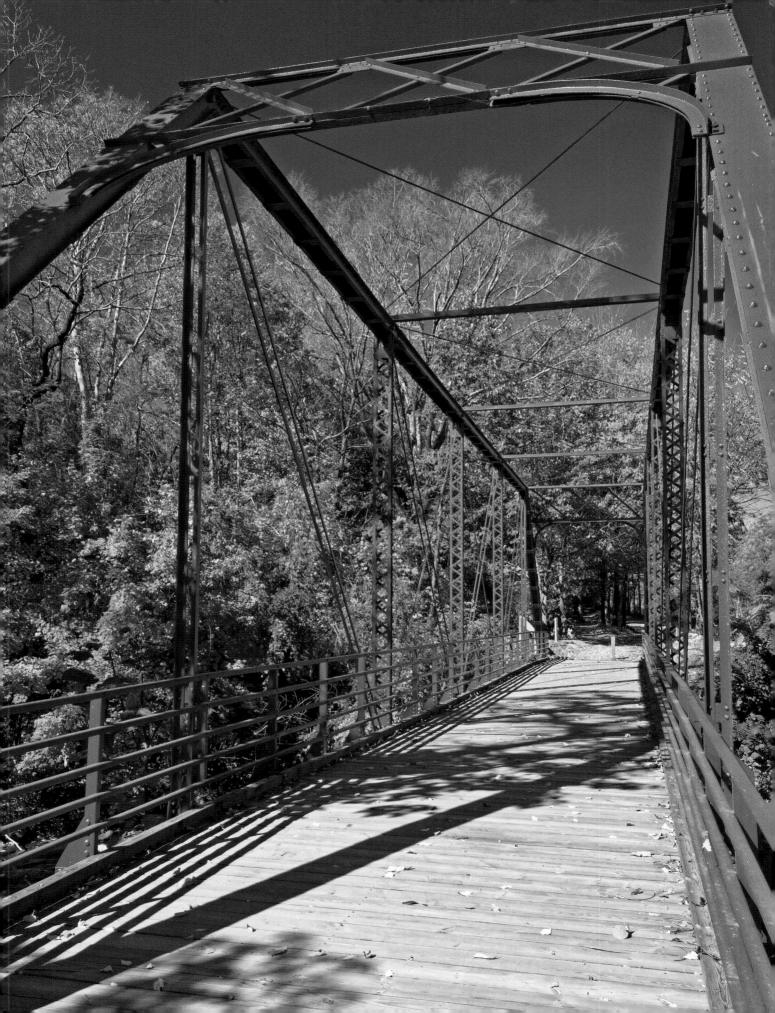

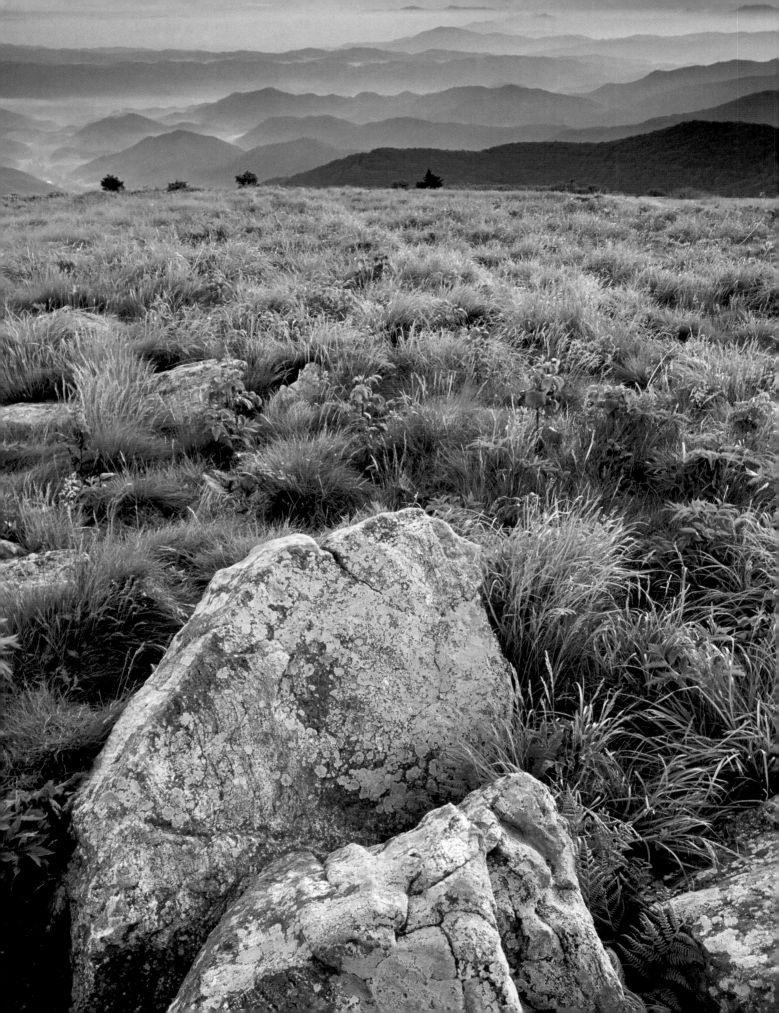

PART I

Bluffs and Valleys

The Northwest

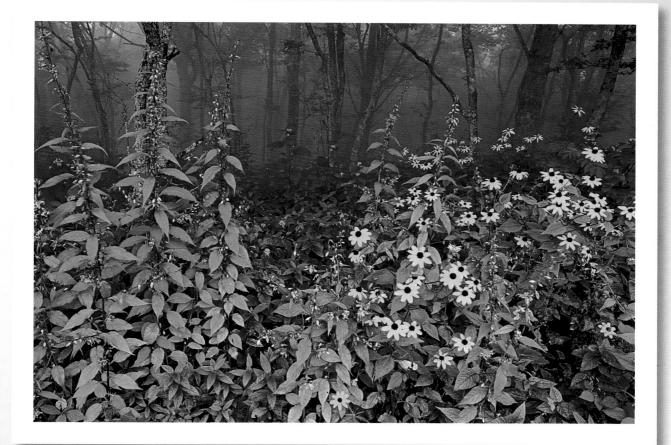

Black-eyed Susans and tall bellflowers grow along the Overmountain Victory Trail near Yellow Mountain Gap in the Roan Mountain Highlands.

OPPOSITE: Lichen-covered rocks create an interesting foreground to this early-morning view from Round Bald in the Roan Mountain Highlands.

North Carolina's contribution to Appalachia might reflect the most range and diversity of any state, particularly in the state's northwestern corner. Asheville, to the south, often appears in travel magazines and "top ten" lists as the place you want be. Boone, to the north, recently celebrated its third straight national championship in the Football Championship Subdivision. The entire region is scenic, attracting hordes of tourists year-round. Skiing is extremely popular here in the winter.

The cool climate and aesthetic amenities of western North Carolina have drawn people forever, but in recent years the influx has reached horrific proportions. Golf resorts and mountainside subdivisions are popping up like dandelions, negatively altering the very qualities that attracted them here. No one, except a real-estate agent, thinks a mountainside covered in vacation homes is an appealing sight. However, you can still drive backroads in this region and witness scenes little changed from a century ago. Some sights remind you that poverty remains prevalent in this country, particularly in the Appalachians. But don't tell that to the people who live here. They will tell you they are just as rich as anyone, and after spending some time in "their" land, you are liable to agree with them.

The roads in this region range from high mountains to pastoral valleys. You can drive the incomparable Blue Ridge Parkway, climb the rugged Grandfather Mountain, browse the shelves of old country stores, float down an ancient river, and share a cheeseburger with Appalachian Trail thru-hikers. You can experience a broad range of cultures, from proud natives to college students hell-bent on changing the world, to former college students still working on it, to hard-working hill folk just trying to earn a living.

ROUTE 1

A River Runs Through It

NEW RIVER COUNTRY

Our first *Backroads of North Carolina* route begins, ironically, in Tennessee. Don't be alarmed; you'll be in the Tarheel State within a couple of miles. From the mountain community of Trade, Tennessee, where our route starts, it's just two miles to the state line. Once you cross into North Carolina, all of the streams flow into the New River. The state's other mountain rivers flow southeast or southwest, but the New starts out by flowing north. It passes through Virginia and into West Virginia and actually bisects the Appalachian Mountains. At its intersection with the Gauley River, it becomes the Kanawha

Route 1

Start out on U.S. 421 in Trade, Tennessee. Head north on Tennessee 67 and cross the state line, where the road becomes NC 88. At 7 miles from U.S. 421, turn right onto Sutherland Road. Go 12 miles, then turn left onto NC 194. Drive 7 miles, then turn right onto Todd Railroad Grade Road. Go 4 miles, then bear left onto Railroad Grade Road. Continue 7 miles, then turn left onto U.S. 221. After a quarter mile, turn right onto Watertank Road. Drive 3 miles, then turn right onto Lower Nettle Road. Follow it 7 miles and turn left onto NC 163. Go 3 miles and turn right onto Frank Dillard Road. Follow it 3 miles, then turn right onto NC 88. Follow it 2 miles to New River State Park. (*55 miles*)

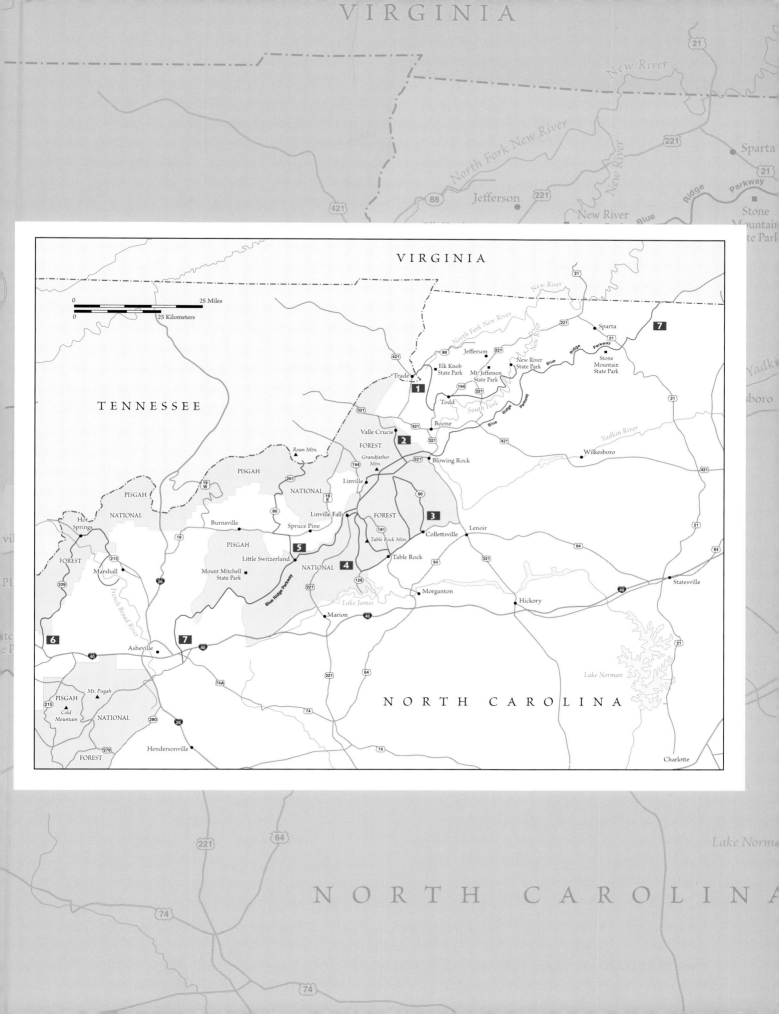

OPPOSITE: Rising more than 5,520 feet high, Elk Knob commands attention from all directions. Elk Knob State Park is among North Carolina's newest parks.

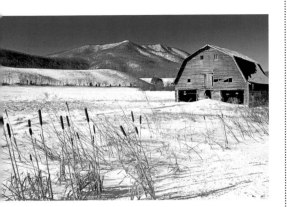

Pastoral scenes characterize New River country. Here, Mount Jefferson towers above the snowy landscape.

River, a tributary of the Ohio River, which in turn is a tributary of the Mississippi River. So the New River's water makes a complete about-face by flowing first north, then west, then south.

No one knows for sure how the New River got its name, but it had nothing to do with its age. The New is old. Very old. In fact, some geologists believe the river may count among the oldest in the world. Some claim it is second oldest only to the Nile, which would make it the oldest river in North America.

Much of our driving route lies along surprisingly gentle terrain for mountain country, but an exception is near the beginning, on NC Highway 88. After passing through a pocket of flat farmland, the characteristic meanders and switchbacks of mountain backroads take over. Snake Mountain towers above NC 88 on the right, while Elk Knob dominates the view to the left.

Elk Knob belongs to a mountain chain called the Amphibolite Mountains, which extends from Boone to Jefferson. The underlying element of these mountains is amphibolite, a metamorphic rock rich in calcium and other minerals. This bedrock contributes to the region's exceptional diversity of flora. The Nature Conservancy's Bluff Mountain Preserve, at the northern end of the range, counts among the most ecologically significant sites in the Southeast. Mount Jefferson, near the end of our route, also belongs to this chain. Views of commanding summits dominate much of the drive.

The entrance to Elk Knob State Park marks the dividing line between the headwaters of the two forks of New River: The North Fork flows off the north side, the South Fork off the south side. We follow the South Fork for the rest of our journey. Part of the route follows the New River Valley Scenic Byway.

As with other regions of the southern Appalachians, the culture of New River country is a paradox. Around one curve, you'll spot a nineteenth-century farmstead worthy of Grandma Moses' brush; around the next, you'll witness a modern development of cookie-cutter houses perched precariously on a denuded hillside.

It wasn't supposed to be this way. Back in the 1960s, someone had the idea to build a dam on the New River and sell the power to customers in the Midwest. At that time, the region had not experienced the tourism and second-home development craze. Things were pretty much the way they had always been. The thought of a dam ruining their way of life did not sit well with the locals. After a long, difficult fight with dam proponents, the people won. In 1976, Congress designated a 26.5-mile section of the New as a National Wild and Scenic River. The state planned to purchase land along the river corridor to protect the viewshed and riparian zone. Unfortunately, these plans did not materialize. Not until the 1990s did serious conservation efforts begin. By that time, commercial and residential development had impacted much of the river corridor; a few pockets

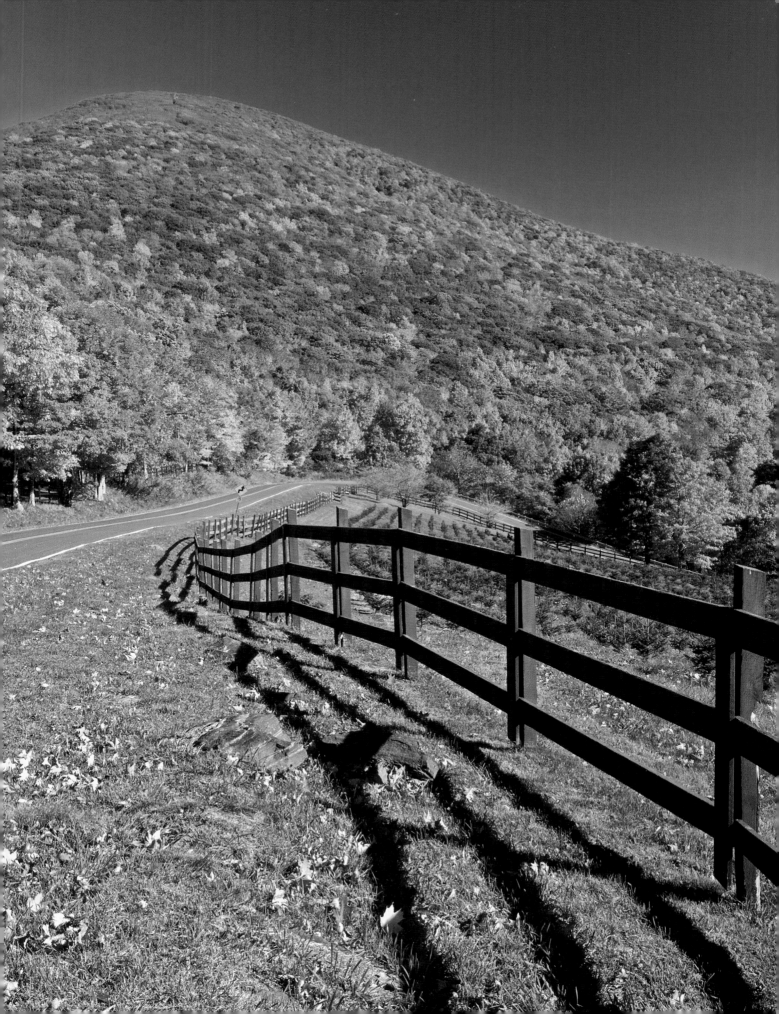

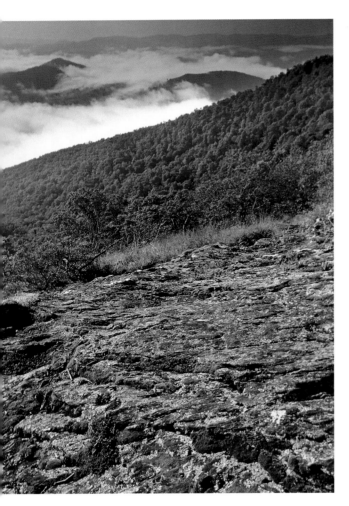

Luther Rock, on the summit of Mount Jefferson, provides a sweeping view of the often fog-enshrouded New River valley.

were protected, but the remaining unspoiled land increased so much in value that the government couldn't afford it.

Be on the lookout for the old and the new as you drive this route. Prominent among the old is the community of Todd, recognized by the National Register of Historic Places as a Rural Historic District. Originally named Elks Crossroads, Todd served as the southern terminus of the Virginia-Carolina Railroad until the company abandoned the line in 1933. The original train depot burned in 1920; an older building brought from Virginia still stands. Built in 1914 and later expanded, the Todd General Store—clad in the same pressed tin as other nearby buildings—still supplies locals with staple goods and tourists with trinkets. An old potbellied stove warms those attending the store's regular storytelling and bluegrass performances.

Upon your departure from Todd, the South Fork of the New River becomes your close traveling companion. Drive slowly and watch out as you go around curves; you're sharing this narrow road with hikers, bikers, and joggers. If you want to experience the river up close, try a canoe trip. Todd is a popular put-in point, with local businesses providing all the logistics.

As you drive alongside the river from Todd, the juxtaposition between the old and the new slaps you in the face. All the new homes and manicured lawns don't fit in the traditional agrarian landscape. Fortunately, enough unspoiled land remains to provide a sense of place. While the original bridges along most of the main roads ("main" being a hugely relative term in this case) have been replaced by sturdy concrete and steel structures, a surprising number of old metal and wood "low-water" bridges remain. These old structures hug the water and look as if they would collapse under the weight of a car. They make great places to pull over and get a close-up view of the river, assuming, of course, the water is not running high. Canoeists know these bridges all too well. Too low to paddle under, the bridges are at the perfect height to mess up a canoe trip.

Near the end of our route, Mount Jefferson looms above the landscape to the west. Separated from the other summits in the Amphibolite Mountains, Jefferson rises above the surrounding valleys and commands admiration from all directions. The summit and upper slopes became Mount Jefferson State Park in 1956; today, the state administers the park as Mount Jefferson State Natural Area. A particularly fine example of a mature northern hardwood forest grows on the upper slopes, contributing to the mountain's designation as a National Natural Landmark. From the summit, an easy hike along the crest of the mountain takes you to Luther Rock, which

provides sweeping views of the New River valley, including much of the route you travel on this drive. No other vista offers as dramatic a sense of place of New River country.

Our route ends at the Waggoner Road access of New River State Park. The park provides camping and picnicking facilities and a nature trail that is among the finest in the mountains for viewing spring ephemeral wildflowers. After exploring the park, spend some time discovering other places of interest nearby. To the north is the historical community of Crumpler and nearby Shatley Springs, with its popular restaurant featuring family-style southern meals (calorie-watchers beware!). To the south, Holy Trinity Church proudly displays its famous fresco created by artist Ben Long. To the west, the towns of Jefferson and West Jefferson offer historical architecture and St. Mary's Church, which displays its own Ben Long fresco. And nearly every backroad in the region offers similarly beautiful sights.

Of course, you can also continue following the New River downstream. From the Waggoner access, it is about twenty-two river miles to the confluence with the North Fork and about five miles farther downstream to the Virginia line. The nationally designated Wild and Scenic portion of the river occurs in this corridor. A spiderweb of backroads provides numerous access points, including the U.S. Highway 221 and Allegheny accesses provided by New River State Park.

Morning sunlight casts a warm glow on the New River at New River State Park.

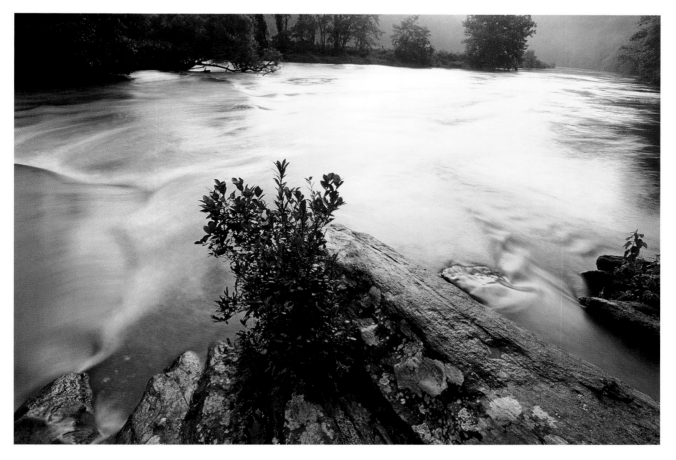

A Rugged Mountain and Gentle Valley

GRANDFATHER MOUNTAIN TO VALLE CRUCIS

A hiker absorbing the 360-degree views atop MacRae Peak on Grandfather Mountain would have no trouble forgiving Andre Michaux for recklessly proclaiming in 1794 that he had "climbed to the summit of the highest mountain of all North America." Michaux visited Grandfather while on a French botanical expedition, and although he drastically miscalculated the mountain's elevation—at 5,964 feet it's not even the highest peak in the state—you really do feel on top of the world up here. The mountain's rugged slopes fall precipitously off the northern and southern sides, and the 4,000-foot elevation difference between the summit and lowlands to the east makes for the greatest relief along the Blue Ridge Front.

One can also forgive the marketing hyperbole from the folks at Grandfather Mountain who proclaim the mountain as "Carolina's Top Scenic Attraction." The statement does have merit. When the late Hugh Morton inherited the mountain in 1952, he immediately began working to attract tourists. He expanded and extended the road and built the famous Mile High Swinging Bridge. Later expansions included an animal habitat, a modern auditorium facility, and a museum with an impressive collection of artifacts representing North Carolina and Appalachia. The collection of North Carolina minerals is among the finest in existence.

Route 2

Start out in the community of Linville. Head north on U.S. 221 for 12 miles and turn left onto Holloway Mountain Road. Drive 3 miles, then turn right onto Church Road. Drive three-quarters of a mile, then turn right onto NC 105. Go a quarter mile, then turn left onto Clarks Creek Road. Drive 2 miles to a T intersection and turn right. Drive 2 miles and turn right onto NC 194. Follow it a mile and turn left onto Watauga River Road. The road follows the river for 7 miles (changing names along the way) to U.S. 321. (*30 miles*)

Grandfather Mountain's Mile High Swinging Bridge has been enticing (and terrifying) visitors since 1952.

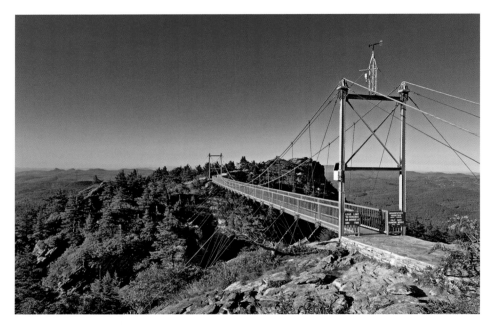

But through all his promotional efforts, Morton made sure not to destroy the very reason for Grandfather's popularity: the spectacular scenery, the significant numbers of rare plants and animals, and the diverse natural communities. Biologically, Grandfather Mountain reigns as king of the southern Appalachian jungle. And anyone who hikes the trail along the mountain's crest knows it's the most rugged. The entrance to Grandfather Mountain lies off U.S. Highway 221, a couple of miles from the start of our route. Plan to spend at least half a day here, more if you do any hiking.

The Parade of Tartans at the Grandfather Mountain Highland Games creates a colorful show.

From Grandfather, follow U.S. 221 north on the old Yonahlossee Road. Those who think of U.S. highways as being the quick way to get from point A to point B are in for a surprise. Completed in 1892 with manual labor, Yonahlossee Road was among the first roads in the East built solely for tourism. It connected the resort towns of Linville and Blowing Rock. The stretch operated as a toll road until around 1916. Although a U.S. highway today, the narrow road still follows the same serpentine course it did in 1892.

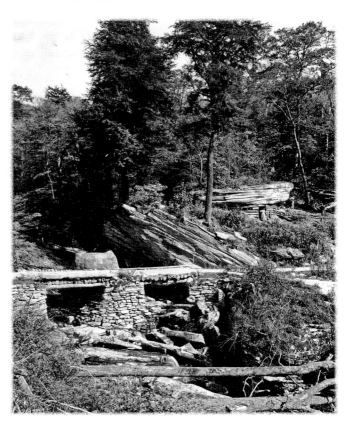

Drive slowly on the Yonahlossee or you'll miss the sights. About three miles from Grandfather Mountain, a wide pullout on the right provides a great view of the Linn Cove Viaduct on the Blue Ridge Parkway. A short distance farther, a huge boulder called Nose-End Rock hangs over the road. Farther along flows a small waterfall where local entrepreneurs once set up roadside stands. Today, it is a popular picture-taking stop.

A couple of miles beyond the waterfall, our route turns off U.S. 221 onto Holloway Mountain Road. In less than a mile, you pass under the Blue Ridge Parkway and the road changes to gravel. The sweeping mountain views, cascading streams, and intimate forest scenes are behind you now; pastoral landscapes, slow-moving rivers, and cultural icons await.

After a brief run through the heavily developed community of Foscoe, you come to Valle Crucis, Latin for "Vale of the Cross." The name comes from an early Episcopal bishop who noticed three streams in the valley forming the shape of St. Andrew's Cross. Old barns, churches, houses, and pastureland occupy a surprisingly rural landscape tucked between suffocating development in Boone, Beech Mountain, and the NC Highway 105 corridor. The historic significance of the valley led to its designation as a Rural Historic District. A great time to drive through Valle Crucis is early in the day, when morning fog softens the landscape.

A woman stands in the doorway of her "rock house" along Yonahlossee Road. Two men and a boy are nearby. One account says these people lived under the rock in the early twentieth century while gathering the galax plant to sell to florists. *George Masa, North Carolina Collection, Pack Memorial Library, Asheville, NC*

Just as when it first opened in 1883, Mast General Store serves the Valle Crucis community as a mercantile and gathering place.

Locals gather at the pot-bellied stove in Mast General Store.

Perhaps the most well-known mercantile in the state, Mast General Store in Valle Crucis first opened in 1893. This place personifies the term "old-timey," although the juxtaposition between the old and the new might be a little hard to take for some.

Mast has the quintessential potbellied stove, the requisite checkerboard set up by the stove, hoop cheese, bulk nails sold by the pound, and candy by the barrel. There is even a post office *inside* the store. When someone needs to mail a package or buy stamps, the cashier steps from behind the counter and assumes the role of postmaster.

But don't expect to find Model Ts parked in front of the store and don't look for old-timers in overalls playing checkers by the woodstove (although resourceful photographers might be able to set up such a scene). You're much more likely to have to jockey for parking space between a Mercedes and a Lexus, and store aisles today are packed with tourists who have never owned a pair of overalls (and aren't likely to buy a pair at the store). It's not that Mast has abandoned the local clientele. In fact, the company tries hard to maintain a sense of place in the community. It's just that in this booming tourist region, out-of-towners have largely replaced the archetypal local.

The original 1883 Mast store is located on NC Highway 194, a short distance north of the junction with Broadstone Road; just south is the Mast General Store Annex, occupying a circa-1909 building that also served as a general store.

If the tourist traffic in Valle Crucis or the crowds at Mast General Store are too much for you, you're going to love the remainder of the route. Watauga River flows through a bucolic landscape largely unchanged since the early 1900s. If you can, drive this route on an August morning when fog rises from the river and showy summer wildflowers such as coneflower, wingstem, and ironweed line the riverbanks.

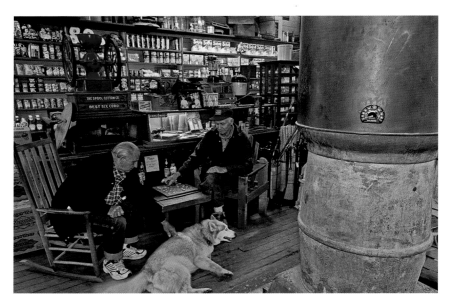

ROUTE 3

A Fishing and Hiking Paradise

UP WILSON CREEK AND DOWN JOHNS RIVER

This route leads you through the southern drainage of Grandfather Mountain in Pisgah National Forest, which provides some of the finest streamside hiking in the state. This region is also rich in historical relevance, evoking the era of the logging industry during the first decades of the twentieth century.

Before emptying into Johns River, Wilson Creek (more like a small river according to North Carolina mountain standards) flows through Wilson Creek Gorge. Scenic water-sculpted rocks, cascades, and deep, emerald-green pools make this a popular destination for trout fishers, sunbathers, and tubers. Designated a National Wild

Route 3

Start out on NC 181 north of Morganton. Turn east onto Brown Mountain Beach Road. Drive 5 miles and turn left to remain on Brown Mountain Beach Road. Drive 9 miles to a T intersection and turn left. Follow the usually unmarked road for 10 miles (without turning) to the community of Gragg, where it becomes Globe Road. Follow it a mile and bear right. Drive 6 miles (road becomes Anthony Creek Road), then turn left onto NC 90. Drive 6 miles, then turn right onto Old Johns River Road. Follow it 6 miles back to NC 90 and turn right. Drive three-quarters of a mile to Colletsville and turn right on Adako Road. Follow it 3 miles back to Brown Mountain Beach Road. (*47 miles*)

Lost Cove Trail parallels Gragg Prong in Pisgah National Forest, providing intimate views of the scenic stream.

Coffey's General Store, recently closed, served the community of Edgemont for nearly a century.

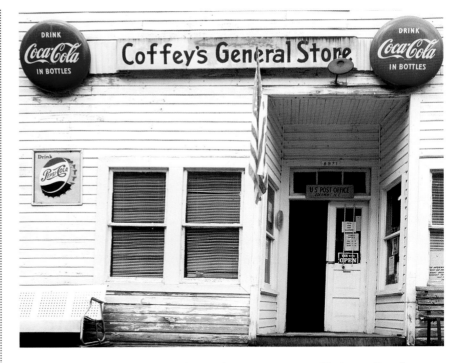

A Shay locomotive hauls logs along the top of Bard Falls in this circa-1909 photograph. The train is on its way to the W. M. Ritter Lumber Mill in Mortimer. Today, North Harper Creek Trail follows the old railroad grade. *Herbert W. Pelton, North Carolina Collection, Pack Memorial Library, Asheville, NC*

and Scenic River by President Clinton in 2000, Wilson Creek stays hugely popular from summer to autumn.

A short distance beyond the gorge on Brown Mountain Beach Road lies the Wilson Creek Visitor Center. If you plan to hike in the area or drive the many forest roads, you'll need a good map and some information about the sights. You can get that at the visitor center, as well as a plethora of information about the region's history.

A couple of miles beyond the visitor center are the concrete remains of a cotton mill from the early 1900s. Just ahead, the road crosses Wilson Creek and passes through a floodplain that plays host to a few vacation cottages. Scattered about are old bridge abutments, rusted pieces of metal, and several overgrown foundations—but apart from these subtle hints, you'd never know that this site once hosted a bustling logging mill town.

Up ahead, in the community of Edgemont, more echoes from the past await. Coffey's General Store, recently closed, served the community for nearly a century. Another early-twentieth-century survivor is the Edgemont Depot. When passenger train service ended in Edgemont in the late 1930s, the depot was moved a short distance and adapted as a private residence.

Two roads branch out from Edgemont: Forest Road 464 and Forest Road 981. Both take you to trailheads for some of the finest hiking in Pisgah National Forest, including access to spectacular waterfalls. Get a trail map and spend some time exploring the roads and trails. Continuing north on the route from Edgemont, you climb out of the valley on another winding forest road to reach the community of Gragg, nestled under the shadow of Yonahlossee Road

(see Route 2). From Gragg, the route turns south and passes through Johns River valley on the opposite side of Wilson Ridge from Wilson Creek. Most of this part of the route cuts through private property, but thankfully it's far enough back in the boonies to have remained largely undiscovered by outsiders and their bulldozers.

There's a lot to see between Gragg and Colletsville, but one particular spot deserves advance notice. To keep from driving into the ditch upon first sight, it's best to know ahead of time about things like Johns River House of Mugs. To find it, look for a small vacation cabin beside Johns River. The cabin has a fence running across the front yard and down both sides of the driveway. If that doesn't help you find it, try looking out for the 14,000 or so coffee mugs hanging on everything in sight. That's right. Coffee mugs cover nearly every square inch of the fence, house, and porch of this vacation cottage. Proud owners Avery and Doris Sisk welcome curious visitors from all over the country to their coffee-cup haven.

Johns River House of Mugs sits beside the river near Colletsville. Adorned with thousands of coffee mugs, the cottage draws visitors from all over the country.

Vines entangle an abandoned gas pump near the community of Colletsville.

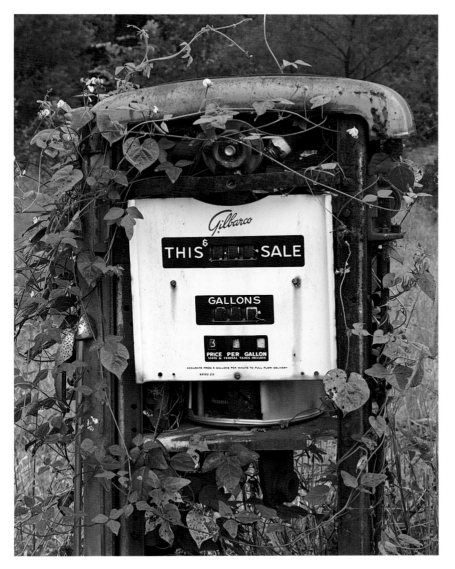

Route 4

Start out on NC 183 near the community of Linville Falls. Turn south onto Kistler Memorial Highway (Old NC 105). Drive 16 miles to the end and turn left on NC 126. Go 5 miles and turn left onto Fish Hatchery Road. Go 7 miles, then turn left onto NC 181 north. After 3 miles, turn left onto Simpson Creek Avenue. Go a quarter mile and turn right onto the usually unsigned national forest road. At 9 miles, the road passes by Forest Road 210B, which leads to Tablerock Mountain. At 14.4 miles, the road joins Gingercake Road. Drive a quarter mile, then turn left onto NC 181. Head north for 3 miles, then turn left onto NC 183. In 4 miles the loop is complete. (*52 miles*)

River of Cliffs

A LOOP AROUND LINVILLE GORGE

Peering into Linville Gorge from the towering rock formation known as The Chimneys, a nineteenth-century traveling party turns to their guide and asks, "Does the Linville run there?" He replies, "Yes, and, poor thing, it sees troublous times before it gets out of there, too."

Troublous, indeed. Linville is the deepest and most rugged gorge in the East. From Linville Falls at the head of the gorge, Linville River drops nearly two thousand feet in its twelve-mile run through the canyon. Mountains along the rim rise some two thousand feet above the river. But what really makes Linville Gorge spectacular is not its depth or the turbulent pace of the river. What really makes it cool is the topography of the canyon's walls and rim. Striking rock formations and peaks called Sitting Bear, Hawksbill, Tablerock, The Chimneys, Shortoff, and Babel Tower line both sides of the gorge and provide unparalled views.

BROWN MOUNTAIN LIGHTS

ON THE COAST, the people wonder what happened to the Lost Colony, but in the North Carolina mountains, the most celebrated mystery is the Brown Mountain Lights. As mysteries go, this is about as good as it gets.

The lights have dazzled viewers for centuries. Supposedly, the Cherokee knew of the lights as early as the year 1200. According to one Cherokee legend, the lights are spirits of Indian maidens searching for men who had died in battle. Other spirited tales tell of the ghost of a slave searching for his master and the ghost of a murdered woman searching for her severed head. UFOs and angels also make the list in the supernatural category. And then there's the explanation offered in an *X-Files* episode—that the lights lured people into caves so that an enormous hallucinogenic mushroom could digest the living tissue from their bodies before exhuming the bones to the surface. Well, what do you expect from Mulder and Scully?

German engineer William Gerard de Brahm offered the first scientific theory in 1771 when he wrote that the lights were caused by windborne vapors that had ignited. Scientific explanations abound, but none have been proven. Among the unlikely theories are automobile or train headlights (the phenomenon was seen before trains existed in the area and also seen right after the 1916 flood that grounded all motorized transportation), methane gas (no source for it), bioluminescence (that type of light is too faint), and refraction from distant electric lights (electric lights were not in existence in the area when the lights were first seen). Among the not-yet-disproved theories are ball lightning, magnetic plasma, and charges resulting from seismic activity.

The truth is that no one knows what causes the Brown Mountain Lights, although many people are searching hard for the answer. If you want to try to see them for yourself, the best place to look is probably Wiseman's View. Those who have seen the lights from here say they appear on the opposite rim of the gorge or down in the gorge near the river. They can be white or bright red or other colors, and they can dance in erratic patterns. If you go, just don't make the mistake that many observers do and assume the distant lights from Lenoir or from airplanes are the real thing.

Beginning in the community of Linville Falls, our route circumnavigates Linville Gorge on mostly unpaved roads and provides easy access to all the sights. At the start is the Pisgah National Forest trailhead for Linville Falls (the National Park Service trailhead is accessed from the Blue Ridge Parkway). Plan to spend several hours exploring the many viewpoints for the waterfall, which is among the most remarkable in the state. It's even more fascinating when you know a little bit about its geology.

When the Appalachians formed millions of years ago, tremendous pressure from continental collisions caused an upheaval in the earth's surface that thrust older rock strata westward and slid it over younger rock. This upheaval formed a precipice of hard, erosion-resistant quartzite overlying softer, erosion-prone rock. Eons ago, Linville Falls flowed over a precipice some twelve miles downstream from its current position. As it flowed over the hard rock layer, it cut into the softer rock underneath. Once the softer rock was sufficiently undercut, the hard rock lip broke off and the process repeated itself. In this manner, the waterfall slowly migrated upstream. At the present location of the falls, the quartzite extends all the way to the bottom of the gorge, so any further migration will occur at a much slower pace.

After you explore Linville Falls, our route follows Kistler Memorial Highway along the entire western rim of the gorge to Lake James. Sometimes listed as Old NC 105, the road honors Andrew Milton Kistler of Morganton, who served with the state highway commission. This must be the most inappropriately named road in the state. You'll probably come up with some choice words for it before you reach the end, but "highway" will not be one of them. It's unpaved, rough, steep, and severely washboarded in places. James Kilbourne sums it up nicely: "Old NC 105 is proof that there is a hell and that roads can die and descend to the underworld." So, with that glowing description, hop in the car and be on your way! Seriously, you can make it in the family sedan as long as the road is dry and you drive very carefully. But if the road is muddy, forget it unless you have four-wheel drive.

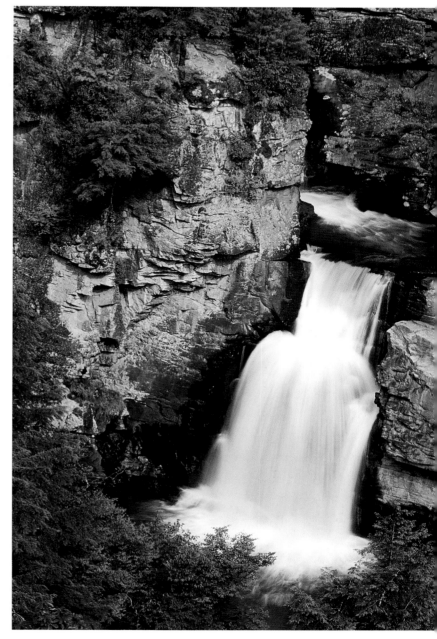

Linville Falls lies at the head of Linville Gorge, the deepest and most spectacular canyon in the East.

A short distance from Linville Falls, you come to a brief section of pavement. You'll find a national forest information cabin here, a great place to pick up a map and obtain information about the gorge. The Forest Service sells a good map called Linville Gorge Wilderness, which you'll need if you do any serious hiking. The cabin is open seasonally.

A short walk from the parking area, Wiseman's View, on the western rim of Linville Gorge, makes a great spot to watch the sunrise. The distinctive profile of Tablerock Mountain is on the right.

OPPOSITE: The summit of Hawksbill Mountain provides an ideal perch from which to survey the early-morning landscape in Pisgah National Forest.

About four miles from Linville Falls, a side road turns to the left and leads to the trailhead for Wiseman's View. A short easy path leads to an overlook of Linville Gorge, directly across from the imposing peaks of Hawksbill and Tablerock mountains. Many people consider this the best view of the gorge.

On the east side of the gorge, our route takes you to the trail-heads for Tablerock and Hawksbill mountains. Tablerock (Jules Verne's "Great Eyre" in his 1904 *Master of the World*) is the easier and more popular hike of the two, but Hawksbill offers the potential for solitude and equal views from the summit. From Tablerock's trailhead you can also hike to The Chimneys, site of the closing scene in the movie *The Last of the Mohicans*.

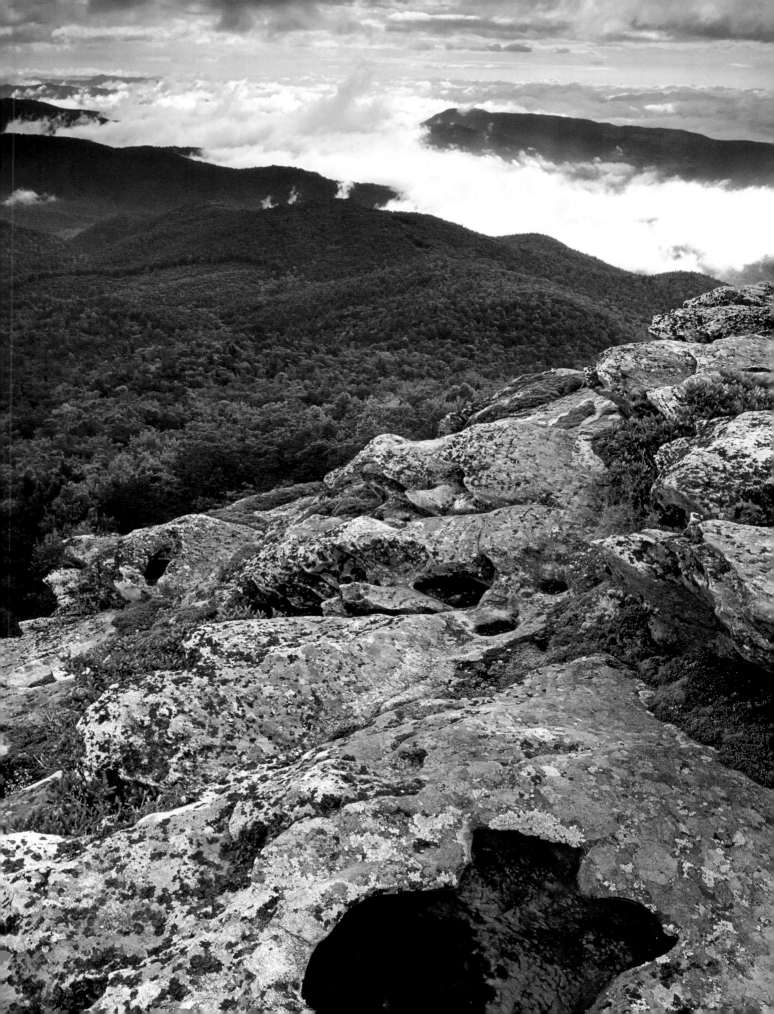

Route 5

Start out on the Blue Ridge Parkway. Exit at Milepost 334 in Little Switzerland, then turn right onto Chestnut Grove Church Road. After 1 mile, turn left onto McKinney Mine Road. Drive 2 miles and turn right onto Crabtree Road. Go 5 miles, then turn left onto U.S. 19E. At 3 miles, turn right onto NC 80 north. Follow it 10 miles and turn left onto NC 226A/80 north. At 2 miles, turn right onto NC 226. Follow it 3 miles to Bakersville, then turn left onto NC 261 north. Drive 13 miles to Carvers Gap. The road on the left leads to the rhododendron gardens. (*40 miles*)

Through the Mining District

LITTLE SWITZERLAND TO ROAN MOUNTAIN

A popular stop for travelers on the Blue Ridge Parkway is the Minerals Museum, located at Milepost 331 in Little Switzerland. Here you can pick up regional information and learn interesting facts about the nearby Spruce Pine Mining District. Chances are the sink you brushed your teeth over this morning and the toilet you, well, you know, has Spruce Pine feldspar in it. The processing chip in your computer—in fact, the chip in every computer in the world—uses high-grade quartz mined from this district. There is a lot to learn about the region, but most tourists get back on the parkway and never explore the area.

The historic Bon Ami Mine is part of the tour of the North Carolina Mining Museum at Emerald Village.

We're going to do some exploring. Departing the parkway a few miles south of the Minerals Museum, we pass through the heart of the Spruce Pine Mining District. The North Carolina Mining Museum at Emerald Village gives you the opportunity to experience a real mine. The museum displays an impressive collection

of mining artifacts and interpretive exhibits that portray the early mining industry of the region.

From Emerald Village to Bakersville, you pass by numerous old mines, shut down long ago. Most of the mines are completely overgrown and hard to recognize. Watch for piles of feldspar (the white rocks) and mica (the glittering flakes). This usually indicates a muck pile, also known as mine waste.

Our route also passes through several small communities that have interesting histories. In Kona, at the confluence of the North and South Toe rivers, the early-nineteenth-century George Silver House stands in a valley below the road. In a bit of grotesque history, George's daughter-in-law, Frankie, murdered her husband in their nearby home and became the first woman hanged in the state in 1833. A less emotionally harrowing side trip along the narrow dirt road in Lunday takes you to the picturesque Lunday Footbridge spanning the North Toe River.

The Sink Hole Mine in Bandana is among the oldest mines in the state. Historians believe that Native Americans worked the mine before the arrival of the Europeans. Mica, the primary mineral mined at Sink Hole, is unique in the mineral kingdom. It is transparent and forms in sheets that are easily separated and ground. It is also flexible and resistant to heat. These qualities made mica ideal for use in windows for early cabins and wood stoves, electrical insulation, dry lubricants, paint additives, and even decorative glitter. Today, mica serves mainly as an additive in drywall joint compound.

Suspension footbridges are fairly common in remote areas of the mountain region. This bridge crosses the North Toe River in the community of Lunday.

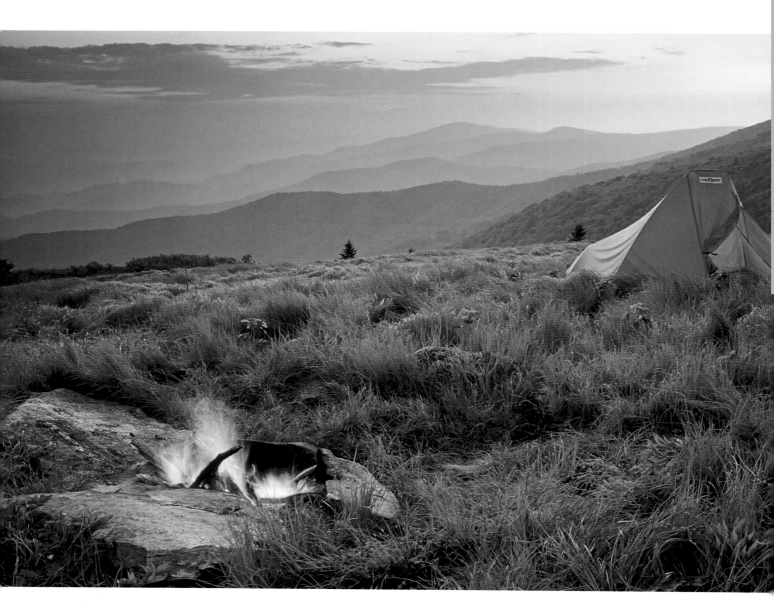

A backcountry campsite sits atop Round Bald in the Roan Mountain Highlands. The Appalachian Trail traverses the mountain's summit.

Try to plan your driving trip for the third week in June. That is the typical peak blooming period for the Catawba rhododendron and flame azalea that grow on the balds of the Roan Mountain Highlands. In a good year, the shrubs put on a floral display unmatched anywhere in the mountains. Even in a poor year, the blossoms make the trip well worthwhile. A good leg stretcher is the path through the Rhododendron Gardens between Roan High Knob and Roan High Bluff. The trail features a handicap-accessible viewing deck overlooking the densely growing rhododendron. Those who want more of a workout can hike the Appalachian Trail north from Carvers Gap. The first mile takes you over the top of Round Bald with its spectacular 360-degree views and then to Jane Bald, where a side trail climbs to the summit of Grassy Ridge, which offers even better views. Catawba rhododendron and flame azalea grow abundantly all along the trail.

ROUTE 6

Valley Farms and River Towns

NC HIGHWAY 209 TO HOT SPRINGS AND THE FRENCH BROAD RIVER TO MARSHALL

It doesn't take long to get away from the rat race on this route. When you exit Interstate 40 and head north on NC 209, as soon as the truck stop disappears from your rearview mirror, you're there.

Over the next thirty-three miles, you pass through a pastoral and forested landscape that somehow has escaped commercial development and subdivisions of cookie-cutter houses. NC 209 has even managed to avoid completely the bulldozers of the North Carolina Department of Transportation, which seems determined to widen and "improve" every highway in the mountains. Except for paving, this road hasn't changed appreciably since the 1920s.

Max Patch Mountain lies west of the highway in Pisgah National Forest and can be easily accessed from side roads. With a tree-less summit more than 4,600 feet high, the mountaintop features impressive 360-degree views of the surrounding countryside. The Appalachian Trail crosses the mountain's grassy peak, and other connecting trails create options for loop hiking.

NC 209 ends in Hot Springs. The village, like the road that brought you to it, seems frozen in time. It has modern conveniences, to be sure. But what it doesn't have are any of the typical commercial tourist trappings of other nearby towns. You won't find a modern hotel here, nor fast-food restaurants, nor neon one-hour photo signs in the drugstore. What you will find is delightful small-town atmosphere and an eclectic mix of warm, friendly people. And dogs. Don't be surprised if you have to stop your car for a dog napping in

Route **6**

Start out at Interstate 40 and NC 209, west of Asheville. Head north on NC 209. Drive 33 miles to Hot Springs, where the road changes to U.S. 25/70. Follow it 7 miles, then turn right onto Stackhouse Road. Drive to the end of the road and backtrack to U.S. 25/70. Continue north for 3 miles, turn right onto Walnut Drive, then take another immediate right onto Barnard Road. Go 2 miles, then turn left onto Anderson Branch Road. Follow it 4 miles, then turn left onto an unsigned road. Go 2 miles and turn left onto Little Pine Road. Drive 1 mile and turn right onto County Road 1114. After a half mile, turn left onto Turnpike Road. Drive 2 miles to the end of the road and turn left onto an unnamed road. Follow it 2 miles to Marshall. (*61 miles*)

Among the finest resorts in the South when it opened in 1886, Hot Spring's Mountain Park Hotel featured elevators, steam heat, and electric lights. The hotel served as a German internment camp during World War I. It burned to the ground in 1920. *North Carolina State Archives*

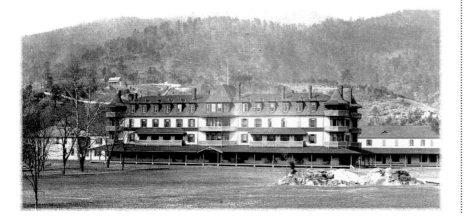

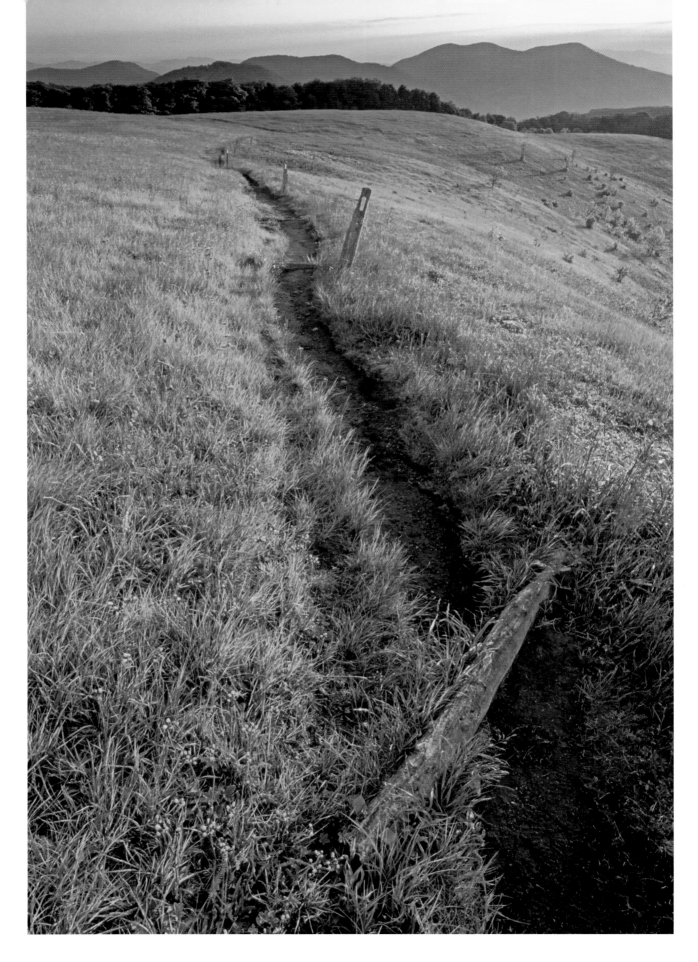

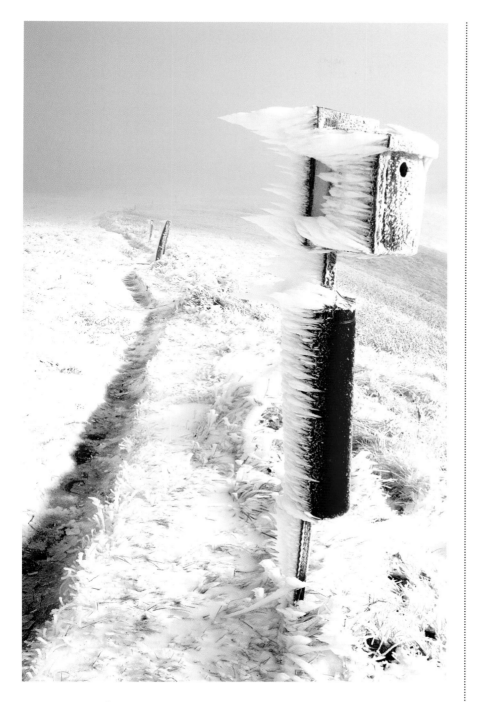

the middle of the street. If you do, just sit tight. A storekeeper will usually come out and shoo the pooch out of the road.

In the latter half of the nineteenth century, Hot Springs, originally called Warm Springs, was a resort town that claimed to have "no superior in any state." The Mountain Park Hotel opened in 1886, featuring elevators, steam heat, and electric lights. The resort also laid claim to the state's first organized golf course. But the big attraction was the hot springs, drawing visitors from all over to partake of the healing waters in one of the hotel's sixteen marble pools. The hotel burned in 1920.

OPPOSITE: The Appalachian Trail traverses Max Patch Mountain, providing access to spectacular views from the treeless summit.

The historic Madison County Courthouse is the principal building in the small town of Marshall.

The most popular activities in Hot Springs today revolve around outdoor recreation. People come to raft on the French Broad River, which runs through town, and to hike in the surrounding Pisgah National Forest. For six months out of the year, Hot Springs welcomes thru-hikers on the Appalachian Trail. (Thru-hikers attempt to hike the trail's entire distance—more than two thousand miles—in one continuous outing.) The trail runs right through town; look for the white blazes painted on the sidewalk. Another popular attraction is the recently opened Hot Springs Resort and Spa on the grounds of the former Mountain Park Hotel. The spa provides tourists and weary hikers alike with a soothing dip in the natural hot springs.

After crossing the French Broad River in Hot Springs, our route follows U.S. Highway 25/70 for about seven miles. Although the drive is somewhat scenic, you'll miss the narrow and serpentine NC 209 from earlier on the route. The North Carolina Department of Transportation folks got hold of U.S. 25/70 big time.

Stackhouse is a ghost town. A grand Queen Anne–style house on a hill overlooks the French Broad River, but there are no other obvious indicators that this was an important commercial site in the early 1900s. The Stackhouse family, owners of the Queen Anne house, once operated a barite mine and crushing facility here, along with a post office and store. A dam across the French Broad River provided power until the great flood of 1916 washed it away. Today, Stackhouse serves as a popular access point for boaters on the French Broad.

Less than a mile downstream from Stackhouse lies another ghost town. Runion once supported a major lumber mill and logging operation, also operated by the Stackhouse family. It's in Pisgah National Forest, so you can freely explore the area. If you spend some time looking around, you will discover building foundations, crumbling chimneys, rusty pieces of metal, and even an intact concrete strong house.

After another brief jaunt on U.S. 25/70, you come to the community of Walnut. On the route from here to Marshall, you'll feel like you're in a time warp. About the only modern structure is the bridge over the French Broad River in Barnard. Everything else looks like it's stuck in the 1950s or earlier. Even the town of Marshall, Madison County's seat, retains an atmosphere akin to the mid-twentieth century. And if you really want to experience a time warp, spend some time exploring the spiderweb of backroads that leads into the fastness of Madison County under the shadow of Spring Creek Mountain.

OPPOSITE: A 1961 Ford tractor shares space with curing tobacco in an old Madison County barn.

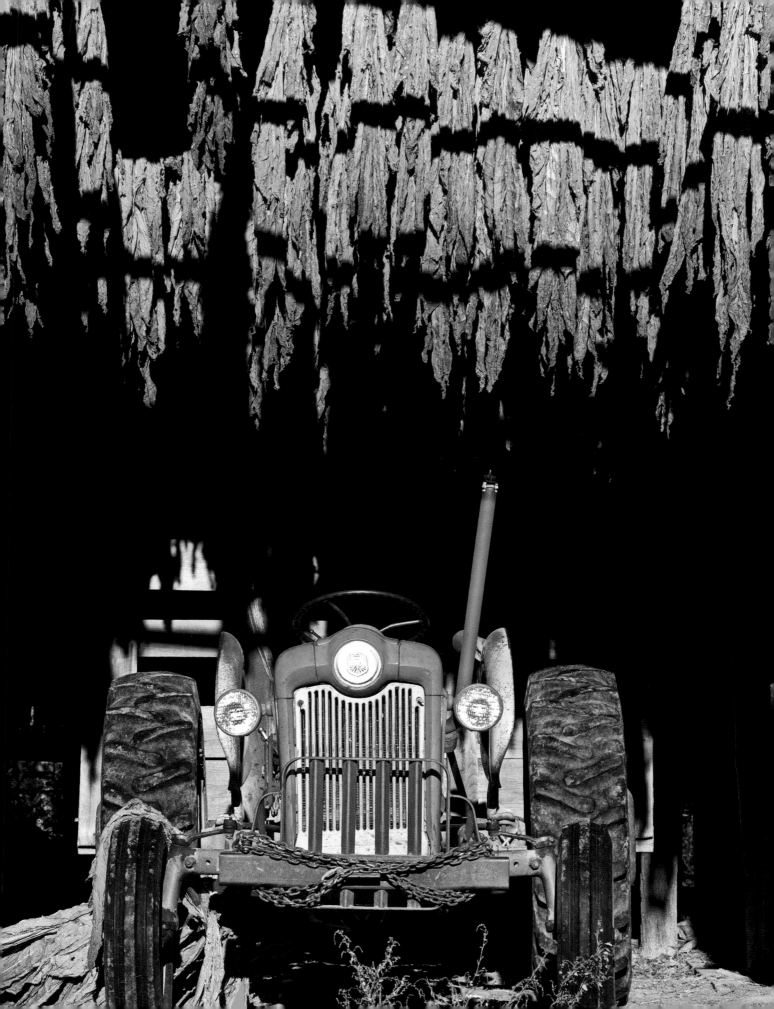

North on The Scenic

THE BLUE RIDGE PARKWAY
FROM VIRGINIA TO ASHEVILLE

Route 7

Follow the Blue Ridge Parkway south from the Virginia border to Asheville. (*166 miles*)

Twenty-five tunnels are located along the Blue Ridge Parkway in North Carolina. Only a few hundred feet separate the Twin Tunnels.

OPPOSITE: Autumn lights up the forest at Crabtree Falls, in the Crabtree Meadows area of the Blue Ridge Parkway.

The mountain folk had never seen anything like the Blue Ridge Parkway. They knew the mountains well, because they had traveled paths and trails over every ridge and into every hollow. They knew how rugged the land was, how difficult it was to go from one valley to the next. No matter that the automobile had been available for nearly three decades. The upper elevations of the Blue Ridge simply didn't have any decent roads on which to drive. Never in their wildest imaginations did they think someone would build a paved road along the crest of these mountains. Caroline Brinegar certainly didn't think so. When told of the news, she allowed, "One of them hard-surface roads like they have below the mountains? Why, Lord have mercy, no body a-livin' could put one of them through here."

But someone did put a road through there. And Caroline Brinegar got a firsthand look when it cut across the front yard of her cabin! Beginning in Shenandoah National Park in Virginia, the highway follows the crest of the Blue Ridge Mountains for most of its 469 miles. Toward the southern end, it passes over the Black Mountains, the Great Craggies, the Great Balsams, the Plott Balsams, and into the Great Smoky Mountains. The government gave the road its official name of Blue Ridge Parkway. The local mountain people called it simply The Scenic.

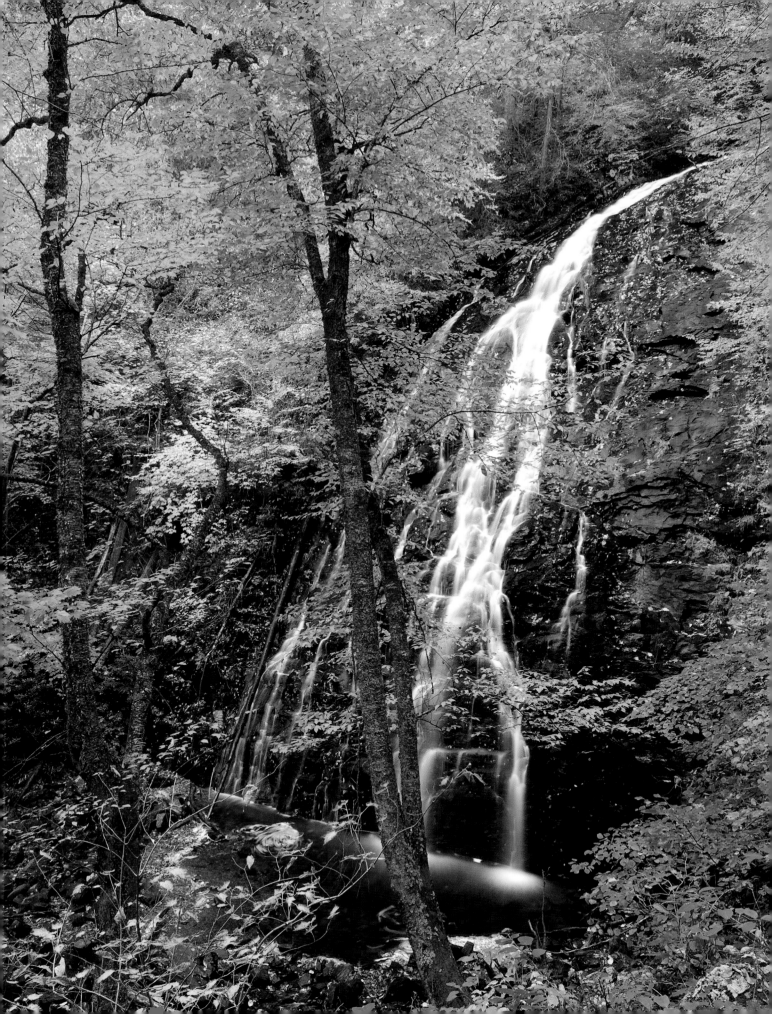

In May, the unfurling foliage of false hellebore adds a vivid green hue to the still-wintry landscapes of the higher elevations along the Blue Ridge Parkway.

The front porch of Cone Manor House at the Blue Ridge Parkway's Moses Cone Memorial Park provides a good platform for watching the sunrise.

Some 250 miles of the parkway run through North Carolina, divided here into two separate routes. Route 7 begins at the Virginia border and follows the parkway south to U.S. Highway 70 in Asheville. Route 8 runs from Asheville to the parkway's terminus in Great Smoky Mountains National Park.

Around every curve of the Blue Ridge Parkway is something new to experience. And there are a lot of curves! With so much to see and do, it would be futile to attempt to illustrate the full drive in the few words allotted to this book. Blue Ridge Parkway literature abounds and an Internet search brings up thousands of interesting sites. Arm yourself with some background information before you head out so you won't miss anything.

The best advice is to not cram too much into a single parkway outing. Pick one or two spots and explore them fully. Doughton Park, E. B. Jeffress Park, Moses Cone and Julian Price memorial parks, Linville Falls, Mount Mitchell, and Craggy Gardens all offer spectacular scenery, hiking trails of all difficulty levels, and opportunities to immerse yourself in the cultural and natural history of the Appalachians. You just have to get out of your car to take advantage of all the opportunities.

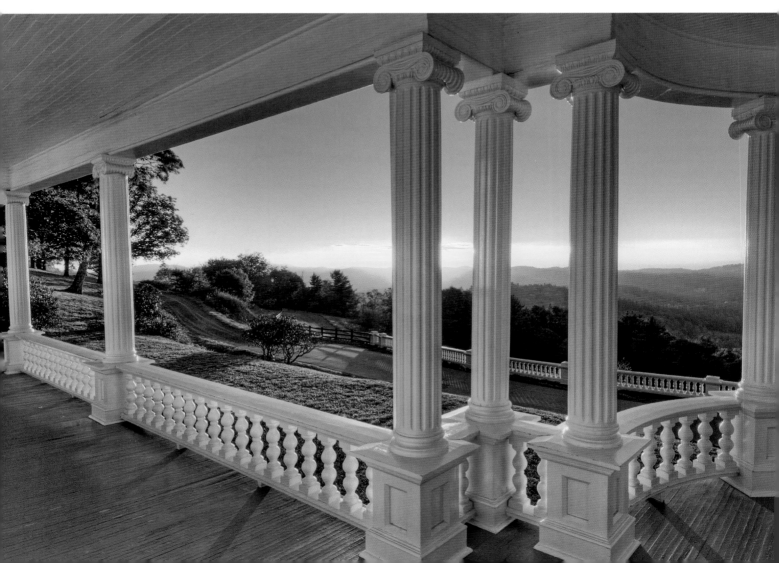

LINN COVE VIADUCT

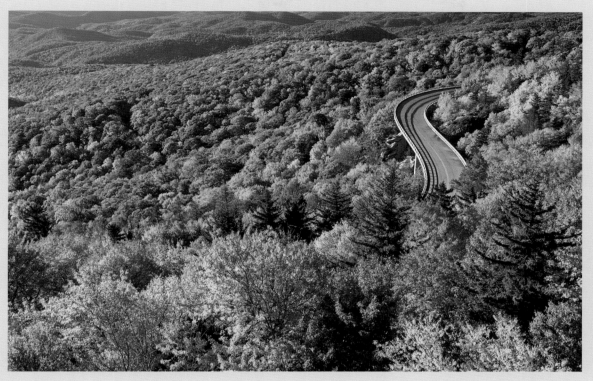

IT TOOK FIFTY-TWO YEARS to build the Blue Ridge Parkway. Construction began in 1935, and by 1967, the 469-mile road was completed except for a short section around Grandfather Mountain. This "missing link," as it became known, passed through a particularly sensitive area on Grandfather's south side, where huge boulders and rock outcrops made road construction impossible without seriously damaging the fragile environment.

The parkway people had wanted to build the road at a higher elevation, but Hugh Morton, Grandfather's protective owner, wouldn't allow it. He claimed the upper route would irreparably harm the mountain's scenery and ecology, comparing the road's construction to "taking a switchblade to the *Mona Lisa*." But the lower route, through Linn Cove, presented much the same problem. The engineers developed a solution that avoided the delicate terrain altogether. They built a viaduct that followed the contours of the slope and rested on carefully placed support piers.

The goal was to do as little harm to the mountainside as possible. Workers covered rocks under the viaduct to protect them from damage, and they only cut trees that were directly in the path of the road. The most remarkable aspect of the construction was that the roadway was built from the top down. Using computer-controlled precast segments (153 in all), work crews constructed the road piece by piece. After the first section was set, a crane lowered the next segment, where it was epoxied into place. High-tension steel cables ran through all the segments, rigidly securing everything together. Once they had assembled 180 feet of the viaduct, workers then constructed a support pier by lowering the materials from above. The only work that was performed from below was drilling the foundation holes for the piers. The completed viaduct is about a quarter-mile long and rests on seven support piers.

When the Linn Cove Viaduct opened in 1987, it immediately became the most popular section of the entire parkway. Stop at the Linn Cove Visitor Center at the southern end of the viaduct to see exhibits and obtain detailed information about the viaduct's construction. A portion of the Tanawha Trail leads from the visitor center directly under the viaduct.

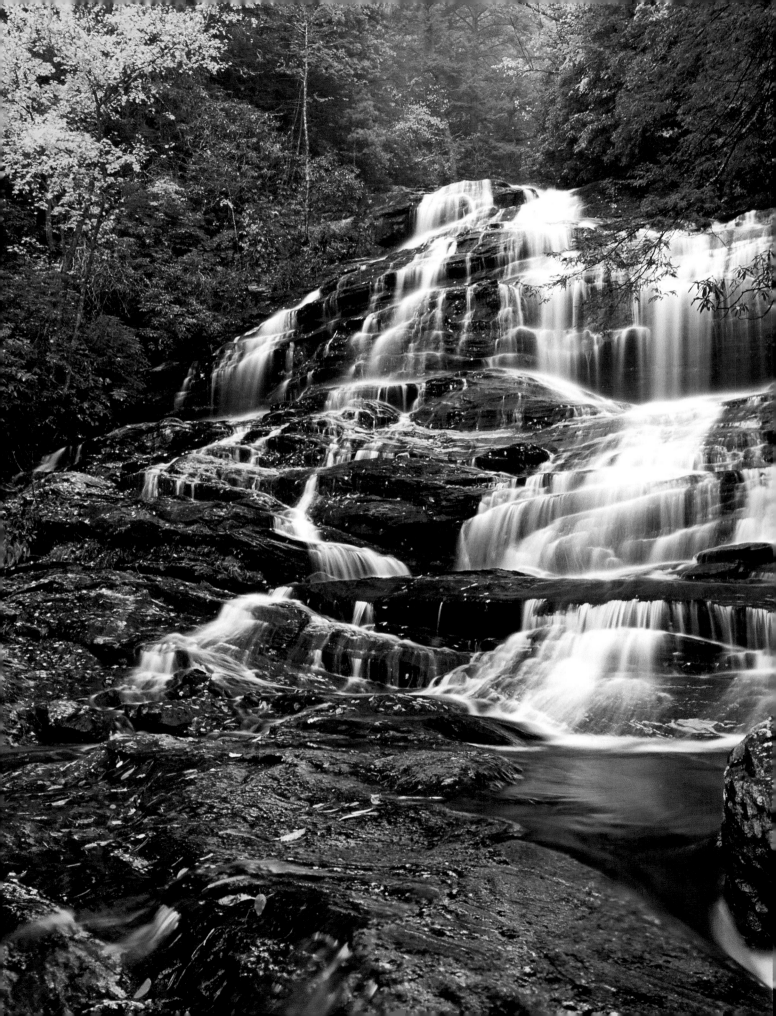

PART II

Land of Waterfalls

The Southwest

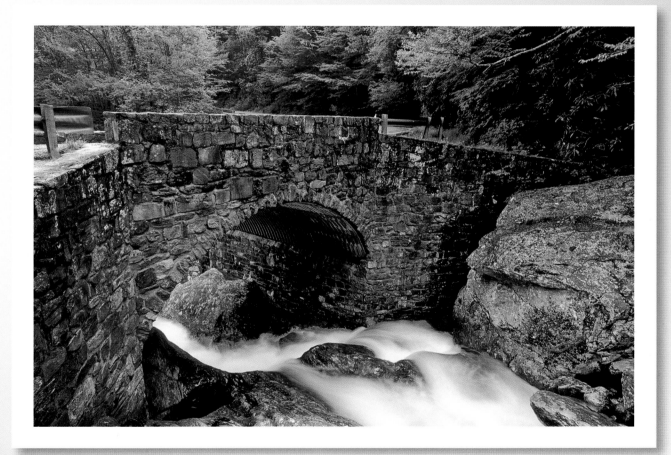

High Arch Bridge, built by the Civilian Conservation Corps in the 1930s, crosses West Fork Pigeon River at Sunburst Falls in Pisgah National Forest.

OPPOSITE: Glen Falls, in Nantahala National Forest, falls in three distinct drops. This view shows the cascading middle drop, considered by many the most scenic.

Transylvania County proudly calls itself the Land of Water-falls. The county easily contains more significant waterfalls than any other county in the state (perhaps more than any county in the East). Some estimates suggest as many as five hundred major waterfalls, but that's a bit of an exaggeration. The neighboring counties of Jackson and Macon have hundreds of major waterfalls as well, and when you factor in all the other mountain counties in the region, this truly is a Land of Waterfalls.

The region offers much more than falling water, though. Much of the land comprises one of two national forests, Nantahala and Pisgah. Mix in DuPont State Forest, Gorges State Park, Chimney Rock State Park, Great Smoky Mountains National Park, and the Blue Ridge Parkway, and you have the recipe for unlimited outdoor recreation and scenic opportunities. A particularly appealing attribute of southwest North Carolina is that many (though not all) of its towns lack the gaudiness brought about by the rise in tourism. Either it hasn't caught up with them yet, or they have made conscious efforts to keep it at bay.

The routes in this section lead you through some of the best areas not just in North Carolina but in the whole southern Appalachians.

ROUTE 8

South on The Scenic

THE BLUE RIDGE PARKWAY FROM ASHEVILLE TO THE SMOKIES

The section of the Blue Ridge Parkway between Asheville and Great Smoky Mountains National Park sits at a higher elevation than the northern portion. The parkway reaches its highest elevation—6,053 feet—just below the summit of Richland Balsam. As the parkway passes through the Great Balsams and the Plott Balsams (Richland is in the Great Balsams), numerous overlooks provide unparalled views.

Read the narrative in Route 7 for general information about the Blue Ridge Parkway. As stated, there is simply so much to see and do on the parkway that any attempt to describe it here would be futile. Read one of the many books about the parkway (see the Further Reading appendix) and spend some time browsing the Internet before you head out.

Particularly scenic and worthwhile stops in the southern section include the Mount Pisgah area, Graveyard Fields, and the Shining Rock region and Waterrock Knob.

Route **8**

Follow the Blue Ridge Parkway south from Asheville to Great Smoky Mountains National Park. (*88 miles*)

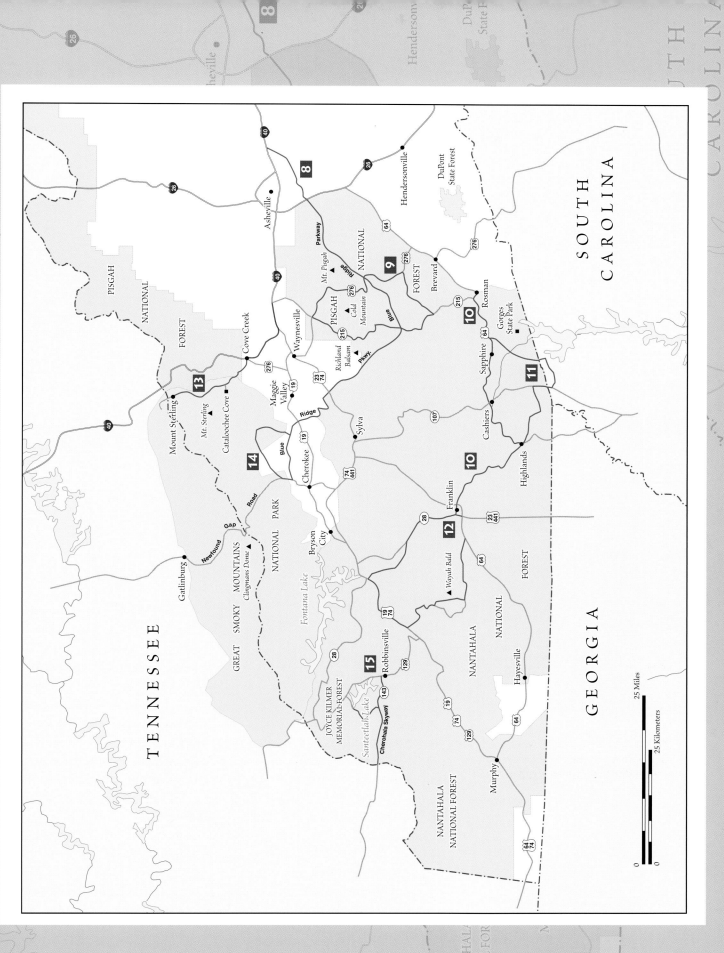

George Vanderbilt's private hunting retreat, Buck Springs Lodge, sits below the soaring Mount Pisgah. Built in 1895, the lodge featured hot and cold running water and electricity from a generator. The building stood until the early 1960s. A short path from the Mount Pisgah Trail parking area accesses the site. *Herbert W. Pelton, North Carolina Collection, Pack Memorial Library, Asheville, NC*

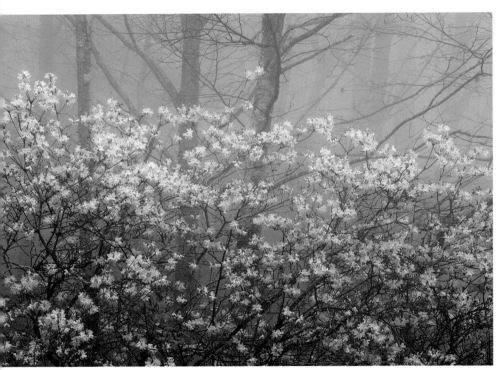

In April and early May, wild azaleas add a splash of color to the monotone woodlands along the Blue Ridge Parkway.

OPPOSITE: Early-spring foliage surrounds Grassy Knob Tunnel on the Blue Ridge Parkway.

Mount Pisgah features one of only two lodging facilities along the North Carolina section of the parkway, Pisgah Inn. If roughing it suits your style better, Mount Pisgah Campground sits across the road from the lodge. Several trails lead from the campground and lodge, guiding hikers into Pisgah National Forest and to the summit of Mount Pisgah.

Graveyard Fields features three picturesque waterfalls and some of the finest parkway views. A few miles farther south, take a side trip on Forest Road 816. The scenic drive climbs about a mile to a dead end at a parking area. Numerous trails fan out from here, providing hikers access to the popular Shining Rock Wilderness Area.

At Waterrock Knob, you can watch the sunset from the western end of the parking area, then return the next morning and watch the sunrise from the eastern side. For a good leg stretcher, take the short trail from the parking area to the 6,292-foot summit. In September, goldenrods, asters, jewelweed, dodder, and numerous other late-blooming wildflowers line the trail.

Of course, like everywhere else on "America's Most Scenic Drive," there really is no best place. Every curve reveals a new discovery and every overlook provides a wonderful glimpse into the southern Appalachian landscape.

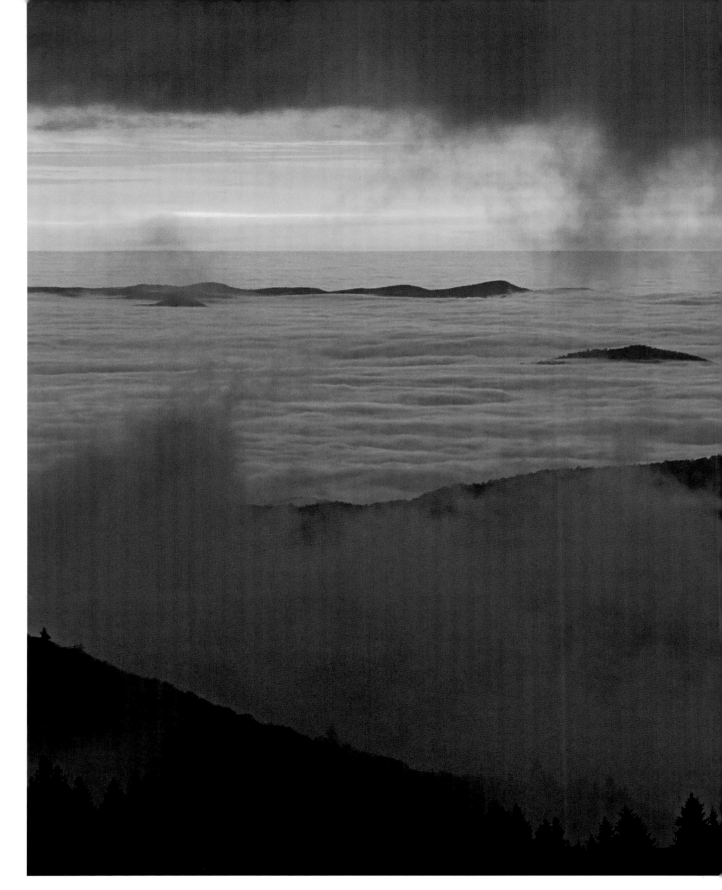

Foggy sunrises are common at the higher elevations of the Blue Ridge Parkway. This view is from the Graveyard Fields area of the parkway.

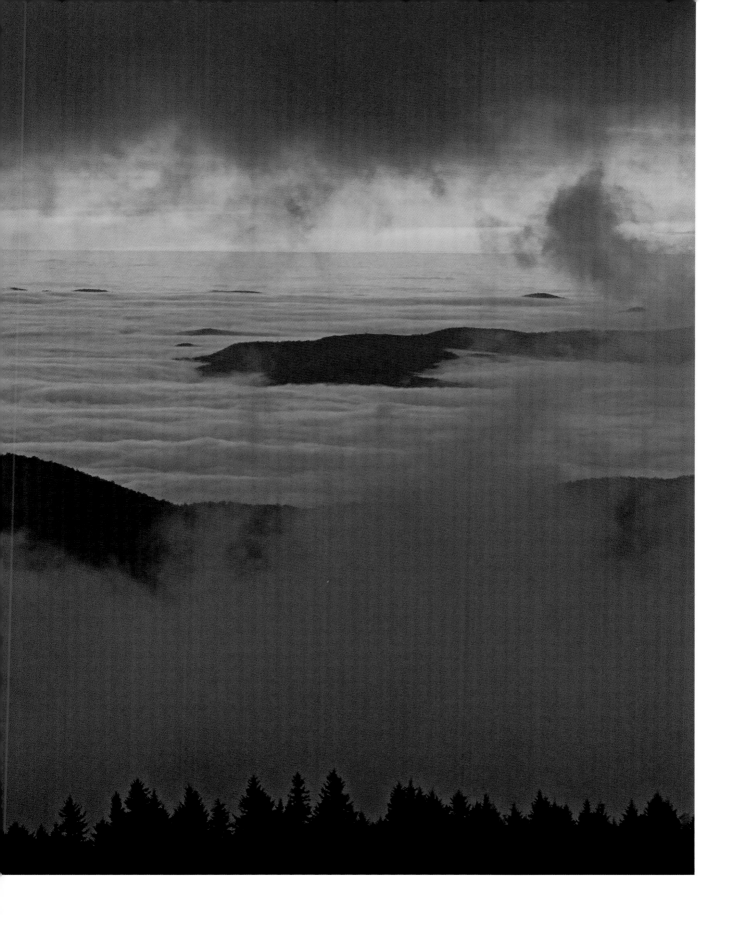

Cradle of Forestry

A LOOP AROUND PISGAH NATIONAL FOREST

Route 9

Start out on U.S. 276 north of Brevard. From the intersection with Forest Road 475, head north on U.S. 276. Drive 24 miles, then turn left onto NC 215 south. Drive 26 miles, then turn left onto County Road 1321. Drive 2 miles and bear left onto Forest Road 475. Follow it 7 miles to complete the loop. (*58 miles*)

When George W. Vanderbilt arrived in western North Carolina in the late 1800s to build his grandiose Biltmore Estate, he had visions even grander than erecting the largest private home in America. Vanderbilt wanted a working estate, one with farms and forests that paid for themselves—and were managed responsibly. He hired Gifford Pinchot as Biltmore's first forester and eventually purchased

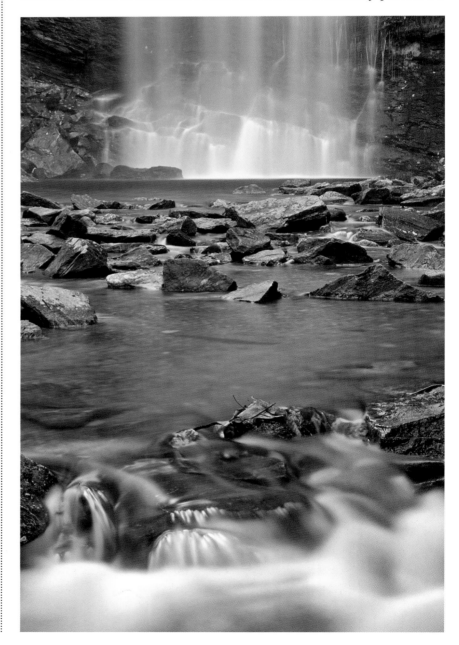

Located beside the Forest Heritage Scenic Byway a few miles north of Brevard, Looking Glass Falls is among the more popular attractions in Pisgah National Forest.

One of many projects completed by the Civilian Conservation Corps in the 1930s, this handsome bridge crosses Looking Glass Creek in Pisgah National Forest.

some 125,000 acres of land southwest of Asheville, which he called Pisgah Forest. In 1895, German forester Dr. Carl Alvin Schenck took Pinchot's place and founded Biltmore Forest School, the nation's first school of forestry.

Much of our route passes through Vanderbilt's forest, now a part of Pisgah National Forest. The land encircled by our broad loop provides arguably the finest outdoor recreation opportunities of any area of comparable size in the southern Appalachians, if not the entire East. The region features hundreds of waterfalls, the wildly popular Shining Rock Wilderness Area, hundreds of miles of exceptional hiking trails and trout streams, challenging rock climbing, and some of the finest scenery in the state. Bisecting the loop is the Blue Ridge Parkway (see Route 8), which provides easy access to many of these features. Perhaps the best attribute of this route is its diversity. Windshield tourists will find new sights around every curve, while those who get out of their cars and put one foot in front of the other will discover unlimited opportunities for adventure. Regardless of your interest, your best first stop is the ranger station on U.S. Highway 276, a few miles north of Brevard. Here, you can pick up maps and guidebooks and get answers from a real person.

Denuded mountain slopes characterized the logging boom town of Sunburst in 1912. A dense forest covers the site today, which lies within Pisgah National Forest. *Herbert W. Pelton, Library of Congress*

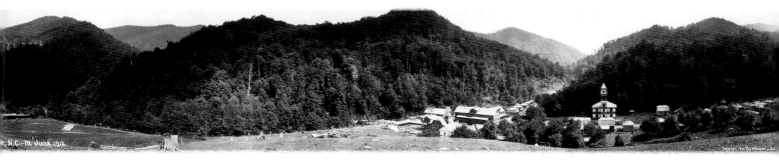

A few miles from the ranger station, you drive beside Looking Glass Falls. Right beside it. You don't have to get out of your car to see this beauty, but you'd be crazy not to. Walk down the steps to the base of the falls and feel the cold spray on your face.

One mile farther up the road is the trailhead for Moore Cove Falls, another beauty. You're going to have to walk a little to see this one, but the three-quarter-mile hike is well worth it. While you're out of the car, look at the elaborate stonework on the auto bridge over Looking Glass Creek. This bridge, like many others along the route, is a product of Franklin D. Roosevelt's New Deal program of the Depression era, in which local men worked in the Civilian Conservation Corps (CCC) to reclaim forested, mined, and otherwise wasted lands. They were also instrumental in building much of the infrastructure of our national forests and parks. You'll see the hard work of the CCC all along this route.

If making this drive in the middle of a summer day, you won't need anyone to tell you when you get to Sliding Rock. Once you encounter the traffic jams and see the crowds of smiling kids—and more than a few adults—you'll know you're at one of Pisgah National Forest's most popular attractions. Don't even try to fight it; just throw on some old jeans shorts and have at it. A few trips over this natural waterslide will take at least ten years off you—for a little while. When you wake up the next morning and realize you're too old for that sort of thing, you'll already be a hero to your kids. Just remember one thing: that water is colder than a, well, let's just say it's cold.

Next up is the Cradle of Forestry in America, where Dr. Schenck operated his forestry school. Plan on taking several hours to explore this historical site fully. From the Cradle of Forestry, the road climbs to Wagon Road Gap, where the Blue Ridge Parkway crosses overhead, and then it heads down the other side of the ridge toward the community of Bethel. That mountain looming in the distance is Cold Mountain, part of Shining Rock Wilderness. Yes, that's the same one Charles Frazier made famous, and yes, it can be cold up there. At an elevation of 6,030 feet, the summit experiences a different weather pattern than the valleys below. The ranger station back near the start of the route offers a superb map of the wilderness area that shows all the trails leading to the mountain's summit.

On the west side of Cold Mountain, NC Highway 215 takes you over picturesque Lake Logan. Now the home of an Episcopal retreat, the lake and surrounding land were once part of an enormous logging operation that employed some four hundred men. The lake covers the old sawmill site. Just beyond the lake, the road twists and climbs through West Fork Pigeon River Gorge, sometimes called the "Yosemite of the East." Were it not for the forested slopes, the steep mountains through the gorge would indeed resemble those of the western park. Watch for waterfalls and trailheads as you climb through the gorge.

OPPOSITE: Art Loeb Trail provides access to the summit of Black Balsam Knob in Pisgah National Forest. The mountain offers panoramic views.

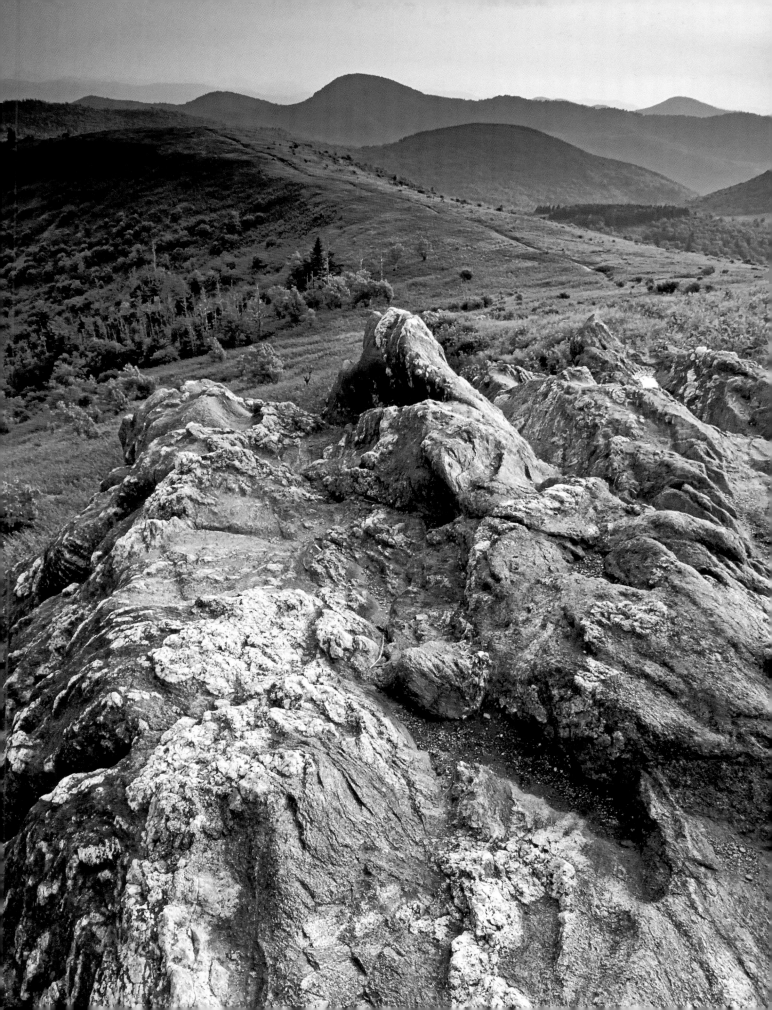

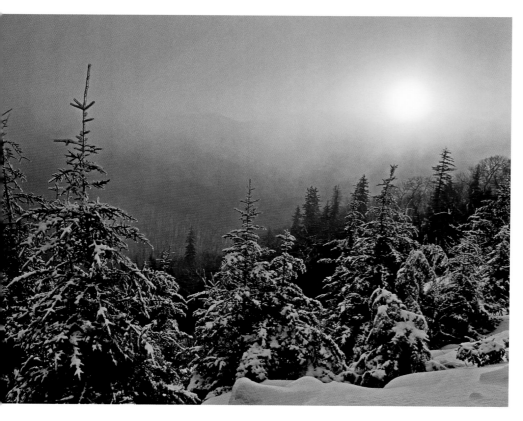
The sun peeks through the fog during a winter sunrise near Beech Gap in Pisgah National Forest.

Try to imagine what this route would look like if you were making this trip a hundred years ago. You'd be traveling on a logging train, for one thing, as roads were mostly nonexistent. The biggest difference would be on the mountain slopes. All the trees would be cut, the slopes bare and eroded, and with so much dry logging slash all over the place, wildfires would be rampant. (One devastating wildfire in 1925 caused the mill to shut down entirely.) Walk along most any trail in the gorge today and you'll find steel cables, railroad rails, and serrated trail surfaces caused by rotted crossties—all evidence of the intense logging that once occurred here. But just look around as you drive through the gorge; except for the fact that there are no big trees, it's hard to imagine that this forested area was once a wasteland. The landscape is a fine showcase of nature's resilience.

At Beech Gap, you pass back under the Blue Ridge Parkway and start downhill again. A number of nice waterfalls are nearby. Dill Falls and Courthouse Falls, two beauties, are accessed easily from Forest Service roads leading off the main route.

The gravel Forest Road 475, which takes you from NC 215 back to U.S. 276, provides access to a number of excellent hiking trails and several waterfalls. It also passes by the Pisgah Center for Wildlife Education, a facility operated by the North Carolina Wildlife Resources Commission. Here you'll find the popular Bobby N. Setzer State Fish Hatchery, which raises trout for stocking local streams. From 1933 to 1936, this site hosted the CCC, one of more than a hundred similar camps across the state. Also here are the trailheads for a number of popular hiking trails, including one to the summit of John Rock, which looms over the hatchery and provides outstanding views.

Just beyond the hatchery is the trailhead for one of the most popular trails in the area, leading to the summit of Looking Glass Rock. You surely noticed the rock at some point along your drive, especially if the sun was shining. That's when the light reflects like a mirror off the usually wet rock surface. Looking Glass Rock is a great spot for rock climbers.

The Land of Waterfalls

U.S. HIGHWAY 64 FROM ROSMAN TO FRANKLIN

Transylvania County has laid claim to the nickname "Land of Waterfalls," so it might be stepping on a few toes to call this route—passing also through Jackson and Macon counties—by that name. No disrespect to Transylvania is intended, it's just that this entire region of southwestern North Carolina is loaded with spectacular waterfalls. So, just how many waterfalls are there along this route? If you count all the falls within about fifteen miles of the U.S. Highway 64 corridor, you're looking at *hundreds*!

To see most of the waterfalls requires you to get off U.S. 64 onto side roads or hiking trails. A good guide is *North Carolina Waterfalls*, listed in the Further Reading appendix. The book provides the most comprehensive coverage of the state's waterfalls available in print. The best website about North Carolina waterfalls is www.ncwaterfalls.com.

Drive this route on a weekday and you might question its legitimacy as a backroad. As the only practical route from Brevard to Highlands, you'll share the road with soccer moms, tractor-trailers, farm tractors, Floridians driving much too slowly, and locals driving much too fast. (You may wonder how the speedy locals can even keep brakes from wearing out on their vehicles, but soon enough you'll realize that they just don't use their brakes.) Besides being busy, this stretch of U.S. 64 seems determined to give up every acre of its natural beauty to retail stores and, particularly, housing developments.

Route **10**

Start out on U.S. 64 near Rosman. From the junction with NC 215, follow U.S. 64 west to Franklin. (*46 miles*)

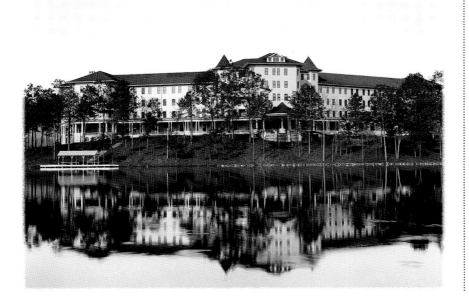

During its heyday in the early 1900s, the Toxaway Inn attracted a virtual who's who of the nation's elite. *R. Henry Scadin, R. H. Scadin Photographic Collection, D. H. Ramsey Library, Special Collections, University of North Carolina at Asheville*

TOXAWAY FALLS

TOXAWAY FALLS HAS PERHAPS the most storied history of any waterfall in North Carolina. The name TOXAWAY in its many spellings and variances has several Cherokee applications, among them a former settlement in South Carolina and a Cherokee chief. The original meaning of the name

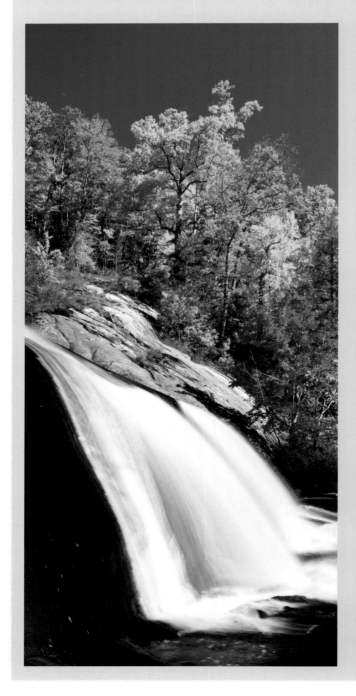

is uncertain. One often-repeated definition is "redbird." Whatever its origin, today the name refers to a river, a mountain, a creek, a lake, and the waterfall.

The development of the Toxaway Falls area began after the turn of the twentieth century with the construction of the lake and a five-hundred-room luxury resort called Toxaway Inn. The region was billed as America's Switzerland. The resort attracted a virtual who's who of the country's wealthy and elite. On the guest list were names like Rockefeller, Edison, Ford, Duke, Firestone, and Vanderbilt.

Lake Toxaway's heyday ended in 1916. That July, two hurricanes hit western North Carolina, flooding the region and likely weakening the earthen Lake Toxaway dam. In August, a third hurricane dumped a reputed twenty-plus inches of rain within a twenty-four-hour period. It proved too much for the dam to handle. On August 13, 1916, the dam failed and more than five billion gallons of water poured over Toxaway Falls and through the gorge below.

The raging torrent of water scoured the riverbanks along the more than two-mile section of gorge from Toxaway Falls to Wintergreen Falls, leaving nothing but bedrock. The destruction caused by the flood is plainly evident today in the great expanse of rock at Toxaway Falls. Before the dam broke, trees grew along the edge of the river and you couldn't see the waterfall unless you were right at it. Along the river below Wintergreen Falls remains evidence of the flood in the form of boulder levees, some of them thirty feet high and containing rocks the size of train cars.

With Lake Toxaway reduced to a 640-acre mud flat and the resort owners mired in litigation resulting from the dam failure, Toxaway Inn closed. It stood dormant until it was torn down in 1948. Pine trees quickly grew over the lakebed and remained standing until 1960 when the Lake Toxaway Company took over the property and rebuilt the lake as part of the Lake Toxaway Estates development.

Toxaway Falls experienced notoriety of another sort when the 1958 motion picture *Thunder Road*, starring Robert Mitchum, showed a car going over the falls during a chase scene. The waterfall is also featured in the 1948 movie *Tap Roots*, starring Susan Hayward.

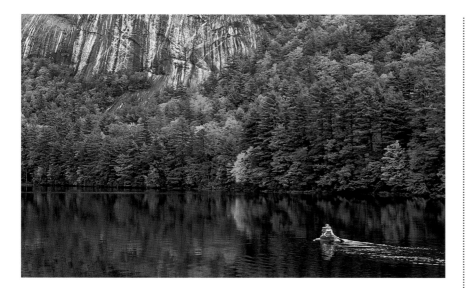

Canoeing is a favorite activity on Fairfield Lake, between Sapphire and Cashiers.

All that said, there is much natural beauty to see, especially for those willing to depart the main drag. The first must-see is Toxaway Falls. You'll know you're there when the road crosses over the top of the waterfall. A walkway lets you safely look over the falls and the huge expanse of bare rock. Behind you is the Lake Toxaway Dam. In 1916, the dam burst, sending the lake water over the falls. The raging torrent scoured the riverbank for miles downstream, leaving nothing but bedrock.

The small town of Cashiers is an appealing stop for lunch or shopping. The town sits on a high plateau from which four major rivers spring: the Whitewater, the Horsepasture, the West Fork Tuckasegee, and the Chattooga of *Deliverance* fame. The main thing you need to know about this place is how to pronounce its name. If you say "Cash-IERS," like someone who takes your money, everyone will know you ain't from around here. If you say "CASH-ers," blurring the distinction between the syllables, you'll fit in just fine.

Whiteside Mountain lies about halfway between Cashiers and Highlands. The 4,903-foot summit stands some 2,000 feet above the valley floor, with sheer rock walls rising over 700 feet high. A National Recreation Trail follows the crest of the mountain, providing outstanding views.

At 4,118 feet, Highlands touted itself as the highest town in the East—until the Watauga County community of Beech Mountain, at 5,506 feet, was incorporated. Highlands has long held a reputation as a popular resort area having many cozy inns, quaint shops, and fine restaurants. The wintertime population of three thousand people swells to over twenty thousand during the summer. Nantahala National Forest surrounds the town, providing numerous opportunities for hiking, fishing, photography, and waterfall watching. Stop at the Forest Service information center in downtown for maps and guidebooks.

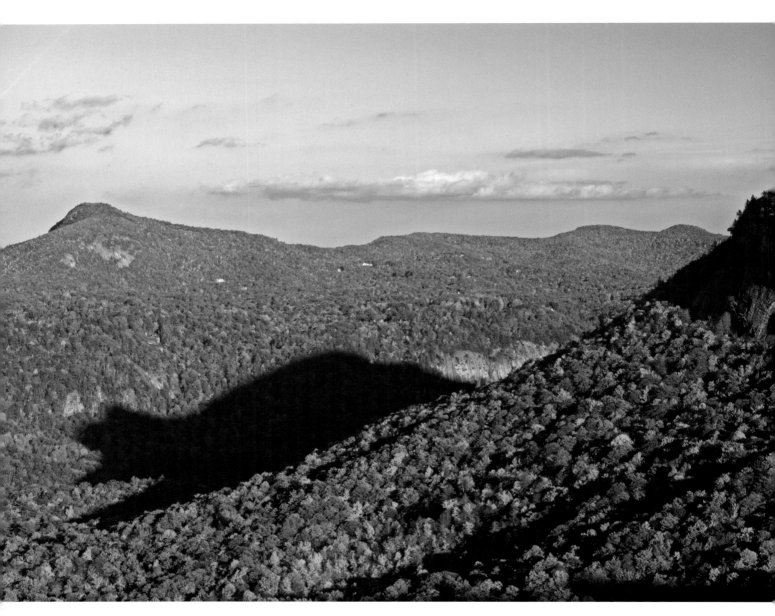

The famous bear shadow appears only for a few weeks in October and February. It is visible from the Rhodes Big View Overlook on U.S. Highway 64 between Cashiers and Highlands.

From Highlands, our route passes through the Cullasaja River Gorge. In the seven miles from Lake Sequoyah to below Cullasaja Falls, the tumultuous Cullasaja River loses 1,400 feet in elevation. Along the gorge lie two major waterfalls and numerous smaller falls and cascades. The scenic section of U.S. 64 paralleling the river through the gorge will make your spine tingle. After its completion in 1929, the *Franklin Press* called U.S. 64 "probably the greatest scenic highway in all the state." Parts of the road were literally carved out of the sheer cliffs, leaving scarcely enough room for two vehicles to pass. Workers were lowered from above with ropes to drill holes for the dynamite.

Early in this route you drove over the top of a waterfall. Well, now you get to drive *under* one. That's right: At Bridal Veil Falls a spur road passes behind the falls. It creates an opportunity to give

your car a bath. A short distance from Bridal Veil Falls is Dry Falls. Here you can walk behind the falls, but don't expect to stay dry unless the water is low.

Cullasaja River makes its final plunge over Cullasaja Falls before leaving the gorge and leveling out. What a final statement it makes! If the water level is up, this is about as good as it gets. On the other hand, the water level can drop so low that little more than a trickle flows over the falls, making it hardly worth stopping for. The viewpoint is right from the road, but be careful here. There is very little room to pull over and it's on a blind curve. This may be the most dangerous highway situation in the mountains.

A sunstar shines in this view from behind Glen Falls in Nantahala National Forest.

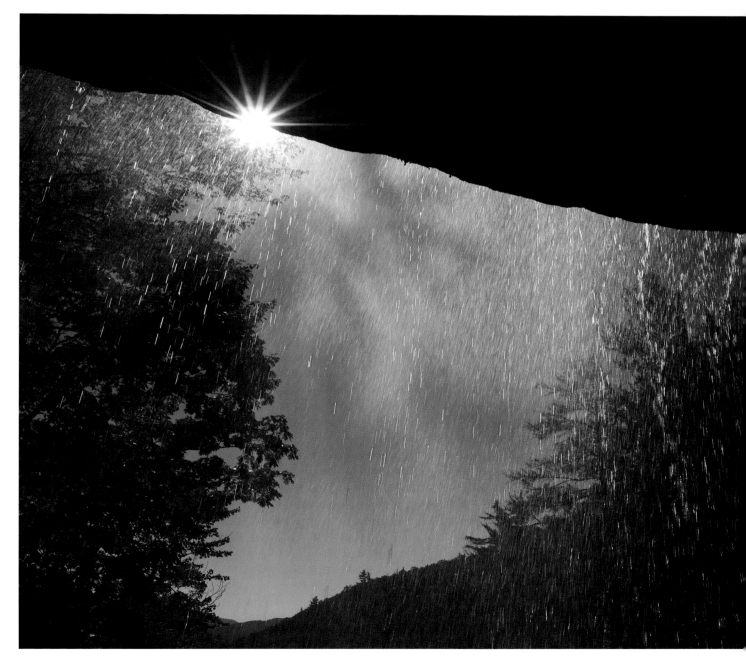

ROUTE 11

Escarpment Rivers

THE BACKDOOR ROUTE FROM LAKE TOXAWAY TO HIGHLANDS

Route **11**

Start out on U.S. 64 in the community of Sapphire. Head south on NC 281. Drive 10 miles, crossing into South Carolina, then bear right onto Oscar Wiginton Memorial Highway. Drive 2 miles, then turn right onto what becomes NC 107 at the state line. Drive 7 miles, then turn left onto Whiteside Cove Road. Drive 7 miles to an intersection. To the left, Bull Pen Road leads 3 miles to the Chattooga River. To the right, Horse Cove Road leads 5 miles to Highlands. (*31 miles*)

Thompson River flows over several waterfalls along its course through the Lake Jocassee watershed. White Owl Falls, seen here, is located just downstream from the U.S. Highway 64 bridge.

OPPOSITE: Considered by many to be the most spectacular waterfall in the East, Whitewater Falls in Nantahala National Forest falls more than four hundred feet.

A good waterfall-producing stream needs two things. First, it needs a lot of water, which comes from a large watershed and high rainfall. Second, it needs some distance between its source and the waterfall so it can pick up runoff and the flow from tributaries. Then, when it's good and ready, it needs to flow over an escarpment of hard, erosion-resistant rock. That's why you don't find many significant falls along the eastern Blue Ridge Front in the northern part of the state. The streams simply don't have enough time to gain any size before plunging down the steep slopes. And it's why you don't see that many major falls along the extreme western mountains of North Carolina. Although the streams often reach considerable size there, they don't flow over the steep, erosion-resistant rock necessary to form the waterfalls.

But on this route—oh, my! The major streams spring from a high plateau near Cashiers and flow for several miles before reaching the southern Blue Ridge Front. Receiving well over one hundred inches of precipitation annually, the region is considered the wettest in eastern North America. By the time the rivers reach the escarpment, they are ready to rumble. The first section of the route, which

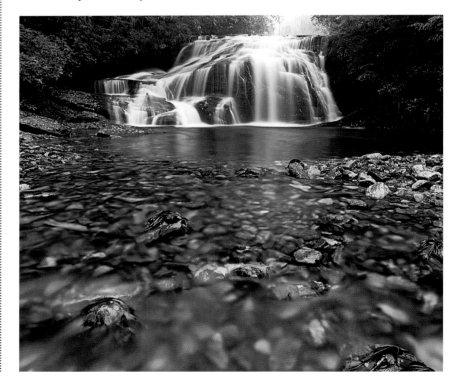

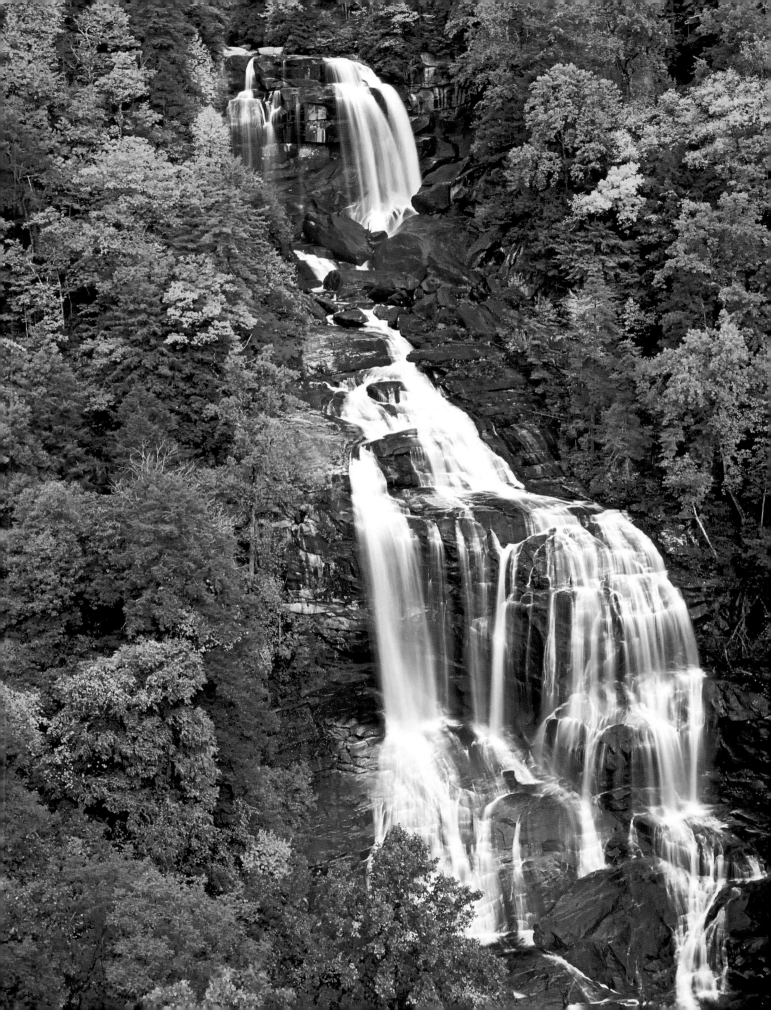

The historic Grimshawes Post Office building sits beside the road in Whiteside Cove.

traverses the Lake Jocassee watershed, probably has more major waterfalls than any area of comparable size in the East. Certainly, no other place in North Carolina can compare.

While the general scenery is superb all along the route, the only way to see the waterfalls is to hike to them. Some are reached by a short, easy path, but most require fairly strenuous effort. Some require very difficult off-trail bushwhacking and creek wading. Few of the trails are marked. If you plan to do any waterfall exploring, you may want to pick up a copy of *North Carolina Waterfalls*, which includes most of the falls in the area. See the Further Reading appendix for more information.

About a mile from the start of our route is the main entrance to Gorges State Park. As of press time, construction of a new visitor center and office is taking place. Hopefully it will be completed when you make your trip and you can stop for information. An interim office is located on U.S. Highway 64. The park offers superb hiking opportunities, including access to the waterfalls on Toxaway River downstream from Toxaway Falls (see Route 10). But most people use the park's NC Highway 281 entrance for access to the waterfalls on Horsepasture River in Nantahala National Forest. The steep sliding Drift Falls, with its enormous plunge pool, Turtleback Falls, precisely resembling its namesake, and the tall crashing Rainbow Falls, displaying colorful rainbows during periods of heavy spray, have always counted among the most popular waterfalls in the state.

After you cross the Horsepasture River, the next major river is the Thompson. Like the Toxaway and the Horsepasture, Thompson River tumbles over a series of impressive waterfalls before entering Lake Jocassee in South Carolina. It's a little smaller than the other major rivers of the Lake Jocassee watershed, having a source closer to the escarpment. But what it lacks in size it more than makes up for in energy. Though impressive, Thompson's waterfalls are not for everyone. You're going to have to invest some boot leather and sore muscles to see them.

Whitewater River, up next, features what many people consider the most spectacular waterfall in the Appalachians: Whitewater Falls. A short, easy paved path leads to an upper overlook. A long series of steps leads from the overlook to a lower viewing deck directly in front of the falls. If you can see only one waterfall in the state, Whitewater is a good choice. At 411 feet, it earns billing from many publications as the highest waterfall east of the Mississippi. That claim is debatable, but no one who sees Whitewater Falls argues its beauty.

As at Whitewater, the path to Silver Run Falls is easy and short, although the waterfall can't compare in size and beauty. It's unique among western North Carolina waterfalls in that it has a large pool with a sandy beach, perfect for wading and swimming.

Route 10 goes from Cashiers to Highlands along the heavily traveled U.S. 64, passing west of Whiteside Mountain. This route takes you along the side of the mountain on a true backroad. It features in-your-face views of Whiteside's sheer rock walls. Binoculars come in handy here. See if you can spot a peregrine falcon soaring overhead. The North Carolina Wildlife Resources Commission began releasing falcon pairs in western North Carolina in the 1980s. The sheer cliffs of Whiteside Mountain—inaccessible to humans—proved ideal for the birds, which feed mostly by catching other birds on the fly. Peregrines are thought to be the fastest animals on the planet, reaching speeds of over two hundred miles per hour when diving for prey.

Potholes characterize the Chattooga River at Bull Pen Bridge in Nantahala National Forest.

Grimshawes Post Office stands in the shadow of Whiteside Mountain. The hut operated in the little mountain community as an official post office from about 1903 to 1953. At one time it had a postmark claiming it to be the smallest post office in the nation. Grimshawes makes a good photo op.

A side trip to Chattooga River gets you even farther off the beaten path. But don't be surprised if you find the river crowded. Tourists might not know about this secluded spot, but local hikers, trout fishers, and shutterbugs sure do. Everyone can walk out on the old bridge and watch the river cascading through the large potholes. The surefooted can climb down the bank and scurry up the rocks under the bridge for a close-up view. Officially named Bull Pen Bridge, people around here just call it the Iron Bridge. And just in case you had any thoughts about it, you can forget the notion of happening upon any toothless banjo players. Folks here are still fighting the stereotype created in the movie *Deliverance* back in 1972. Besides, the river scenes in the film were shot downstream in South Carolina and Georgia. That's where the banjo players live.

Rafts and Rubies

COWEE VALLEY, NANTAHALA RIVER, AND WAYAH BALD

Route **12**

Start out on NC 28 in Franklin. Head west for 12 miles, then turn left onto Tellico Road. Drive 1 mile, then turn right onto Needmore Road. Follow it 9 miles, then turn left onto U.S. 19. Drive 12 miles, then turn left onto Wayah Road. Drive 8 miles, then turn left onto White Oak Lane. Go a quarter mile, then turn right onto Cold Springs Road. Drive half a mile, then turn right onto Forest Road 711 (may be gated in winter). Drive 15 miles, then turn left onto Wayah Road. Drive 2 miles, then turn left onto Forest Road 69. Drive to the end, then backtrack to Wayah Road and turn left. Follow it 9 miles to Old Murphy Road. (*80 miles*)

ABOVE: Nine-year-old Angela Booth proudly displays the treasures she discovered at a Cowee Creek Valley gem mine.

RIGHT: Buckets of local dirt await gem hunters at the Sheffield Mine in Cowee Creek Valley.

You're going to see a lot of smiling faces on this route. You'll see people playing in mud, floating down rivers, and having the time of their lives. To get the most out of this route, plan to get dirty and wet.

In the Cowee Creek Valley region outside Franklin, kids and their parents sift through mud in search of rubies, sapphires, and a rose-colored form of garnet called rhodolite. Ruby and sapphire are colored varieties of the naturally clear mineral corundum. Because corundum is second only to diamond in hardness among minerals, it is ideal for use as an abrasive. Local commercial mining of the mineral began in the late 1800s, but the efforts never proved very profitable. And with the development of synthetic corundum in the early 1900s, the industrial demand for the natural stones diminished.

The demand for gem-quality corundum never ceased, though. In 1893, Tiffany's sent a man to investigate Cowee Creek Valley. His report caused quite a stir, and the local people began to realize the importance of those red and blue stones they had been finding in the creek beds for so long. Ever since, people have been looking here for rubies, sapphires, and rhodolite. Rhodolite, like the rhododendron plant, gets its name from the Greek word for "rose."

At most area mines, you pay a fee for a bucket of dirt and a seat at a flume. Using a sieve, you slowly wash away the smaller mud particles, hopefully revealing a prized find. At the Sheffield Mine, a ruby or sapphire weighing thirty carats or more is called a "honker"

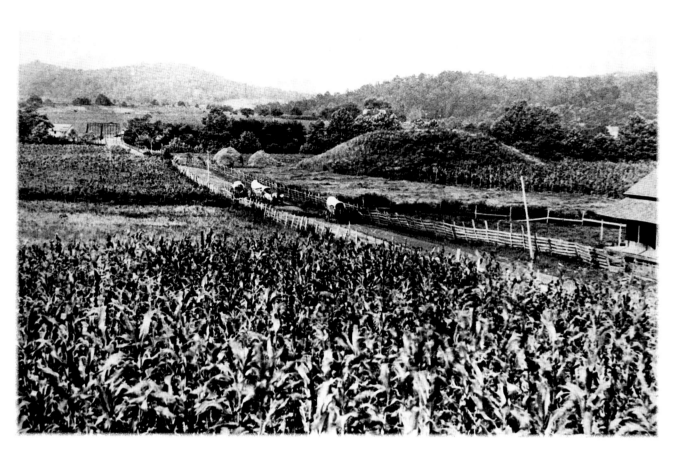

and when someone finds one, a loud bell announces it to the crowd. During the 2006 season, visitors found some four hundred honkers at the mine. At most mines you can buy "native" buckets, meaning the dirt comes straight from local ground, or "salted" buckets, which have low-quality gemstones or other colorful minerals added. These added stones may or may not be from this area. Salted buckets are good for the kids, who are guaranteed to find something, but serious rockhounds wouldn't take a salted bucket if you gave it to them.

You can pick up a map of the mines at most any local store. In Franklin, stop at Ruby City Gems & Minerals, which has all the information you'll need. In addition to selling gems, minerals, and lapidary supplies, Ruby City boasts a fine museum collection of gems, minerals, and Native American and pre-Columbian arti-facts. The historic "old jail" in Franklin houses the Franklin Gem & Mineral Museum, also worth a stop.

While in the Cowee Creek Valley region, you'll also want to explore the historic community of West's Mill, and, in season, Perry's Water Gardens. Perry's is famous for its twelve acres of water lilies, lotus, and other aquatic plants.

Nearby on the Little Tennessee River is an interesting sight. It's a fish weir, a V-shaped structure of rocks designed to funnel fish into a trap. No one knows when the weir was built, but the Cherokee were the first known to utilize it. Look for a large dirt pullout on the

A Cherokee council house, long gone when this photo was taken circa 1896, once stood on top of the mound rising from the cornfield. Called Nikwasi, it served as the ceremonial center of a major Cherokee settlement. The mound remains in the town of Franklin, although roads and commercial businesses engulf it. *North Carolina Collection, University of North Carolina Library at Chapel Hill*

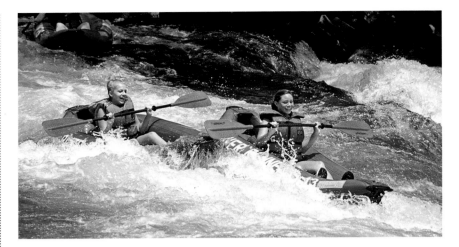

left side of the road; the weir is located at the pullout. A little farther downstream, in a field beside the river, stands Cowee Mound. Believed to have been constructed around AD 600, the mound served as the village heart of the Aniyunwiya (the Principal People), who would later become known as the Cherokee. Cowee Mound is on private property and barely visible from the road, but in Franklin you can climb Nequassee (Nikwasi) Mound. Like Cowee, no one knows when Nequassee was built, but we do know that it played an important role in Cherokee history. It served as the ceremonial center of a major Cherokee settlement. Today it's a grass-covered mound of dirt surrounded by gas stations and stores.

Before the white people started collecting rubies and sapphires from Cowee Creek Valley, the Cherokee may have mined kaolin from a nearby site in the present-day community of Lotla. The Cherokee used the fine-grained white clay as an ingredient in their pottery. In 1767, English potter Josiah Wedgwood sent Thomas Griffiths to purchase some of the clay and have it shipped to London. The clay proved ideal for Wedgwood, who used it to make his famous Queensware and Jasperware. Unfortunately, the high cost of transportation made it impractical to obtain another supply, forcing Wedgwood to find another source.

The best views of Little Tennessee River are in the Needmore section, where the narrow road hugs the riverbed. The Nature Conservancy recently purchased this biologically important tract. The Little T, as the locals call the river, supports a number of rare aquatic species, including the Appalachian elktoe and the little pearly-wing, two federally endangered mussel species.

The Little T is the largest river that feeds Fontana Lake, which is not far downstream from Needmore. Another major stream flowing into the lake is Nantahala River, next up on this route. The Nantahala is the most popular whitewater boating river in the region. Drive through the eight-mile gorge in the middle of a summer day and you'll be caught behind rafting buses ferrying boaters to the put-in

and tourists gawking at boaters on the river. You'll also share the road with hikers, bicyclists, trout fishers, and ordinary traffic, so slow down. Nantahala Outdoor Center (NOC), at the downstream end of the gorge, makes a good stop for lunch or outdoor supplies. As the largest and most popular of the many commercial outfitters for the Nantahala, NOC is a good choice if you want to join the fun on the river. If you just want to watch others shoot the rapids, stop at the large pullout just beyond NOC and walk back to the overlook of Nantahala Falls. As a Class III rapid, it's the largest rapid on the commercial section of the river. It's fun to watch the smiling—sometimes terrified—faces of the people going over the falls.

The route back to Franklin from Nantahala Gorge passes through Nantahala National Forest. Besides general mountain scenery, watch for waterfalls and views of Nantahala Lake. Wayah Bald, at the end of Forest Road 69, makes a nice side trip. The summit offers 360-degree views from the historic fire tower.

An abandoned truck slowly rusts in a fallow field in the community of Kyle.

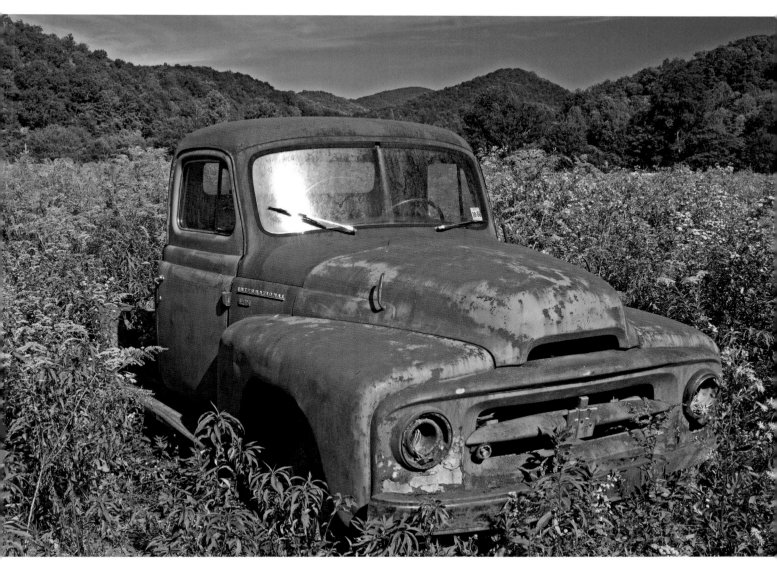

Route 13

Start out near Interstate 40 and U.S. 276, west of Asheville. Head west onto Cove Creek Road. Drive 7 miles, then turn left onto the paved road. Drive 3 miles, then turn right (straight ahead is Cataloochee Cove). Drive 2 miles, then turn left. Drive 12 miles to the community of Mount Sterling, then turn left onto Big Creek Park Road. Follow it 1 mile to the parking area. (*25 miles*)

The Palmer House is one of several historical structures in Cataloochee Cove in Great Smoky Mountains National Park.

History and Hiking in the Smokies

CATALOOCHEE TO BIG CREEK

The land encompassing Great Smoky Mountains National Park hasn't always looked like the natural oasis it is today. Back in the 1930s, eighteen timber companies owned 85 percent of the park. They were feverishly logging the mountain slopes from the bottom up. The other 15 percent of land consisted of some 1,200 farmsteads and more than 5,000 summer homesites. When the land became public, the government removed hundreds of structures, let thousands of acres of farm fields turn fallow, abandoned thousands of miles of old trails, wagon paths, and logging roads, and took up miles of logging railroad tracks. Entire mountainsides, left bare by the loggers, were either replanted or left to revegetate naturally. In other words, when the park came, this region was just like any other in the Appalachians: Its residents worked the land hard to make a living, and timber and mining companies squeezed what they could from it before moving on to the next location. It was not the vast virgin wilderness so many imagine it to have been.

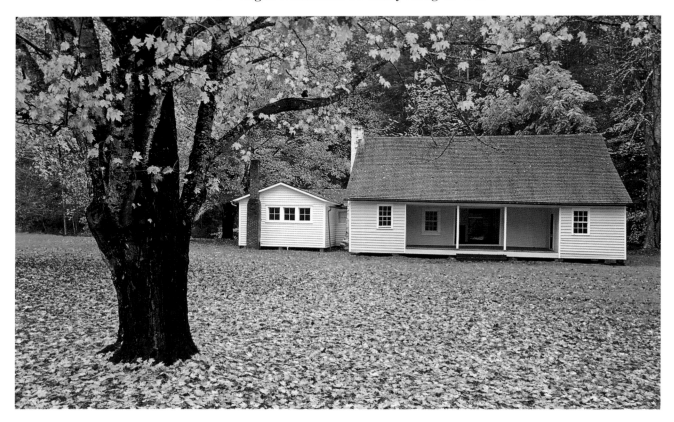

Some 1,200 people lived and worked in Cataloochee when the park came to town, making it the largest settlement in the Smokies. The park removed most of Cataloochee's two hundred buildings, but those that remain provide a glimpse into the past. There are old frame houses, barns, a church, a school, and a few other structures. A narrow, partly unpaved road winds through the valley, providing access to the historic buildings. High mountain ridges surround the pastoral valley, making Cataloochee among the more scenic spots in the Smokies.

Despite the scenic and historic attributes of Cataloochee, most park visitors ignore the valley in favor of the more accessible and popular areas of the park such as Newfound Gap Road and Cades Cove. Cataloochee lies well off the beaten path and requires a long drive on a winding road. Of course, that's the perfect type of trip for readers of this book. In recent years, Cataloochee's visitation has increased dramatically. People come here today to see elk, reintroduced into the park in 2001. If you want to see one of these magnificent animals, get here early in the morning, when a sighting is just about guaranteed. You might even have to stop the car for an elk crossing the road.

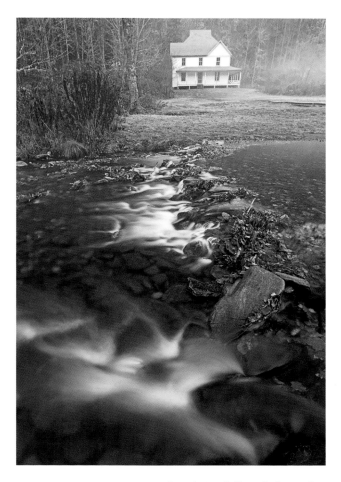

Rough Fork Creek flows in front of Caldwell House in Cataloochee Cove in Great Smoky Mountains National Park.

From Cataloochee, our route travels on dirt roads to Mount Sterling Gap. Before you reach the gap, a gated side road forks to the left. The road leads to Little Cataloochee. As its name suggests, the ghost town is a smaller version of Cataloochee, which is sometimes called Big Cataloochee. It has a couple of cabins and a church. Scattered all about are subtle reminders that this area was once a thriving settlement. Visitors are welcome, but the road is for hikers and horses only.

At Mount Sterling Gap, a three-mile trail leads to the summit of Mount Sterling, where a historic fire tower provides spectacular views. A designated backcountry campsite lies directly below the tower, giving backpackers the opportunity to watch the sunrise from the tower for an unforgettable experience.

From Mount Sterling Gap, the gravel road descends to the community of Mount Sterling, just outside the park boundary. Nearby is Mountain Mama's, a community store and classic rest stop for thru-hikers on the Appalachian Trail. Most thru-hikers start in early spring from the southern terminus in Georgia. This takes them along some seventy miles of the Smokies' crest and deposits them at Davenport Gap, a mile or so up the road from Mount

BRINGING NEW LIFE TO THE SMOKIES

BEFORE THE ARRIVAL OF THE WHITE MAN, when the Cherokees lived and hunted in the Smoky Mountains and fought only with neighboring tribes, the animals in this region were much different from today. Passenger pigeons darkened the skies in unfathomable numbers; wood bison and elk browsed in meadows and clearings; gray (and possibly red) wolves hunted for rodents and deer; peregrine falcons soared overhead; beavers dammed the creeks while otters played in them; fishers hunted for squirrels; mountain lions did whatever they wanted; and the smoky madtom, spotfin chub, duskytail darter, and yellowfin madtom (all species of fish) darted about in the streams.

The arrival of the white man signaled the end for many of these species. The bison were gone by 1765, the elk by the mid-1800s, the gray wolf by 1887, and the mountain lion by the late 1800s. Martha, the last passenger pigeon remaining on Earth, died in captivity at the Cincinnati Zoo in 1914. At one time or another, all the species mentioned above had been extirpated from the Smokies—every one of them at the hand of man.

In keeping with the National Park Service's mission to "conserve the scenery and the natural and historic objects and the wildlife therein," Great Smoky Mountains National Park has initiated a number of efforts to reintroduce some of these species. Of course, we will never see another passenger pigeon, and it is highly doubtful that locals today will tolerate a mountain lion in their neighborhood. But river otters once again play in some of the larger streams; peregrines soar over Alum Cave Bluff; and the smoky madtom, spotfin chub, duskytail darter, and yellowfin madtom ply the waters of Abrams Creek.

In the early 1990s, biologists reintroduced the red wolf to the Cades Cove section of the park. Unfortunately, the experimental release proved unsuccessful. Everyone liked the idea of having the wolves in the park, but the wolves themselves had other plans. They kept leaving the park boundary and getting into trouble, so the plan had to be squelched.

Perhaps the most popular reintroduction effort is that of the elk. In 2001, biologists released twenty-five elk in Cataloochee Cove. Another twenty-seven were released the following year. The herd now numbers about seventy-five and seems to be doing well. The number of visitors to Cataloochee Cove has increased dramatically since the elk were released. The cove becomes especially crowded in the fall, when the bulls make their majestic bugling calls.

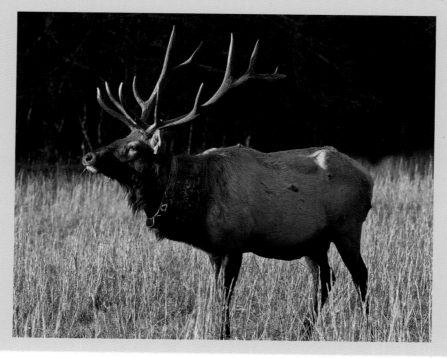

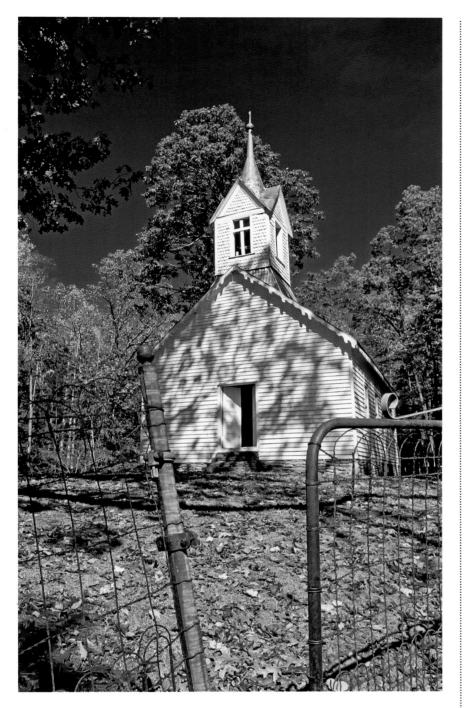

The historic Little Cataloochee Baptist Church in Great Smoky Mountains National Park still holds services on special occasions.

Sterling. By this time, they are exhausted and hungry. Mountain Mama's might not impress anyone arriving by automobile, but those showing up on foot love it.

Mount Sterling community marks the entrance to the park's Big Creek section. Here you'll find a picnic area and seasonal campground. But the best part about Big Creek are the hiking trails. Three trails start here, and combined with connecting trails, they make up several miles of fine backcountry hiking. Several options are available for hiking to the summit of Mount Sterling.

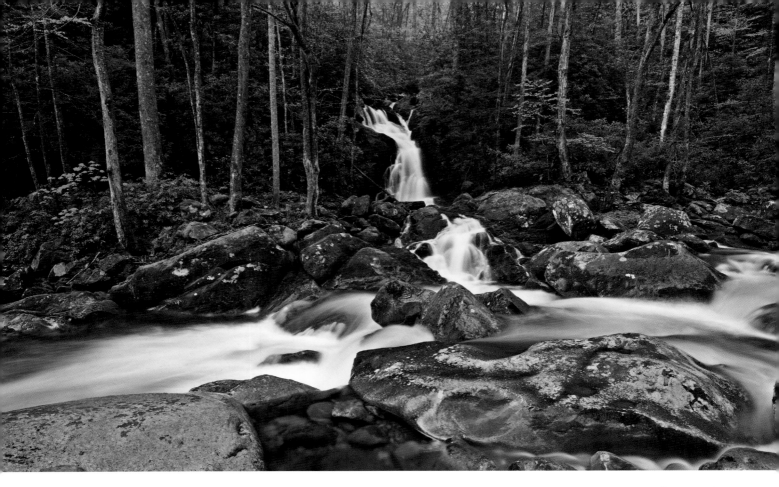

Mouse Creek Falls tumbles into Big Creek in Great Smoky Mountains National Park.

This Civilian Conservation Corps facility operated in the Big Creek section of Great Smoky Mountains National Park. *Hunter Library, Western Carolina University*

A good option for a family hike is Big Creek Trail. It follows the cascading stream for five miles along an abandoned railroad grade to Walnut Bottom, the site of an old logging camp. The train transported logs from deep within the Big Creek watershed to a mill that stood about where the trailhead parking area is today. Look around; you might spot the crumbling remains of the mill's foundation. In the woods behind the restroom building is the site of CCC camp NP-7. Between 1933 and 1939, the CCC boys of NP-7 built miles of hiking trails and constructed the fire tower atop Mount Sterling and the lookout building on Mount Cammerer.

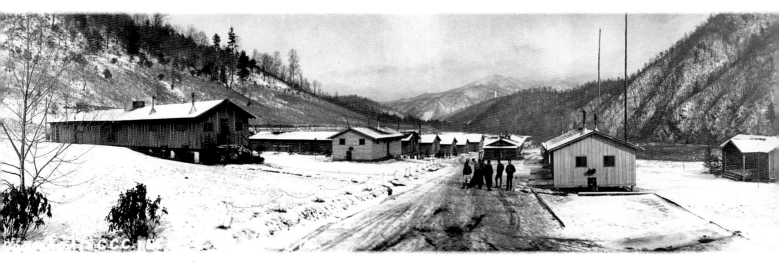

ROUTE 14

Cherokee Country

FOLLOWING HEINTOOGA, ROUND BOTTOM, AND BIG COVE ROADS INTO CHEROKEE

At Wolf Laurel Gap on the southern section of the Blue Ridge Parkway (Route 8), Heintooga Ridge Road turns off to the north and heads deep into Cherokee country. At an elevation of over five thousand feet, this ridgeline road lets you drive into a different season. In mid-May, when the spring wildflowers have finished blooming in the valleys and the trees have lost that early spring-green hue, you can drive up here and find wildflowers carpeting the roadsides and the trees just beginning to leaf out. Later in the year, you can do just the opposite; fall comes much earlier here than in the valleys below. Heintooga Ridge Road is closed in winter.

A little more than three miles from the parkway, the road enters Great Smoky Mountains National Park, just before reaching Black Camp Gap. At the gap, a handicap-accessible path leads from the parking area to the Masonic Monument. Embedded in the marker are stones from all over the world, including all seven continents. Among the 687 stones are those from Plymouth Rock, the Rock of Gibraltar, the Alamo, and the White House.

Balsam Mountain Campground lies near the end of the paved road. At the end is what may be the most appealing picnic area in the state. Situated in a spruce-fir forest at an elevation of over 5,500 feet, the air is cool (sometimes frigid in spring and fall) and the forest smells like a Christmas tree. Red squirrels, called "boomers," chatter incessantly, as if begging someone to toss a crumb. Most likely, they are just defending their territory from your intrusion. (Feeding any wildlife is strictly against park regulations.) A really cool thing about the picnic area is the tables. A few are made from huge natural rock slabs. Moss covers some of them, serving as a natural green tablecloth. A hiking trail leads from the picnic area a short distance to Heintooga Overlook, a great spot to watch the sunset.

Most people turn around at Heintooga Picnic Area and backtrack to the parkway. But we're not like most people. We're going to continue on Balsam Mountain Road, which takes off from the circle at the picnic ground. The one-way gravel road winds its way down the mountain, providing an intimate view of the forest. It quickly leaves the high-elevation spruce-fir forest and takes you through mixed hardwood woodlands, complete with heath balds and hemlock.

The land we're passing through was once Cherokee country. In the 1830s, when the U.S. government rounded up the Cherokee and

Route 14

Start out on the Blue Ridge Parkway near Cherokee. From Milepost 458, drive 9 miles on Heintooga Ridge Road (closed in winter) to the Balsam Mountain Picnic Area. From here, follow the one-way Balsam Mountain Road for 18 miles, then turn left onto Big Cove Road. Follow it 9 miles to Cherokee. (*35 miles*)

Street signs in Cherokee include the syllabary invented by Sequoyah in the early 1800s, the first written language of the Cherokee.

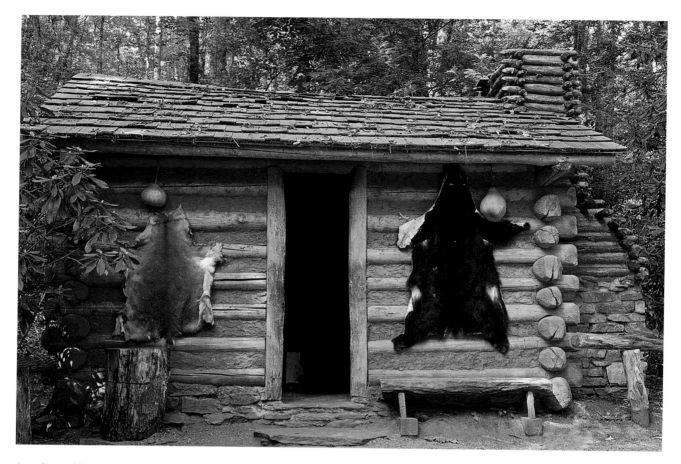

A replica cabin at Oconaluftee Indian Village represents typical nineteenth-century Cherokee housing.

force-marched them to Oklahoma along the now-infamous Trail of Tears, some Cherokees sought refuge in the fastness of this wilderness. A century later, lumbermen penetrated the virgin forest and left barren mountainsides in their wake. Balsam Mountain Road follows the course that the old narrow-gauge railroad used to haul logs down the mountain. While not pristine and no longer harboring giant trees, the land has healed well since the park came along in the 1930s. The last few miles of the road follow the scenic Straight Fork through a beautiful bottomland forest. In the latter half of April, this area is lush with spring ephemeral wildflowers.

Once you get on Big Cove Road, watch for the signs to Mingo Campground. The trailhead for Mingo Falls is here. Falling some 150 near-vertical feet over layered rock, Mingo Falls is the quintessential cascading waterfall of the southern Appalachians. Surprisingly, Mingo is not a Cherokee name. According to Cherokee storyteller Jerry Wolfe in *Cherokee Heritage Trails Guidebook*, loggers from West Virginia named the falls. Supposedly, the waterfall resembles one in that state. Wolfe says the Cherokee already had a name for the falls: "The Big Bear Falls."

Our route ends at Cherokee, but our adventure is only beginning. Drive on by those tourist shops hawking "authentic" Indian wares; ignore the men standing out in the parking lots wearing

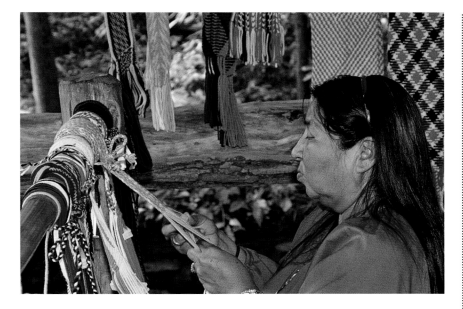

At Oconaluftee Indian Village, native Cherokees depict the way of life from the nineteenth century. Here, a woman demonstrates the craft of hand weaving.

wildly colored, inauthentic headdresses and charging $5 to pose for pictures; and in that one parking lot, try not to notice the stuffed black bear standing on its hind legs and growling—that poor exploited animal has been a fixture here for decades, so long that its fur is shredding. All that stuff is here in abundance for those who like that sort of thing. But if you want to learn about the true history and culture of the Cherokee, you won't find it at a tourist shop. You need to go to the Museum of the Cherokee Indian and Oconaluftee Indian Village.

The museum features the finest collection of Cherokee artifacts in the world. Its exhibits and narratives take you from the beginning of humans in the southern Appalachians through all the major periods and events of Cherokee history. Oconaluftee Indian Village is an authentic recreation of an eighteenth-century Cherokee settlement. Native Cherokees wearing period costumes portray life in the village. Among the demonstrations are beading, basket weaving, dart blowing, and dugout canoe making.

Beading is one of the craft demonstrations at Oconaluftee Indian Village in Cherokee.

Next door to the village is the amphitheater for *Unto These Hills*. The popular outdoor drama has entertained more than five million visitors since its debut in 1950. *Unto These Hills . . . a retelling* debuted in 2006. The show uses a new script that more properly portrays the Cherokee perspective of their history. It features authentic costumes, traditional dance and music, and a cast that includes a majority of local Cherokee actors.

Old Trees and Grand Scenery

JOYCE KILMER MEMORIAL FOREST AND CHEROHALA SKYWAY

Route 15

Start out on U.S. 129 north of Robbinsville. Head south on NC 143. Drive 3 miles, then turn right to remain on NC 143. Drive 7 miles to the start of Cherohala Skyway, then turn right, exiting the skyway. Drive 2 miles, then turn left and drive to the trailhead for Joyce Kilmer Memorial Forest. Backtrack to the skyway and follow it 18 miles to the Tennessee border. (*34 miles*)

Trees aren't the only ancient things in the Joyce Kilmer-Slickrock Wilderness. This sign appears to have been here as long as the old-growth hemlocks and yellow poplars.

OPPOSITE: Cherohala Skyway winds through the Snowbird Mountains in this early-morning autumn view.

Blue Ridge Parkway and Newfound Gap Road are arguably the most scenic drives in the southern Appalachians. But tucked back in the corner of Graham County on the Tennessee border, Cherohala Skyway gives both of them stout competition. But we're getting ahead of ourselves; the skyway is at the end of our route.

We begin just outside Robbinsville at Santeetlah Lake. In a few miles, you'll come to the ranger station for the Cheoah District of Nantahala National Forest. Stop here for detailed forest information. If you plan to hike, be sure to pick up the Snowbird Area trail map and the map for Joyce Kilmer-Slickrock Wilderness and Citico Creek Wilderness.

Snowbird offers excellent hiking opportunities, including access to four major waterfalls. The area is not as crowded as the more well-known areas of the national forest, but don't expect to find complete solitude. During the infamous Indian removal of the 1830s, many Cherokees fled and hid in the fastness of the Snowbird wilderness. More than five hundred direct descendants remain, living on tribal lands as a satellite group of the Eastern Band of Cherokee Indians. Descendants of another kind also remain. In the early 1900s, George Moore established a hunting preserve here. Among the exotic animals he imported were buffalo, Russian wild boar, and Russian

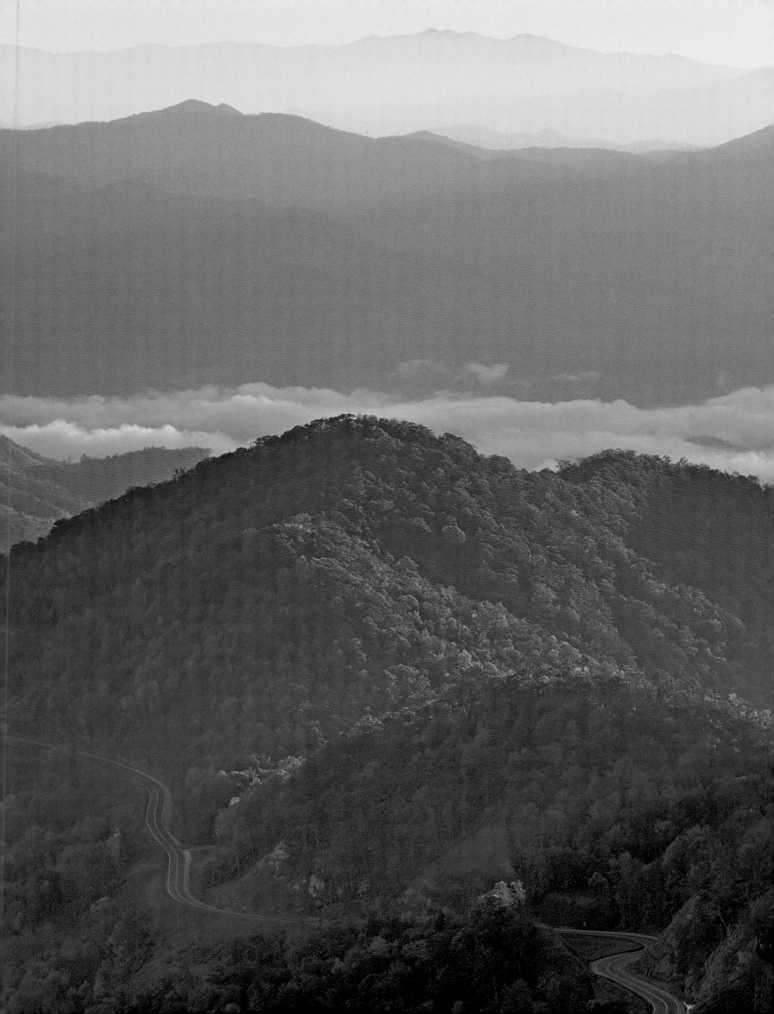

Joyce Kilmer Memorial Forest features the finest collection of old-growth yellow poplar trees in the nation.

brown bear. Moore's efforts proved fruitless, with many animals poached and others escaping their fenced enclosures. All of the animal species eventually died out except for the wild boar, which flourished and eventually spread to forests all over the southwestern mountains of North Carolina. The boar's method of feeding by uprooting vegetation wreaks ecological havoc, particularly in the Smokies.

At the beginning of the Cherohala Skyway, our route takes a side trip to Joyce Kilmer Memorial Forest. Alfred Joyce Kilmer, a poet who died in battle in World War I, is best known for penning the poem "Trees." You know, the one that begins with "I think that I shall never see / A poem lovely as a tree." Kilmer's poem might be a little sappy to some, but his forest–oh, my! Even a sentimental poem seems perfectly suited to the giant poplars and hemlocks and the carpets of wildflowers "Against the earth's sweet flowing breast."

Biologists don't like to use the word "virgin" when describing ancient forests. They use the term "Class A" to describe old-growth forests where no significant signs of human disturbance can be determined. Joyce Kilmer Memorial Forest is classic Class A. Barely saved from the axe in the 1930s, it contains some of the largest yellow poplars and eastern hemlocks in existence. In early April,

spring ephemeral wildflowers carpet the ground, with trillium, wild geranium, violet, jack-in-the-pulpit, hepatica, bloodroot—dozens more—everywhere you look. Tragically, the forest's grand hemlocks are dying, the result of infestation by the hemlock woolly adelgid.

After visiting Joyce Kilmer Memorial Forest, backtrack to the beginning of the Cherohala Skyway at Santeetlah Gap. *Cherohala* comes from combining the words "Cherokee" and "Nantahala," the two national forests through which the road runs. About eighteen miles of the road pass through Nantahala National Forest in North Carolina; the rest goes through Cherokee National Forest in Tennessee. The highway was built purely as a recreational drive, and at a price of $100 million, it is North Carolina's most expensive road. Like the Blue Ridge Parkway, it features a high-elevation course, overlooks, trails, and spectacular scenery.

At Stratton Meadows, about sixteen miles from Santeetlah Gap, you can take a side trip down Forest Road 217 to Forest Road 210 along the Tellico River in Tennessee's Cherokee National Forest. If you go, be sure to visit the scenic Bald River Falls, viewed easily from the road. In the other direction from Stratton Meadows, Forest Road 81 drops down and follows Santeetlah Creek through Nantahala National Forest. The road rejoins the Cherohala Skyway at Santeetlah Gap, making this an excellent loop option.

A footbridge over Little Santeetlah Creek takes hikers into Joyce Kilmer Memorial Forest.

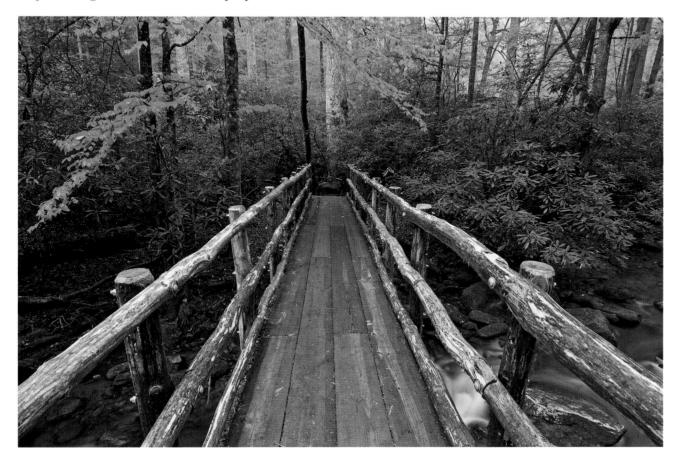

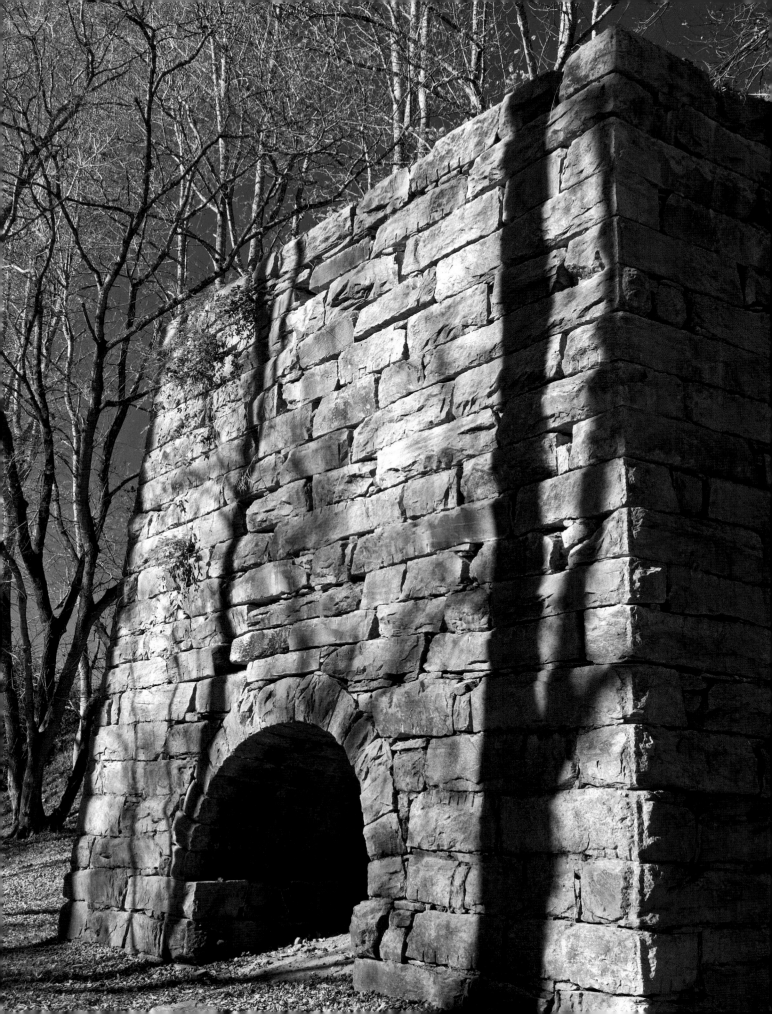

PART III

History and Scenery in the Heartland

The Piedmont

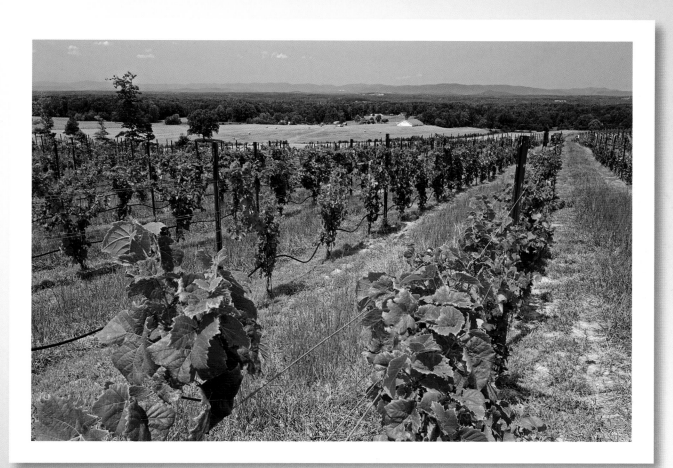

The Blue Ridge Mountains serve as backdrop for the grapevines at Raffaldini Vineyards.

OPPOSITE: The Confederacy depended on Moratock Iron Furnace for iron production during the Civil War.

North Carolina's heartland includes the densely populated Triad region of Winston-Salem, Greensboro, and High Point; the Triangle region of Raleigh, Durham, and Chapel Hill; and the state's largest city, Charlotte, with its never-ending sprawl. Far more people live in the Piedmont than in the western and eastern regions of North Carolina combined. At first glance, you might not think the Piedmont would be particularly favorable for scenic backroads, but that's not the case at all. In fact, you don't have to drive very far outside any of the metropolitan areas to find scenery and historical features every bit as good as anywhere else in the state.

The region's beauty lies largely in its pastoral settings. Agriculture has always been important to North Carolina and remains so today. In the Piedmont, you'll see rolling fields of corn, wheat, and soybeans. And of course, tobacco. North Carolina was built on a foundation of tobacco farms, and the state remains the largest producer in the nation. In the last few decades, dozens of vineyards have popped up in the Piedmont region, adding another picturesque quality to the countryside.

While much of the Piedmont landscape has been altered by man, there are still places where nature holds a good grip on the reins. Uwharrie National Forest protects some fifty thousand acres of the gentle Uwharrie Mountains, and a number of state parks and nature preserves are here. We'll visit many of these places and explore the rich history of the region.

In the past couple of decades, vineyards have made an important contribution to the North Carolina economy, as well as to its pastoral scenery.

ROUTE 16

Reds, Whites, and Blue Skies

YADKIN VALLEY WINE COUNTRY

If you like pastoral settings and cultural history, you're going to love this route. If you also like to drink wine and see it being produced, you're *really* going to love it. This route passes through the heart of the Yadkin Valley American Viticulture Area (AVA), which encompasses some 1,400,000 acres in the Yadkin River Valley. Designated as an AVA by the U.S. government in 2003, the official status allows winemakers to label their bottles with the Yadkin Valley name. Some two dozen wineries currently operate in the Yadkin Valley region, with several more in the works. Seven wineries are located directly along our route, but all of the others are only short side trips away. Most wineries provide literature about the region and directions to the other wineries.

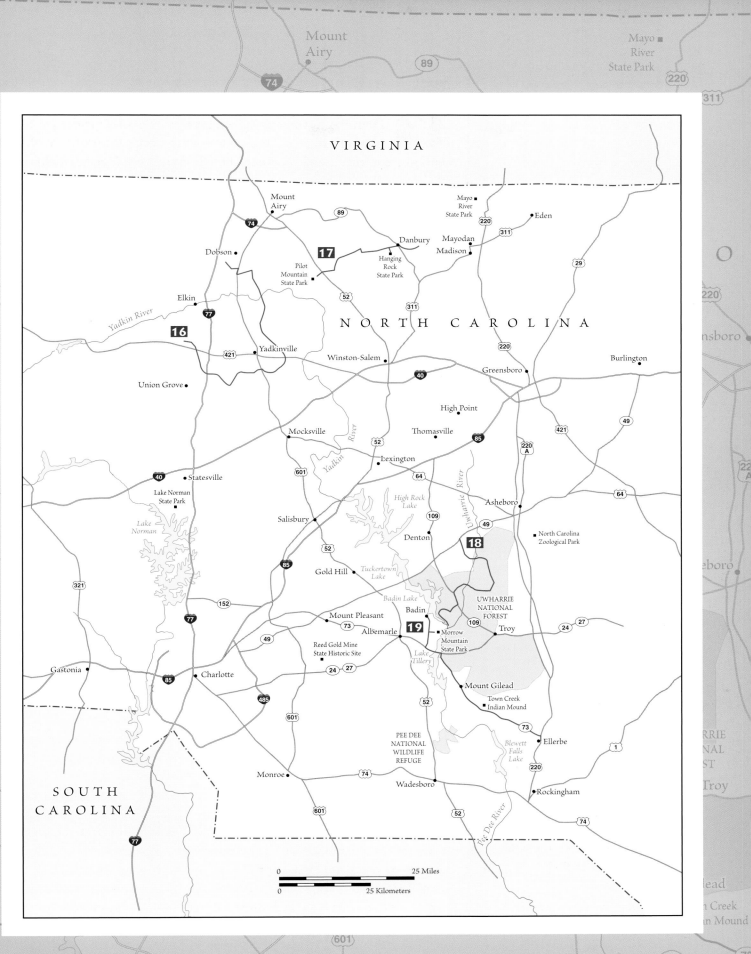

A horse and buggy carries an Amish family to church at Windsors Crossroads.

Route 16

Start out on U.S. 421, west of Interstate 77. From Exit 267, follow the signs to Raffaldini and Laurel Gray vineyards, then backtrack to U.S. 421. Head south on Windsor Road. Drive 6 miles to Windsors Crossroads, then continue straight ahead. Drive 3 miles, then turn left onto Barnard Mill Road. Drive 1 mile, then turn left onto U.S. 21. Drive 2 miles, then turn right onto Lone Hickory Road. Drive 6 miles, then turn right onto Fish Brandon Road. Drive 2 miles and cross U.S. 601 onto Courtney-Huntsville Road. Drive 2 miles, then turn left onto Brawley Road. Drive 2 miles, then turn right onto Old Stage Road. Drive 2 miles, then turn left onto Shacktown Road. Go a quarter mile, then turn right onto Styers Mill Road. Drive 2 miles, then turn left onto Old U.S. 421. Make a quick right turn onto Pilot View Church Road. Drive 5 miles, then turn right onto Rockford Road. Drive 5 miles, then turn left to cross Yadkin River. Drive 5 miles, then turn left on Stony Knoll Road. Drive 3 miles, then turn right onto U.S. 601. Drive 2 miles, then turn left onto NC 268. Drive 1 mile, then turn right. Follow the road 3 miles to Shelton Vineyards. (*62 miles*)

The first three wineries on the route—Raffaldini, Laurel Gray, and Buck Shoals—are located within the new Swan Creek AVA. Designated in spring 2008, Swan Creek AVA refers to a specific appellation within the broader Yadkin Valley AVA. Driving from Raffaldini to Laurel Gray vineyards, you can't help but notice the miles of black rail fencing and the palatial brick house tucked away from the road. Notice those letters on the entrance gate? J. J. stands for racing icon and legendary moonshine runner Junior Johnson.

A few miles down the road from Buck Shoals Vineyard, in the community of Windsors Crossroads, there's a good chance you'll share the road with a horse and buggy. A small group of Amish families settled here in the mid-1980s and while not as conservative as their Old Order brethren (the Amish of Windsors Crossroads use electricity and some types of modern machinery), they still embrace the New Order Amish faith and lifestyle, which generally forbids automobiles. Just off the main route on St. Paul Church Road is Shiloh General Store. Owned and operated by an Amish family, the popular store offers a wide selection of baked goods, deli meats, cheese, and sundries.

Next up on the route is Hanover Park Vineyard, occupying an 1897 farmhouse. Not far from Hanover Park, you'll cross back over U.S. Highway 421 and, after a couple of turns, end up on Styers Mill Road. Half a mile down the road is the Shore-Styers Mill Park, the site of several early gristmills. Only ruins of the mills remain, but the waterfall is impressive considering its location this far east of the mountains.

Nearly every mile of this route passes through agricultural land. At one time, most of the farms grew tobacco, like everybody else in the state. As health issues amplified and the market for tobacco dwindled, farmers began turning to other crops and means for

support. As you have already discovered, one of those new crops is grapes. Many of the vineyards in Yadkin Valley are located on former tobacco farms. RagApple Lassie Vineyards, next up on our route, is located on a *current* tobacco farm. Its grape vines share the soil with golden-leaf tobacco. Having tobacco and alcohol covered, it seems the only thing missing for a clean sweep of the vices is a brothel!

Rockford is a delightful village situated beside the Yadkin River. The seat of a then much-larger Surry County from 1790 to the 1850s, the town retains a number of historical structures dating from the era and into the early twentieth century. Be sure to stop by the Rockford General Store, in continuous operation since 1890. Pull up a rocking chair, enjoy a Nehi soda, and try one of the dozens of varieties of hard candy sold by the pound.

Two more wineries await after visiting Rockford: Stony Knoll Vineyards and, at the end of the route, Shelton Vineyards. At Shelton, you can tour the winery, have dinner at the Harvest Grill, and enjoy an outdoor evening concert during the Sunset Concert Series held during the summer.

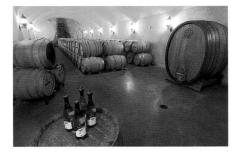

The Barrel Room at Shelton Vineyards is a popular stop on a tour of the winery.

Pilot Mountain breaks the horizon in this sunrise view of RagApple Lassie Vineyards.

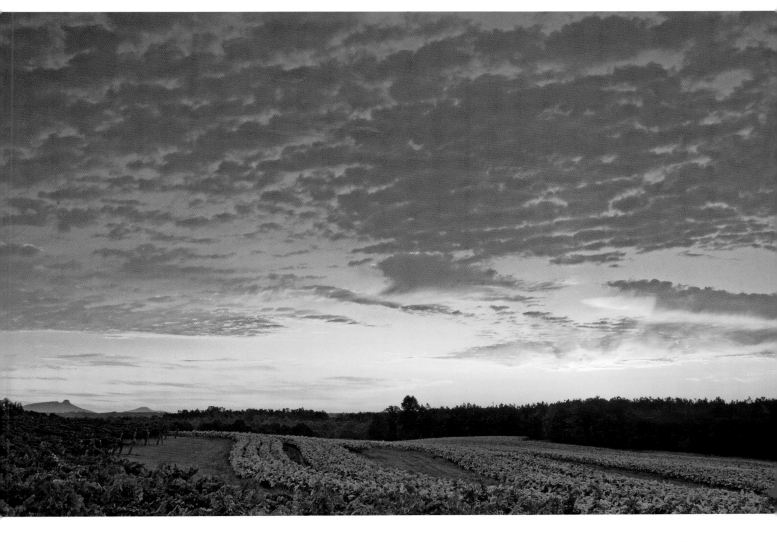

The Mountains Away from the Mountains

PILOT MOUNTAIN AND HANGING ROCK

OPPOSITE: The jagged quartzite of Hanging Rock in Hanging Rock State Park contrasts with the surrounding rolling countryside.

Pilot Mountain commands attention from all directions.

You won't have trouble finding the start of this route. From every direction, Pilot Mountain commands attention, rising abruptly some 1,400 feet above the surrounding plains. The early Saura Indians named the mountain *Jomeokee*, which means "great guide." The Moravian name Pilot has been used since the mid-eighteenth century. Two peaks make up Pilot Mountain: Big Pinnacle and Little Pinnacle. Big Pinnacle is the one you can't miss, with its two-hundred-foot sheer rock walls and flat top.

Geologists call Pilot Mountain a "monadnock," meaning an isolated knob that rises abruptly above the surrounding land. But

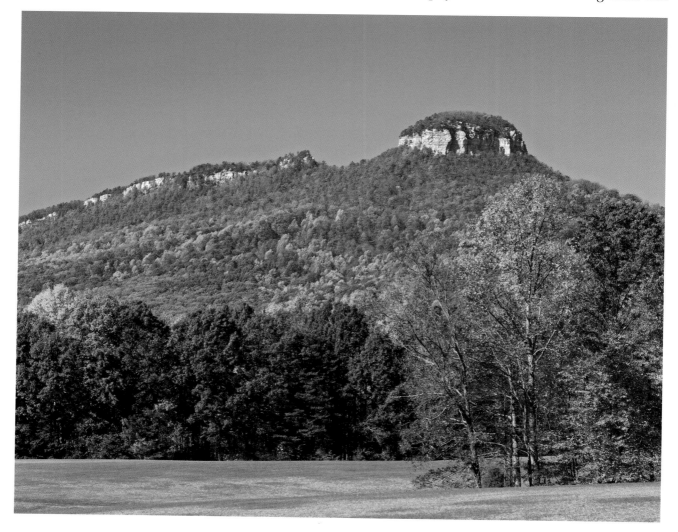

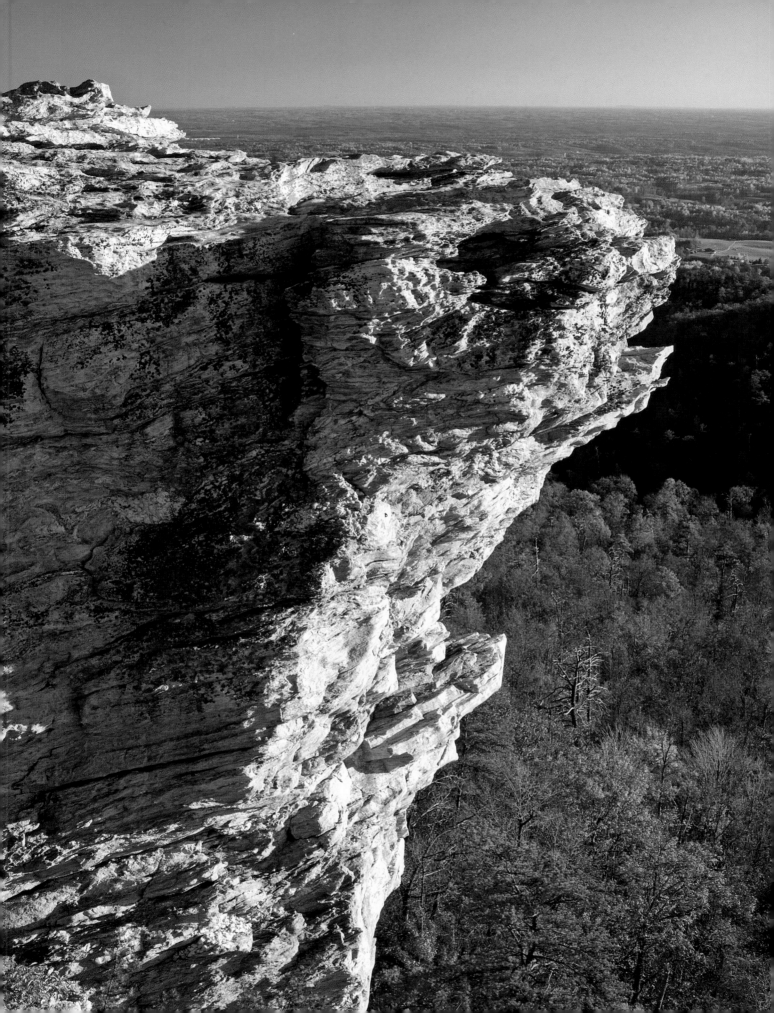

Start out at the entrance to Pilot Mountain State Park on U.S. 52, north of Winston-Salem. Visit the park, then head east on Pilot Knob Park Road. Drive 1 mile, then turn right onto Old Winston Road. Drive half a mile, then turn right onto Old U.S. 52. Go a quarter mile, then turn left onto High Bridge Road. Drive 3 miles, then turn right onto Brims Grove Road. Drive 1 mile, then turn right onto Oscar Frye Road. Drive half a mile, then turn right onto Flat Rock Road. Drive 1 mile, then turn left to remain on Flat Rock Road. Drive 3 miles, then turn right onto Rock House Road. Drive 2 miles, then turn left on Taylor Road. Go a quarter mile, then turn right onto NC 66. Drive 2 miles, then turn left onto Moores Springs Road. Drive 5 miles, then turn right to visit Hanging Rock State Park. Backtrack to Moores Springs Road, then continue on the park road to NC 8/89 and turn right. Drive 2 miles, then turn left onto Sheppard Mill Road. Drive 2 miles to Priddy General Store. (*25 miles*)

like all the other prominent peaks in North Carolina, Pilot Mountain is as much a product of erosion as it is uplift. The peak is made of quartzite, an extremely erosion-resistant type of rock. Over the eons, erosion cut into the less-resistant surrounding rock, and streams washed the sediment away.

Because monadnocks are isolated from their surroundings and are usually quite a bit higher, they often harbor uncommon species of flora and fauna. Mountain laurel (*Kalmia latifolia*) and Catawba rhododendron (*Rhododendron catawbiense*)—plants more typical of the higher mountains farther west—thrive here. The common raven, once a rare Piedmont nester but now more common, has been an inhabitant of Pilot Mountain as long as anyone can remember. In fact, the bird's presence contributed greatly to the mountain being designated a National Natural Landmark. As a state park, Pilot Mountain is user-friendly, with the usual complement of trails, picnic areas, campgrounds, and interpretive displays.

Near the other end of our route is another state park, Hanging Rock. It harbors striking geologic features, including Moores Knob, Cooks Wall, Wolf Rock, and—the park's namesake—Hanging Rock. Like Pilot Mountain, the peaks and rock walls within Hanging Rock State Park owe their existence to hard quartzite. Both parks are remnants of an ancient range called the Sauratown Mountains. Their isolation from the Blue Ridge Mountains to the west and north has given them the nickname "the mountains away from the mountains."

Facilities at Hanging Rock State Park include the usual amenities, as well as a small lake and swimming area, which can be crowded in the summer. An extensive trail system leads hikers to mountain peaks with expansive views, cascading waterfalls, and even to a small grotto said to be a hideout for loyalists during the Revolution. Hikers who want a little more of a challenge can tackle the twenty-two-mile Sauratown Trail, which connects Hanging Rock to Pilot Mountain.

The gateway to Hanging Rock is the small town of Danbury, seat of Stokes County. To complete the route, you'll pass through the heart of the village and alongside the historic 1904 courthouse. Just outside of town are Moratock Park and the Moratock Iron Furnace. One of only a handful of nineteenth-century iron furnaces remaining in the state, Moratock supplied the Confederacy with much-needed iron during the Civil War.

Our route ends a couple of miles from Moratock Park at Priddy General Store. Built around 1888 and serving as a post office and bank, the two-story frame building was purchased in 1929 by N. D. Priddy, who opened it as a store. Priddy descendants continue to operate the store today, selling just about everything you can imagine, including the requisite hoop cheese and thick-sliced bologna sandwiches. At various times throughout the year and every Saturday in October, visitors enjoy "Pickin' at Priddy's" live bluegrass music.

The former Stokes County Courthouse in Danbury features a mansard-style cupola.

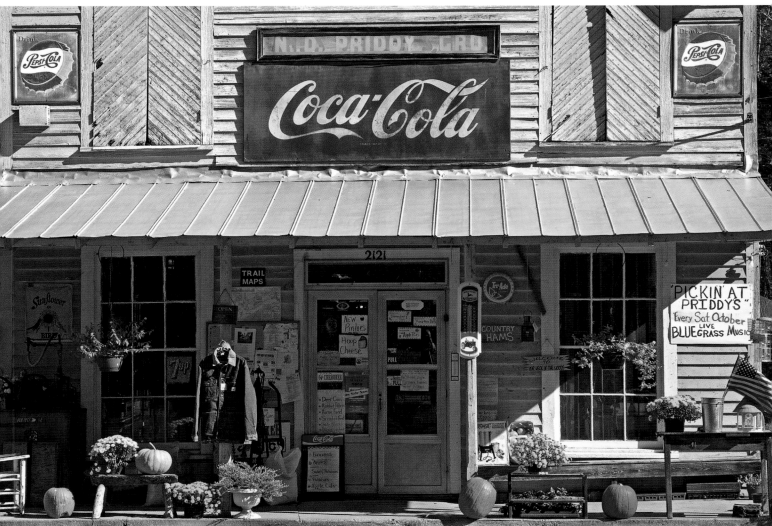

Priddy General Store is the quintessential "old-timey" mercantile, drawing visitors from all over.

Mountains That Aren't

THE UWHARRIES

OPPOSITE: Coneflowers complement a summer view of Pisgah Covered Bridge, one of only two remaining covered bridges in the state.

The pastoral landscapes in the Uwharrie Mountains region become especially scenic at sunrise.

The casual tourist driving through the middle of the Uwharrie Mountains might be forgiven for asking where they are. At a maximum elevation of just over one thousand feet and projecting only a few hundred feet above the surrounding land, the Uwharries look nothing like their neighbors to the west, the Appalachians. At one time, it was believed the Uwharries might be the oldest mountain range on the continent, but geologists today tell us that they are mere babies at around 18 million years old (the Appalachians are around 300 million years old). Actually, the Uwharries aren't even technically considered mountains. They are the hard-rock remnants of an eroded flat plain, called a peneplain.

Our route takes us through open, rolling, agricultural lands and deep within hardwood forests. At the beginning of the route, New Hope Road and High Pine Church Road offer the finest pastoral views in the Uwharries. The road crosses Uwharrie River just downstream

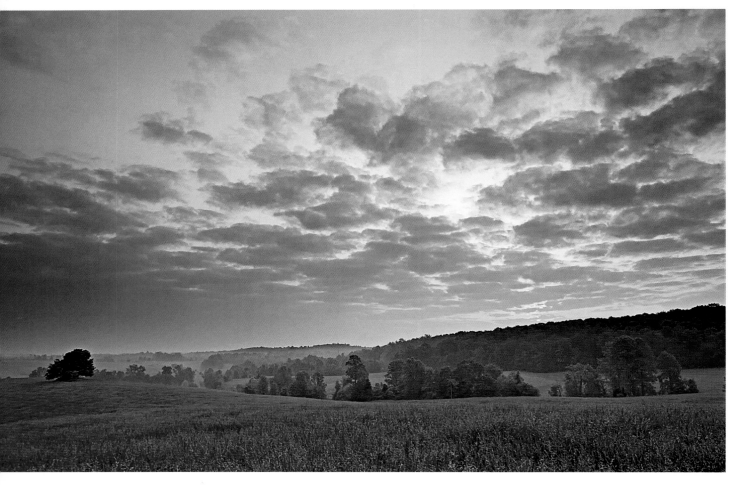

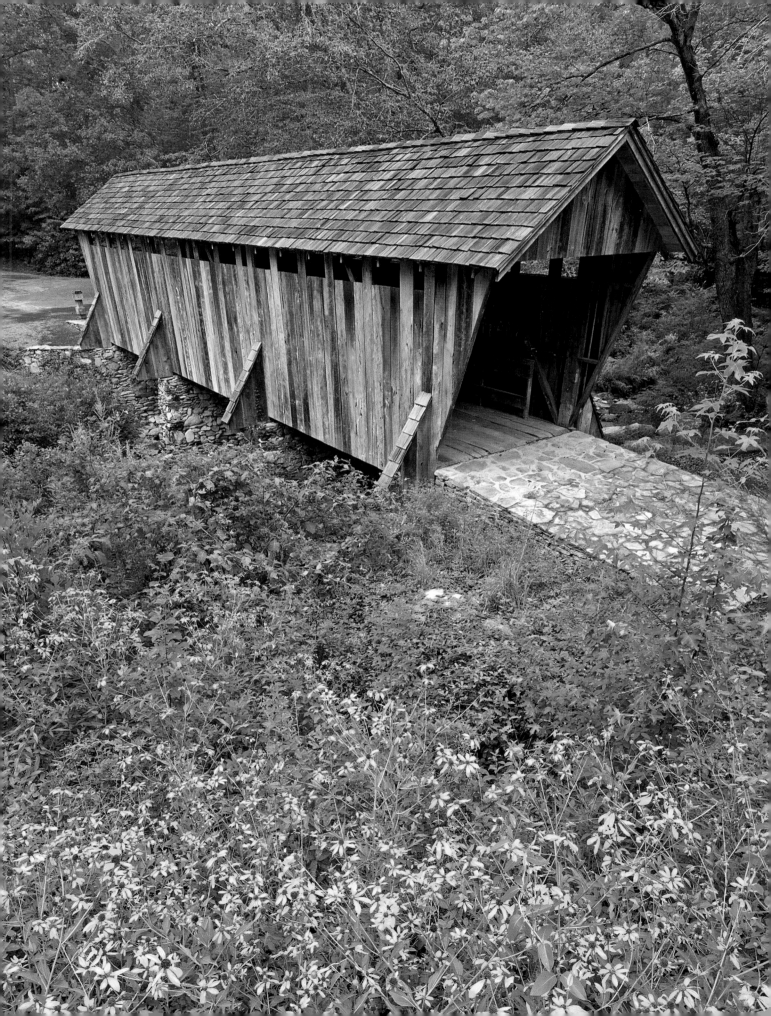

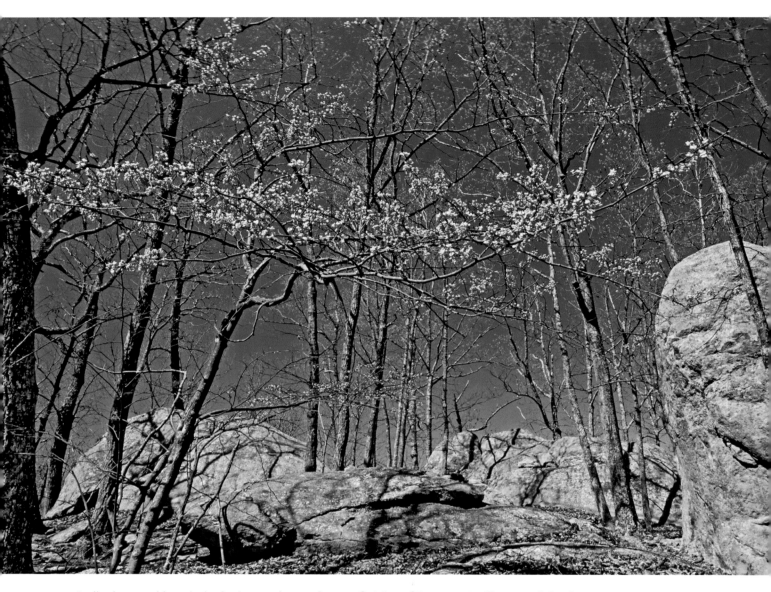

Redbud trees add a splash of color to the March woodlands in Uwharrie National Forest.

OPPOSITE: Abandoned gold mines are scattered throughout the Uwharrie Mountains. This shaft is part of the Russell Mine in Uwharrie National Forest.

and out of sight of Lassiter Mill, one of the few remaining gristmills in a region once filled with them. At the crossroads up from the river, a left turn takes you into the Birkhead Mountain Wilderness Area and some of the best hiking trails in the Uwharries.

Continue straight from the crossroads and in a few miles you cross the West Fork of Little River at Pisgah Covered Bridge. Of the hundreds of covered bridges that once spanned North Carolina's waterways (as many as sixty in Randolph County alone), Pisgah is one of only two remaining. An easy loop path winds through the forest downstream from the bridge and provides up-close views of the abundant mountain laurel shrub, a plant more at home in the western North Carolina mountains than here in the Piedmont.

Shortly after turning off Horseshoe Bend Road onto Flint Hill Road, look out on the right for a dirt pullout at a cliff area. This is the Jumpin' Off Rock, a popular landmark in the Uwharries. Down

the road from the cliff is a parking area on the left and the northern trailhead for Uwharrie National Recreation Trail. About twenty miles long, the trail is the longest and most challenging of those offered within Uwharrie National Forest.

The second crossing we'll make over the Uwharrie River is on what the locals call the Low Water Bridge. When you see it, you'll know why. And if you take this drive after a good rain, you can forget any notion of finishing the route without making a detour.

Low Water Bridge Road ends at Coggins Mine Road. The Uwharries are gold country, and this intersection is "gold central." About a mile down the road to the right is an old path leading to the long-abandoned and mostly overgrown Russell Mine. If you're into things like this, Russell Mine is about as cool as it gets. Its largest pit is the length of a football field, half as wide, and some sixty feet deep. A gently sloped path descends into the pit from one end and provides access to two of the mine's horizontal shafts, both of which exit onto the adjacent slopes. Explorers beware: With deep, open pits scattered throughout the dense woods, Russell Mine is not the kind of place for casual wandering.

Our route turns left at the intersection and immediately passes by the Coggins Mine site on the left. During its heyday in the early 1920s, Coggins was among the largest operations in the Uwharries. Like most of the region's early mining operations, nothing remains

Route **18**

Start out on NC 49, about 12 miles south of Asheboro. Head east on New Hope Road. Drive 1 mile, then turn left onto High Pine Church Road. Drive 9 miles, then turn right onto Lanier Road. Drive 2 miles, then turn right onto Pisgah Covered Bridge Road. Drive 2 miles, then turn left onto Mount Lebanon Road. Go half a mile, then turn right onto Randall Hurley Road. Drive 2 miles, then turn right onto Horseshoe Bend Road. Drive 3 miles, then turn right onto Flint Hill Road. Drive 3 miles, then turn right onto Ophir Road. Go half a mile, then turn left onto Low Water Bridge Road. Drive 5 miles, then turn left onto Coggins Mine Road. Drive 2 miles, then turn left onto NC 109 south. Drive 2 miles, then bear right onto Reservation Road. After half a mile, turn right onto Forest Road 576. Follow it 8 miles to the end. (*39 miles*)

at the Coggins site. Fortunately, you can see a part of the Coggins operation at Reed Gold Mine State Historic Site. The state rescued the stamp mills from Coggins Mine in the 1980s and created a working display of them at Reed.

After turning off NC Highway 109, you enter into the region of Uwharrie National Forest called "the Reservation" by the locals. Except for Sundays, you might want to avoid this area from early November through December, when deer hunting is in season. You don't want to be wandering around here when the woods are full of hunters carrying high-powered rifles. At other times, the Reservation provides fine outdoor recreation opportunities. This area is extremely popular with hikers, mountain bikers, equestrians, fishers, and off-roaders. A particularly scenic section lies near the end of the route, where the forest road parallels Falls Reservoir for a short distance on a high bench. In spots on this stretch, paths lead along ridges to good viewpoints. Drowned under Falls Reservoir is the famous "Narrows of the Yadkin," where the Yadkin River once squeezed through a rocky passage only thirty or forty yards wide and over a distance of a mile dropped some ninety feet.

The crusher building at Coggins Gold Mine still stood in the late 1970s. By the 1990s, nothing remained at the site but a tangle of vines and weeds. Today, the crushers operate once again as an interpretive display at Reed Gold Mine State Historic Site. *JoAnn Sieburg-Baker, Library of Congress*

ROUTE 19

Native American Heritage

MORROW MOUNTAIN, TOWN CREEK, AND ELLERBE

Company towns sprouted up all over North Carolina during the nineteenth century. Built mostly by timber, mining, and textile companies, they prospered until resources were depleted or the markets changed. Most became ghost towns and faded into obscurity. Badin is unique. It didn't sprout until well into the twentieth century, among the last of North Carolina's company towns. And despite the recent closing of its benefactor, Badin remains a delightful village with an interesting collection of historical architecture.

A French aluminum company started Badin in 1912. The company came here to capitalize on the enormous hydroelectric potential of the Narrows of the Yadkin, where the Yadkin River narrowly squeezed between rock walls and dropped some ninety feet in a mile. World War I forced the company to sell the project to Aluminum Company of America, which completed the dam (and eventually built three more dams on the Yadkin) and the town. But the French influence had been established, evidenced today in the distinctive architecture of the town, and also in its name, after the president of the French company, Adrien Badin. In 1983, the National Register of Historic Places recognized Badin as a National Historic District.

The history of the Badin region goes far deeper than house styles. Just outside the town, an archaeological site recognized as a National Historic Landmark overlooks the Yadkin River. Called Hardaway, the site has relinquished nearly two million Native American artifacts, making it among the most significant archaeological discoveries in the nation.

As you might expect, access to the Hardaway site is strictly prohibited. But nearby is another significant archaeological site that is open to the public. Morrow Mountain State Park lies along our route, just down the road from Badin. At Morrow Mountain you can camp, hike, fish in Lake Tillery, take a dip in the swimming pool, picnic, and watch the sun setting from the summit of the park's namesake—all typical activities in our state parks.

What sets this park apart from most others is its archaeological history. Countless rock shards cover the summit of Morrow Mountain, the remains of an ancient quarry utilized by Native Americans. Modern analysis shows the rock to be metarhyodacite, more commonly known as rhyolite. Indians prized the rhyolite as their material of choice for arrowheads, scrapers, axes, and other stone tools. They came from all over the region, some traveling

Route **19**

Start out in the town of Badin, near Albemarle. Head south on Valley Drive. Drive 2 miles to Morrow Mountain State Park. Visit the park, then continue 3 miles on Valley Drive and turn left onto NC 73. Drive 17 miles, then turn left onto Indian Mound Road. Drive to Town Creek Indian Mound, then backtrack to NC 73 and turn left. Drive 11 miles, then turn right onto U.S. 220 south. Drive 1 mile to Ellerbe, then turn right onto Church Street. Follow it to the Ranking Museum. (*45 miles*)

OVERLEAF: Fishermen try their luck on Lake Tillery early in the morning.

Wall paintings decorate the interior walls of the Temple Mound hut at Town Creek Indian Mound State Historic Site.

considerable distances, to obtain the material. No evidence exists that Indians had permanent settlements at Morrow Mountain. Most likely they only quarried the rhyolite, breaking it into manageable chunks called cores and hauling those away for further processing. Most of the artifacts at the Hardaway site, for example, were made from Morrow Mountain rhyolite. How big was this operation? One geologist suggests that Morrow Mountain is covered with *millions of tons* of quarrying debris! You can easily see it for yourself by hiking the Mountain Loop Trail encircling the summit. Remember that everything is protected within the state parks. Collecting is strictly prohibited.

After whetting your archaeological appetite at Morrow Mountain, it's time for the main course at Town Creek Indian Mound. Like Hardaway, the Town Creek site is nationally significant for contributing to our understanding of Native American culture. The site served as a political and ceremonial center for Native Americans during the period archaeologists call the Pee Dee Culture, beginning around AD 1200. Unlike Hardaway, however, Town Creek Indian Mound is open to the public as a state historic site. Visitors can tour the reconstructed Major Temple atop an earthen mound, a smaller Minor Temple, and a burial house, all surrounded by a log palisade. The visitor center features interpretive displays and a slide program.

Now that you've had the main course, it's time for the dessert. For Native American and early American history buffs, it doesn't get much sweeter than the Ranking Museum of American Heritage in Ellerbe. The museum displays a remarkable collection from the fields of paleontology, natural history, regional cultural history, and general Americana. But most impressive are its archaeology displays, perhaps the finest in the state open to public viewing. The museum makes a fitting conclusion to our route of Native American influence in the Uwharrie Mountains.

OPPOSITE: A stockade fence frames a view of the Temple Mound at Town Creek Indian Mound State Historic Site.

PART IV

Deep History and Endless Water

The Northeast

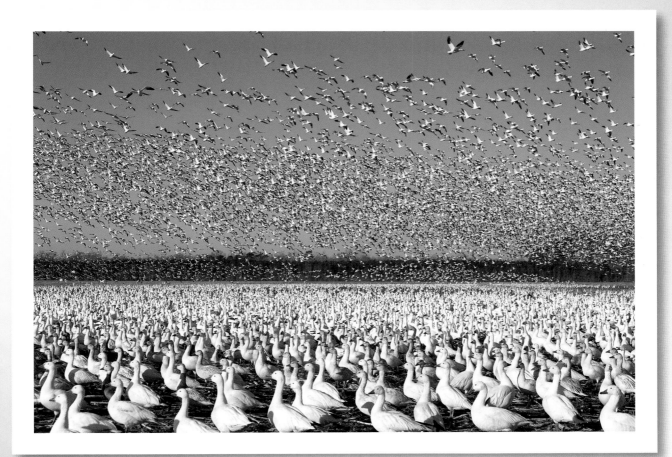

Tens of thousands of snow geese overwinter at Pocosin Lakes National Wildlife Refuge.

OPPOSITE: Swiss cannons overlook the waterfront of Edenton Bay in Edenton, North Carolina. The cannons were brought from France for use in defending North Carolina during the Revolutionary War.

The northeast section of North Carolina wonderfully blends rich history, spectacular scenery, outdoor recreation, wildlife viewing, shopping, and diverse culture. In was here in the northeast section that Noth Carolina became the first state to sign the Declaration of Independence, declaring its intent to secede from Britain. North Carolina's first town is in the northeast, and the first time man flew a powered machine, it happened here.

Water characterizes northeast North Carolina. Two major rivers, the Neuse and the Roanoke, flow through the region and empty into vast sounds. Pamlico Sound and Albemarle Sound, along with several smaller sounds, make up the second-largest estuary system in the nation (Chesapeake Bay is the largest). Albemarle Peninsula, which separates Albemarle and Pamlico sounds, provides some of the finest wildlife habitat in the country. Tens of thousands of ducks, geese, swans, and other migratory birds overwinter here or use the land as a stopover along their migration routes. Four national wildlife refuges protect critical habitat for these birds and other wildlife. At Alligator River National Wildlife Refuge, biologists made the first attempts to reintroduce the endangered red wolf into the wild as a self-sustaining population.

For most people, the defining characteristic of northeast North Carolina is the Outer Banks. Barrier islands occur along the entire coastline of the state, but the name Outer Banks refers only to the islands in the northeast and in Cape Lookout National Seashore. These thin ribbons of shifting sand are immensely popular—and packed—but by visiting during the off-season, you can still find relative solitude. Much of the islands are protected as part of Cape Hatteras National Seashore and Pea Island National Wildlife Refuge.

While tobacco is no longer the most valuable commodity in the state, North Carolina still grows more of it than any state in the Union. The northeast region contains a large share of tobacco farms.

ROUTE 20

Northern Route to Coast

EXPLORING HISTORY AND NATURE IN THE NORTHEAST

Everyone is in a hurry to get to the Outer Banks. They whiz along U.S. Highway 64, oblivious to the treasures that parallel their pathway to the north. And when the vacation is over, they are in an even bigger hurry to get back home. To borrow from Robert Frost, the goal with this route is to entice people to take the road less traveled, with the certain knowledge that it will make all the difference. Most people wouldn't travel such a long, serpentine route from start to finish unless their ultimate destination lay at the end. So this route is perfect for the hordes of people who vacation on the northern

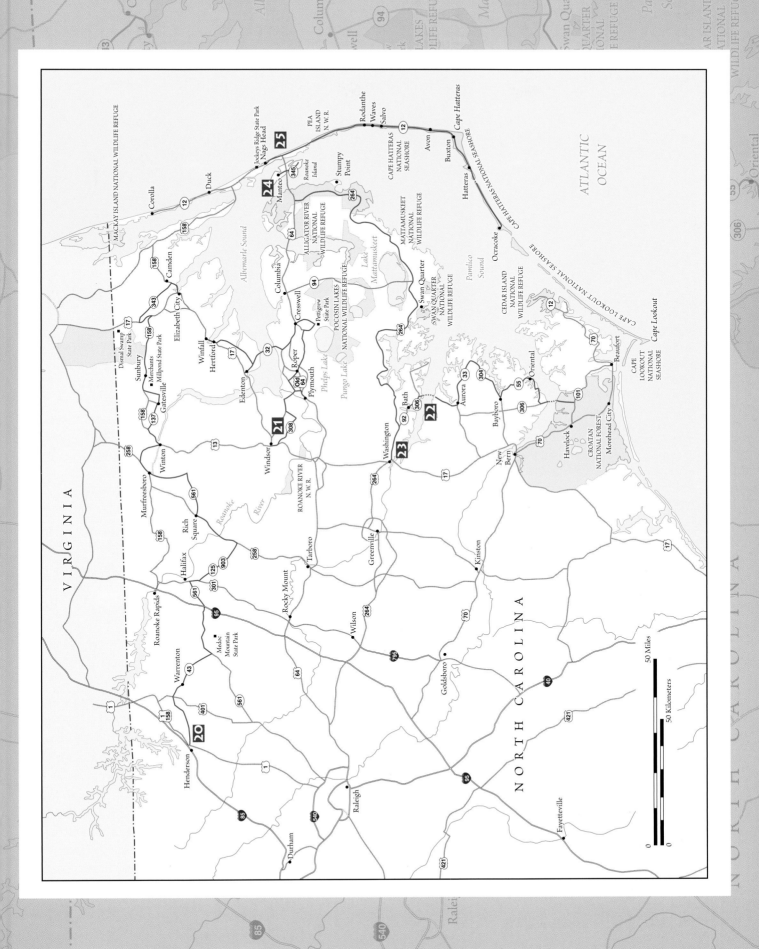

Parker's Ferry evokes the early days before bridges spanned North Carolina's rivers. Only three cable ferries remain operating in the state.

Route 20

Start out on Business U.S. 1/158, north of Henderson. Head west on Warrenton Road. Drive 14 miles to Warrenton, then turn left onto Main Street. Go a quarter mile, then turn right onto U.S. 158A. Go half a mile, then turn right onto NC 58. Drive 4 miles, then bear left onto NC 43. Drive 11 miles, then turn left onto NC 561. Drive 23 miles, then turn left onto U.S. 301. Visit Halifax, then backtrack and head south 2 miles and turn left onto NC 125/903. Drive 14 miles, then turn left onto U.S. 258. Drive 13 miles, then bear right onto NC 561. Drive 12 miles, then turn left onto Menola St. John Road. Drive 1 mile, then turn right onto Flea Hill Road. Drive 3 miles, then turn right onto Benthall Bridge Road. Drive 6 miles, then turn right onto Business U.S. 158 in Murfreesboro. Drive 1 mile, then turn left onto U.S. 258. Drive 5 miles, then turn right onto Parker's Ferry Road. Drive 8 miles, then turn left onto U.S. 158. Drive 1 mile, then turn left to remain on U.S. 158. Drive 4 miles, then turn right onto NC 137. Drive 8 miles, then turn right onto NC 37. Drive 3 miles, then turn left onto Millpond Road. Drive 4 miles, then turn right onto U.S. 158. Drive 20 miles, then turn left onto U.S. 17 north. Drive 1 mile, then turn right onto Business U.S. 17. Drive 1 mile, then turn right onto NC 343. Drive 12 miles, then turn right onto U.S. 158. Follow it 3 miles to Elizabeth City. (*180 miles*)

beaches. But be forewarned. Once you experience the cultural and natural history of northeastern North Carolina and the relaxed lifestyle of its people, getting to the beach might drop a notch on the priority list.

Nearly our entire course follows an official state scenic drive called Lafayette's Tour Scenic Byway, so named because the French general visited several places along the route during his 1825 tour of the country. The first town on the route, Warrenton, is an idyllic pedestrian town, the perfect size to explore on foot. Pick up a walking tour map in one of the local shops. Outstanding among Warrenton's attractions is its antebellum architecture, exceptional for a town this size.

The first of three state parks on this route is Medoc Mountain. At barely more than three hundred feet in elevation, "mountain" is a bit of a misnomer. In the 1830s, Sidney Weller established North Carolina's first commercial winery here. Weller's Vineyard eventually was renamed Medoc Vineyards, after the famous red-wine region of Bordeaux, France. After Weller's death, the Garret family operated the winery. Paul Garret, whose father had purchased the winery in the 1860s, began his own winery in 1900. His Virginia Dare label, using scuppernong grapes from vineyards all over the region—as well as from Medoc—became the bestselling wine in the nation. After Prohibition began in 1909, Medoc's vineyards gradually fell into decline. No trace of them remains today. Visitors to Medoc Mountain can enjoy hiking, canoeing, picnicking, and nature observation at one of the state's least-crowded parks.

Corn, tobacco, cotton, and soybeans line the road from Medoc Mountain to Halifax. (For that matter, they line just about *every* road in northeastern North Carolina.) Chartered in 1757 and made the seat of Halifax County in 1758, Halifax is situated along a broad

bend in the Roanoke River. Until the Revolution, the town grew rapidly as a center of commerce and politics. On April 12, 1776, delegates of the Fourth Provincial Congress took the first official action of any colony in declaring independence from Britain. The Halifax Resolves, as it became known, empowered North Carolina delegates in the Continental Congress to vote for independence with delegates from other colonies. On July 4 of that year, the North Carolina delegates—William Hooper, John Penn, and Joseph Hewes—signed the Declaration of Independence in Philadelphia.

After the Revolution, Halifax's prominence in the state gradually declined. Although still the county seat, only a few hundred people call it home. Halifax is a wonderful place to visit, however. Much of the town is part of the Historic Halifax State Historic Site, which includes several historic buildings. History buffs should plan to spend at least half a day to experience all the intriguing discoveries the town has to offer.

Scotland Neck, named for the Scot settlers of the early 1700s, is worthy of a little time touring back streets, as well as Main Street. The town's biggest attraction is one you wouldn't expect. How would you like to see an African pygmy goose? Or perhaps a Patagonian crested duck? Well, in Scotland Neck you can. The town is home to the Sylvan Heights Waterfowl Park and Eco-Center, a world-class breeding facility dedicated to the survival of waterfowl. More than 180 bird species breed here, including many of the world's rarest species of waterfowl. The best thing for visitors is that many of the birds live in open aviaries, providing close-up, unobstructed viewing.

From Scotland Neck to Murfreesboro, you drive through a land of cotton, interspersed here and there with a little tobacco and other crops. During November, after the cotton harvest, white clumps that have fallen off the trucks litter the roadside. It looks like someone drove by in a big truck tossing confetti all over the place.

To experience Murfreesboro fully, you'll need to get off Main Street. The Broad Street Historic District in particular has a fine collection of historic homes and other buildings, some open to the public. Just out of town, we'll make the first crossing of Meherrin River on a high, modern bridge. The second crossing will be a little different and a lot more fun. Parker's Ferry is one of three cable ferries still operating in North Carolina. Ferries have crossed this section of Meherrin River since long before the Civil War. The first one was called Jordan's Ferry; its name changed to Parker's Ferry around 1880. Cable ferries operate by pulling themselves along a steel cable stretched across the river. The crossing is loud, slow, and a little tense during storms. But it's always a fun and nostalgic journey.

The small village of Gatesville is the seat of Gates County, among the smallest of North Carolina's counties in both size and population. Size really doesn't matter, though, especially if swamps

are your thing. Just outside Gatesville is a jewel of the state parks system. Merchants Millpond is the quintessential southern swamp. Spanish moss hangs from trees that have huge swollen buttresses. Duckweed and water lilies cover the surface of the water. Turtles bask on stumps and logs. Nearly two hundred species of birds, from waterfowl to warblers, are recorded in the park. No other swamp, millpond, or blackwater river in North Carolina crams as much natural beauty into such a small area.

The cool thing is that Merchants Millpond State Park offers canoe rentals, so you don't have to bring your own boat. It also features two canoe camping areas, which allows you to paddle the millpond at night for an unforgettable experience. Astronomy buffs refer to areas with little artificial light pollution as having "black skies." The skies above Merchants Millpond are about as black as they come in this part of the country.

Part of the once-vast Great Dismal Swamp occupies the eastern end of Gates County. We'll travel through a few miles of the swamp shortly after leaving the community of Sunbury. To see more of it, make a short detour from our route and drive north on U.S. Highway 17 from South Mills. The new Dismal Swamp State Park lies a few miles up the road, just shy of the Virginia border.

In South Mills, cross the historic drawbridge and head south to Camden, the seat of Camden County. Camden is even smaller than Gatesville, with little more than a courthouse and a few buildings,

The quintessential southern swamp, Merchants Millpond makes a great place to paddle a canoe or kayak.

so don't be surprised if you drive right by without realizing it. If you get to U.S. Highway 158, turn around and drive back less than a quarter mile to see the courthouse on the west side of the road. Built in 1847, it is among the oldest courthouses in North Carolina still functioning as such. The 1910 Camden County Jail sits beside the courthouse.

Our route ends at Elizabeth City, less than five miles from Camden. This charming waterfront town owes its prosperity to its location on the Pasquotank River at the southern end of the Dismal Swamp Canal. The commercial district and waterfront are best explored on foot. Mariner's Wharf, on the waterfront, is a wonderful spot to watch the sunrise.

From Elizabeth City, northern beachgoers need to backtrack to Camden and then head east on U.S. 158. Those heading to southern beaches can take U.S. 17 south out of Elizabeth City.

Watching the sunrise from the Elizabeth City waterfront is always a memorable experience.

ROUTE 21

Albemarle Tributaries

RIVER TOWNS OF THE CASHIE, CHOWAN, ROANOKE, AND PERQUIMANS

Route **21**

Start out on U.S. 17/13 in Windsor. Head south for 2 miles, then turn left onto Woodard Road. Drive 12 miles, then turn right onto NC 308. Drive 7 miles to the first intersection beyond Roanoke River. Turn right and visit Plymouth, then backtrack and proceed straight on NC 308 east. Drive 2 miles, then turn right onto Woodlawn Road. Drive 3 miles, then turn right onto Cross Road. Drive into Roper and turn left onto Old U.S. 64. Drive half a mile, then turn right onto Newland Road. Drive 11 miles, then turn right onto Weston Road. Drive 4 miles to Pettigrew State Park, then take Thirty-Foot Canal Road. Drive 4 miles, then turn left onto County Road 1142. Drive 2 miles to Creswell, then turn right. Drive half a mile, then turn left onto Old U.S. 64. Drive 8 miles, then turn right onto NC 32. Drive 11 miles to where Yeopim Road cuts back to the right. Continue straight for 2 miles to Edenton, then backtrack and take Yeopim Road. Drive 8 miles (road name changes), then turn right onto Snug Harbor Road. Go a quarter mile, then turn left onto Pender Road. Drive 4 miles, then turn left onto Harvey Point Road. Drive 4 miles, then cross over U.S. 17 into Hertford. Continue through town on Business U.S. 17, then turn left on NC 37. Follow it to Winfall. (*100 miles*)

Idyllic small-town charm, rich history, and pastoral beauty characterize the upper reaches of Albemarle Sound. The drive suggested here, while touching on some of the chief attractions of the area, is only one choice among many good options. An official state byway, the Edenton-Windsor Loop Scenic Byway, follows a shorter and different route that, while visiting fewer towns, guides the traveler to some other scenic options.

We begin in the small town of Windsor on the Cashie River. Most people bypass the town on U.S. Highway 17 or U.S. Highway 13, but since we know better, we'll get off these main roads and explore the heart of the town. Settled in 1772, Windsor is named for Windsor Castle in England. If you have a pair of strong legs, you can navigate the entire town in about an hour and visit the fine collection of eighteenth-, nineteenth-, and twentieth-century houses along King Street. A worthwhile detour from the main route is to take NC Highway 308 west out of Windsor for about four miles to the 1803 Hope Plantation.

From Windsor, we travel through open farmland to the first crossing of the Cashie River on the Sans Souci Ferry. The name comes from the French and means "without concern." Like Parker's Ferry in Route 20, Sans Souci is a cable ferry. Its original perfunctory role—of getting vehicles and passengers from point A to point B in the quickest amount of time—no longer applies. Today, people drive *out of the way* just to cross on the ferry. Nostalgia and scenic backwoods splendor have a way of doing that to people. Besides, who could resist a ride on a ferry called Sans Souci?

A few miles from Sans Souci, you come to the second crossing of the Cashie River, followed immediately by the Middle River and the Roanoke River. The high vantage point of the overpass provides a great view for the passenger, but it's not safe to stop on the bridge.

Civil War buffs will love Plymouth, the next town on our route. Situated beside the Roanoke River, Plymouth was the site of the second-largest Civil War battle in the state. Union forces occupied Plymouth in May 1862. In April 1864, Confederates, under the command of twenty-six-year-old General Robert F. Hoke, recaptured the town in the Battle of Plymouth, helped immeasurably by the ironclad CSS *Albemarle*. Later that year in October, a gutsy move by twenty-one-year-old Navy Lieutenant William Cushing sank the *Albemarle*, and Plymouth once again fell to Union forces. The town remained under Union control until the end of the war.

Because of the heavy fighting, few antebellum structures remain in Plymouth. However, the town has a nice collection of early-twentieth-century buildings, all easily viewed along the town's official walking tour. Must-sees are the replica Roanoke River Lighthouse, the Maritime Museum, and the Port O' Plymouth Museum, the latter a fine Civil War museum. Plymouth also boasts a scale replica of CSS *Albemarle* anchored at the waterfront.

From Plymouth, we backtrack to NC Highway 45 and head for the community of Roper. Watch for the tunnel created by the row of old oak trees lining the road. After passing through Roper, the land opens wide and for the next several miles you pass through a major agriculture district, with soybeans and corn as far as the eye can see.

Cypress Point is a great spot to view the sunrise over Lake Phelps in Pettigrew State Park.

The kitchen is one of several buildings open to visitors at Somerset Place State Historic Site on Lake Phelps. The antebellum Collins Mansion House is visible through the window.

Pettigrew State Park is a hidden gem of the North Carolina parks system. Lake Phelps, which lies entirely within the park boundary, is the state's second-largest natural lake at over sixteen thousand acres. Sitting at a higher elevation than the surrounding land and having no springs to feed it, the lake depends entirely on rainfall. As such, its water is relatively clean and usually crystal clear. Some thirty ancient dugout canoes have been discovered buried in the lake bottom. Radiocarbon analysis dates the canoes from 2430 BC to AD 1400. That makes the oldest one more than four thousand years old! Most of the canoes still lie buried, but some have been removed and are on display at the park.

Pettigrew has a lot more to offer than just Lake Phelps, though. Surrounding the lake are dense pocosin, cypress, and hardwood forests. Some of the trees here are so large they are state and national champions. Hiking and biking paths lead through these old-growth forests. The park also offers camping and picnicking facilities, in addition to fishing and boating on the lake.

Next door to Pettigrew State Park and also on the lakeshore is Somerset Place State Historic Site. Begun as a rice plantation in the late 1700s and built on the backs of slave labor—many brought directly from Africa—Somerset became one of the most prosperous plantations in antebellum North Carolina. At one point, more than eight hundred slaves lived here. Somerset thrived until the Civil War, after which there was no one left to work the land.

During the days of horse-drawn wagons, stately elm trees lined the streets of Edenton. This circa-1900 view shows Main Street, renamed Broad Street sometime in the early twentieth century. *North Carolina Collection, University of North Carolina Library at Chapel Hill*

From Somerset Place, we drive to Creswell on Thirty Foot Canal Road, alongside a canal dug by slave labor for the rice plantation. This canal was used to drain the farmland. Transportation Canal, paralleling Thirty Foot Canal to the east, was used for transporting the rice to market by way of the Scuppernong River into Albemarle Sound. Creswell, at the end of the canals, is a tidy little village with a wide main street possessing a fine collection of nineteenth-century wood-frame buildings.

From Creswell, our route takes us over the Albemarle Sound on the second-longest bridge in North Carolina at over 3 miles long. (The new Virginia Dare Bridge over Croatan Sound is the longest at 5.2 miles). A few miles later, we come to historic Edenton, known as "the South's prettiest town." Situated at the head of Edenton Bay, this delightful town begs you to find a parking place and explore on foot. Established in 1712 and left mostly intact during the American Revolution and

A cannon display sits on the lawn of the Barker-Moore House in historic Edenton. Edenton Bay is in the background.

Originally constructed in 1782 at a point farther up the street, Edenton's Barker-Moore House was moved to the waterfront in 1952 and now serves as a visitor center.

the Civil War, Edenton has a fine collection of historical architecture. Two buildings, the Cupola House (1758) and the Chowan County Courthouse (1767), are National Historic Landmarks. The visitor center at Historic Edenton State Historic Site has maps and all the information you need to get the most out of your visit. They offer guided walking tours throughout the day.

Some of the region's most scenic farmland lies along our route between Edenton and Hertford. Grand old farmhouses surrounded by large trees sit as islands in the sea of corn, cotton, and soybeans. A couple of miles before Hertford is the Newbold-White House (circa 1730), believed to be the oldest brick house in the state. The house and grounds are open for tours.

Hertford and the neighboring community of Winfall make a fitting end to our Albemarle route. History and scenery blend wonderfully here. The picturesque S-shaped bridge over the Perquimans River, built in 1928, is said to be the only one like it in the nation.

ROUTE 22

History and Prehistory

BATH, AURORA, ORIENTAL

North Carolina's first town makes a fitting start for this historical tour. Incorporated in 1705 on a grid drawn by early explorer John Lawson, Bath sits on a small point overlooking picturesque Bath Creek. Though once an important political and social center, the little village never grew much larger than Lawson's original plan. It's easy to see that the people here like it that way.

Historic Bath State Historic Site occupies the heart of Bath. A splendid walking tour guides visitors to an impressive collection of eighteenth- and nineteenth-century buildings and to scenic views of Bath Creek. Among the notable buildings are St. Thomas Episcopal Church, the oldest church building in the state (1734), and the Palmer-Marsh House (1750), which is a National Historic Landmark.

The first of two ferry rides on our route takes you across the Pamlico River. Like most ferry trips in North Carolina, the ride is

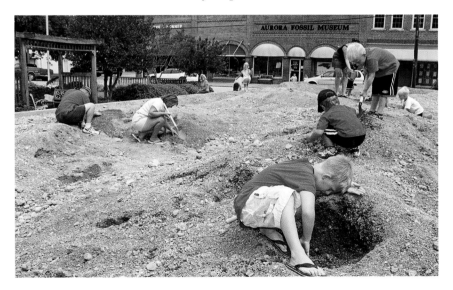

relaxing and scenic. After landing on the south shore, however, your senses are in for a bit of jarring. For the next few miles, you will drive through the largest industrial mining complex in the state. PCS Phosphate operates its Aurora plant here, mining the fossil-rich Castle Hayne formation for phosphate for use in fertilizer and food additives. The operation is so enormous that the History Channel featured it on a *Modern Marvels* episode. Don't plan to stop for any pictures though; you'll barely get your camera to your eye before a guard stops you and sends you on your way. So just drive through

Route 22

Start out in Bath. Head east on NC 92. Drive 6 miles, then take the Bayview-Aurora ferry across Pamlico River. Drive 7 miles on NC 306, then turn left onto NC 33. Drive 16 miles (road changes to NC 304) to Bayboro, then turn left onto NC 55. Drive 10 miles to Oriental Road. Drive 3 miles on Oriental Road, then turn left onto Janeiro Road. Drive 6 miles to NC 306, then turn left. Follow it 2 miles to the Cherry Branch-Minnesott Ferry. (*60 miles*)

Kids love searching for shark's teeth and other fossils at the Aurora Fossil Museum.

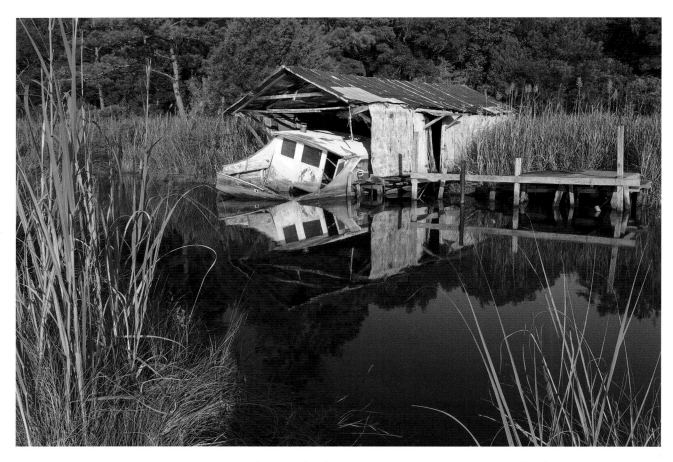

Abandoned boats are a common sight on the canals and marshes of the coastal plain. This dilapidated boat and boathouse lie on a canal near Bayboro.

and marvel at how one company can so alter the landscape. If you're wondering, yes, the mine creates enormous environmental problems. And if the company gets its way, it will soon begin mining thousands of additional acres in the largest single destruction of wetlands in North Carolina history.

Leaving these pleasant thoughts behind us, we drive into the little village of Aurora. Interestingly, were it not for the phosphate mining operations, this back-of-the-backroads hamlet might have been forgotten to the world. Millions of years ago, the sea covered Pamlico Peninsula. When the ocean receded, it left behind not only the phosphate but also an incredibly rich deposit of fossils. The Aurora Fossil Museum displays fossils retrieved from the mine and tells the prehistoric story of the North Carolina coastal plain. The museum's collection is among the finest on public display in the country. Outside the museum are piles of material brought in from the mine, where adults and kids alike enjoy searching for shark's teeth and other fossils.

If Aurora is considered off the beaten path, the route between it and Bayboro is what early-twentieth-century writer Horace Kephart might have called "the back of beyond." You'll want to drive slowly and savor this slice of remote eastern North Carolina. Make sure you turn off the main route to explore the end-of-the-road

communities of Hobucken, Lowland, and, especially, the quaint fishing village of Vandemere. As the locals like to say, "Vandemere is a destination, not a pass-through." From the little Pamlico County seat of Bayboro, our route follows NC Highway 55 to Oriental. Like the section from Aurora to Bayboro, a little exploring off the main route is well worth it.

Oriental is a sailor's town, proudly proclaiming more boats than residents. Three times more, in fact. Idyllically situated on the Intracoastal Waterway where five creeks (Whitaker, Kershaw, Greens, Smith, and Raccoon) meet at the Neuse River, this village overflows with small-town charm and striking beauty. Yet it has somehow managed to avoid most of the trappings of modern society. You'll find no stoplights, no fast food, and no traffic jams–unless you count the occasional tight encounters of the sailboats. Truth is, it seems almost a sacrilege to drive a car through here. To borrow from Nancy Sinatra, Oriental's streets were made for walking. But you don't need to be wearing boots.

Our route officially ends with a ride across the Neuse River on the Cherry Branch-Minnesott Beach Ferry. If you turn left a couple miles from the ferry landing, NC Highway 101 brings you to Beaufort and the beginning of Route 26.

With three times more boats than residents, Oriental teems with sailboats.

Route 23

Start out in Washington on U.S. 264. Drive east to U.S. 64 near Manteo. (*115 miles*)

Snow geese are a common sight at Pocosin Lakes National Wildlife Refuge.

ROUTE 23

For the Birds

A DRIVE THROUGH THE ALBEMARLE PENINSULA

For many travelers along U.S. Highway 264, the road is nothing more than the quickest route to the Outer Banks. In their haste to get to the beach, they whiz right by striking scenery, towns rich with historical significance, and some of the finest wildlife viewing in the state.

Washington, where we begin our route, changed its name from Forks of the Tar in 1776, becoming—according to townspeople—America's first town named after George Washington. Ideally situated on the Pamlico River, the town became an important port during the Revolution when other Southern ports were under control by the British. Washington also saw considerable action during the Civil War. While no longer a significant port, the town still boasts an impressive collection of late-nineteenth- and early-twentieth-century architecture. And its waterfront is still a bustle of activity—with sailors, joggers, bicyclers, sightseers, and sweethearts watching the sunset over the river.

As you drive out of Washington, you leave behind just about everything urban for the remainder of the route. For the next hundred miles, you'll encounter just a couple of stoplights and fast-food restaurants.

At Pantego, you'll want to make a side trip to Pocosin Lakes (formerly Pungo) National Wildlife Refuge. The first of four wildlife refuges on the route, Pocosin encompasses some 110,000 acres of wildlife habitat. Over forty species of mammal call the refuge home, including black bear, bobcat, coyote, white-tailed deer, and the federally endangered red wolf, as do a diversity of reptiles and amphibians. But it's the more than two hundred species of bird that make the refuge famous. The best time to visit is from early December through February, when you can see large numbers of waterfowl, raptors, and red-winged blackbirds. This is probably the best location in the East to see snow geese. Up to eighty thousand of the birds overwinter at the refuge, creating an astonishing show at sunrise when they fly into the fields after roosting for the night.

A few miles from Pantego is the small town of Belhaven, home to the most unusual museum in the state, if not the country. The Belhaven Memorial Museum, occupying the second floor of the historic 1911 City Hall building, displays a collection of, well, just about everything. There's a pig preserved in a jar, German helmets and a machine gun from World War II, a human skeleton, thirty thousand buttons, a ten-pound tumor removed from a local woman, a display of toenails and tonsils, Civil War memorabilia (no

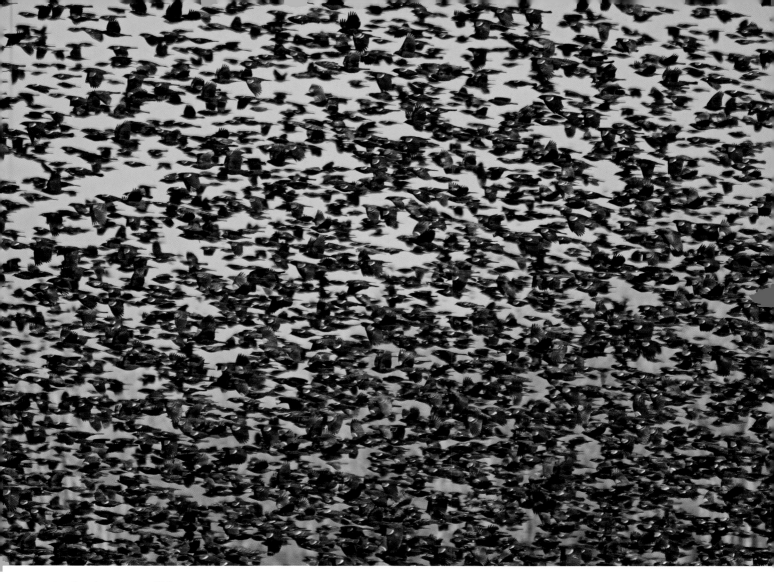

Thousands of red-winged blackbirds flock at Pocosin Lakes National Wildlife Refuge.

doubt there's stuff from *every* war), seashells, clothes, books, pottery, rocks, archeological artifacts, antique dolls, and a dress worn by a 700-pound woman. The museum literally has tons and tons of . . . *stuff.* The museum even has two fleas (yes, fleas) dressed as a bride and groom, viewable under a magnifying glass.

Swan Quarter is definitely worth a detour off the main route. The tiny maritime village remains largely untouched by modern trappings, its residents still earning a living from the sea and the surrounding farms. Be sure to drive out past the seafood houses to the viewpoint over Swanquarter Bay. Swanquarter National Wildlife Refuge occupies much of the marsh and associated waters in the area, but it is not user-friendly to those without a boat.

Mattamuskeet National Wildlife Refuge, just up the road from Swan Quarter, is among the best wildlife refuges in the country for scenic beauty and wildlife viewing. The refuge consists of open water, marsh, timberlands, and crop fields, with the vast majority being Lake Mattamuskeet. At eighteen miles long and six miles wide, it's the largest natural lake in North Carolina. The lake averages only a little more than two feet in depth and the lake bed is said to have

soil that is among the richest in the world. Many early attempts were made to drain the lake, the grandest effort culminating in 1916 with the completion of the massive pumping station that still stands on the south side of the lake.

A visit to the refuge should begin on NC Highway 94 with a drive along the six-mile causeway that transects the lake. Numerous breaks in the vegetation provide good views of the lake and birdlife. The best view along the causeway is from a boardwalk extending a short distance into the lake, with a viewing gazebo at the end. A small island of cypress trees sits in the lake in front of the overlook, and you can often see bald eagles in the trees. In November, you can always see waterfowl of some kind on the lake. This view is especially scenic at sunrise and sunset.

After exploring along the causeway, turn off NC 94 onto the refuge entrance road. The two-mile drive offers exceptional wildlife viewing opportunities, particularly in early morning and late evening. Near the end of the road, just before the old lodge, is the refuge headquarters, where you can pick up a map and ask questions. From here, you can walk around and explore the lodge building. When viewing the lodge in a photograph, persons not familiar with the history of the lake often mistake the 120-foot smokestack for a lighthouse.

Lake Landing Historic District, designated by the National Register of Historic Places, stretches along several miles of U.S. 264 near Lake Mattamuskeet and follows backroads through the communities of Middleton, White Plains, and Nebraska. The district features numerous nineteenth- and early-twentieth-century farmhouses, churches, and abandoned stores. This is plantation country, with fields of corn, cotton, and soybeans stretching to the horizon. It's also white-tailed deer country. Drive through here at dawn and dusk and the question is not will you see any deer, but whether you can slow down quickly enough when they cross the road in front of you. Slow speeds and alert eyes are called for. The maritime village of Engelhard, a few miles northwest of the historic district, also features interesting historical architecture, as well as scenic amenities associated with the waterfront.

Most of the nearly forty-mile stretch between Engelhard and U.S. 64 passes through the fourth wildlife refuge on this route, Alligator River. Like all national wildlife refuges, its mission is to provide habitat and safe haven for wildlife. But Alligator River National Wildlife Refuge also offers superb recreational opportunities. Its dirt roads and walking trails provide access for wildlife viewing, and a network of paddling trails takes canoeists and kayakers into the backcountry for an unforgettable experience. Lucky visitors might hear the howls of the endangered red wolf, reintroduced at Alligator River in the late 1980s.

The smokestack on the massive pumping station at Lake Mattamuskeet resembles a lighthouse.

The best access to Alligator River NWR is not directly along our route. When you get to U.S. 64 (route's end), turn left and drive a little over four miles to the Creef Cut Wildlife Trail, where you can pick up a refuge map and other information. A right turn on U.S. 64 brings you to Manns Harbor, the start of Route 24.

Mysteries and Maritime Heritage

A TOUR OF ROANOKE ISLAND

Route 24

Start out at the west end of Virginia Dare Memorial Bridge near Manteo. Head east on Business U.S. 64. Drive 10 miles, then cross over the intersection with U.S. 64 onto NC 345. Follow it 5 miles to Wanchese. (*15 miles*)

At fifteen miles, this is the shortest route in the book. But those miles are packed with enough beauty, history, and maritime heritage to keep you engaged for as long as you like. You could drive the route straight through in about thirty minutes. But to see and experience everything to even a moderate degree requires at least a couple of days.

Prior to the summer of 2002, it would have been a stretch to call this a "backroad." With thousands of vehicles passing through daily on their way to the Outer Banks, Manteo had become a frustrating place to visit, and that's being kind. That all changed when the new Virginia Dare Memorial Bridge opened across Croatan Sound, bypassing Manteo altogether. Our route begins at the bridge in Manns Harbor, but instead of crossing it on the new Bypass U.S. Highway 64, we're going to head north on the old U.S. 64. Of course, no one is going to come here without crossing the state's longest bridge (5.2 miles) at least once, so you can either go ahead and get it out of your system now, or wait until later in the route when we get close to it on the other side.

Manns Harbor typifies a small fishing village abandoned by late-twentieth-century economies. Most everyone here is bound to the sea, but for most, it is an avocation. Only a few crusty residents still earn a living from fishing and shellfishing. Turn off the main road onto Old Ferry Dock Road and drive out to the abandoned ferry landing, where you will find abandoned boats, stacks of crab pots, old nets rotting in the sun, collapsing fish houses, and boat parts scattered everywhere.

The William B. Umstead Bridge over Croatan Sound opened in 1957, eliminating the need for a ferry to cross the sound. For forty-five years, the bridge served as the main artery between the mainland and Roanoke Island and the beaches beyond. When the Virginia Dare Memorial Bridge opened in 2002, Umstead Bridge was left to the birds. Actually, the birds had already claimed the bridge, but the heavy vehicle traffic was making their life difficult. The birds we're talking about are purple martins. Thousands of them. Tens of thousands of them. During the summer, the birds migrate some 150 miles to roost on the bridge. At sunset, they gather in incredible flocks and swarm around the bridge before settling in for the night. This little-known event makes for a spectacular wildlife-viewing scene.

The purple martins begin arriving in mid-June and remain until late August. The peak period, with up to 100,000 birds, occurs from about mid-July until the third week of August. With so many birds flying around the bridge during the peak tourist season, it's not surprising that deadly encounters happen on a regular basis. (The tiny two-ounce birds are no match for two-ton SUVs.) The new bridge has lessened the traffic, and flashing lights warn people to slow down, but the crashes still occur at an alarming rate. Concerned groups have petitioned the North Carolina Department of Transportation to install barrier fencing along the bridge (paid for by outside financing). Their efforts have largely fallen on deaf—one might say dumb—ears.

To see this incredible spectacle, park at the west end of the bridge about thirty minutes before sunset and wait for the birds' arrival. At sunrise, the birds tend to fly directly away from the bridge, but at sunset they gather in a swarm and fly in circles before settling down.

It would take an entire book to discuss adequately the historical, aesthetic, and recreational attributes of Roanoke Island. Indeed, many books *have* been written about the island. The intent here is merely to mention some of the highlights to get your juices flowing. You'll want to do more research to get the most out of your trip.

Roanoke Island is, of course, the believed location of the Lost Colony, the failed English attempt at settlement in the New World in 1587. Fort Raleigh National Historic Site interprets this rich history. Next door is the Waterside Theater, where the famous outdoor drama

The Lost Colony has been entertaining guests since 1937. The famous outdoor drama depicts the failed attempt at English settlement in the New World in 1587.

The Lost Colony has been presented since 1937. Also adjacent to Fort Raleigh is Elizabethan Gardens, created in 1951 by the Garden Club of North Carolina as a living memorial to the first colonists.

The North Carolina Aquarium on Roanoke Island is one of three aquariums operated by the state. Although worthy of a visit at any time, the aquarium is an especially good place to go in the middle of a hot summer day or when thunderstorms threaten outdoor activities.

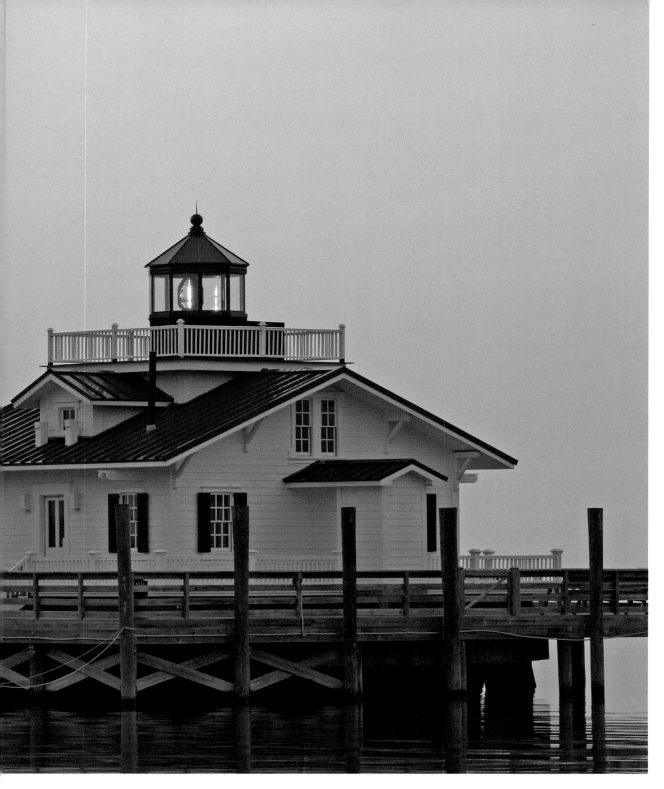

"Downtown" Manteo is a pedestrian utopia. Shops, restaurants, old buildings, maritime history, and the scenic beauty of a village waterfront blend wonderfully in this place. Here you experience North Carolina's maritime heritage in the George Washington Creef Boathouse and explore the reconstructed Roanoke Marshes Lighthouse.

Roanoke Island Festival Park lies on a small island just across from the Manteo waterfront. Administered by the North Carolina Department of Cultural Resources, the park provides a "living

The rising sun complements the replica Roanoke Marshes Lighthouse on Roanoke Sound in Manteo.

Before the William B. Umstead Bridge opened in 1957, the only way for travelers to get across Croatan Sound was by ferry. This photograph shows the ferryboat *Governor Cherry* docked at Manteo. *Aycock Brown, The Outer Banks History Center, Manteo*

The *Elizabeth II* at Roanoke Island Festival Park is a replica of the sixteenth-century sailing vessels used to bring colonists from England to the New World. This image shows a close-up view of the rigging.

Net pulleys and rigging on an old fishing boat at the Wanchese harbor contrast with the clear blue sky.

history" experience for visitors. At the Settlement Site, you can watch and interact with interpreters who demonstrate blacksmithing, shingling, carpentry, and other jobs required of the early colonists. The park's biggest draw is *Elizabeth II*, an accurate representation of the sixteenth-century sailing vessels used to transport the colonists. You can view the ship easily from the Manteo waterfront, but an on-deck experience is part of the Festival Park entry fee.

While the northwestern end of Roanoke Island represents North Carolina's earliest colonial history, Wanchese, at the southeastern end, offers a glimpse into the rich fishing heritage of the state. In fact, Wanchese may be the best example in the state of a real working fishing village. People here have always earned their living from the sea. If you spend any time getting to know them, it's plain to see they like it that way and will fight any attempts to change their way of life. So don't expect any fast-food restaurants or miniature golf courses. At the same time, don't expect any stereotypical postcard scenes either. The beauty of Wanchese lies in the salt-wrinkled skin and dark suntans of hardworking people earning a living as their fathers and grandfathers did.

ROUTE 25

Ribbon of Sand

THE OUTER BANKS FROM NAGS HEAD TO OCRACOKE

Unquestionably, North Carolina's most idyllic mountain drive is the Blue Ridge Parkway. On the coast, that honor falls to NC Highway 12 from Nags Head to Ocracoke. Most of the drive passes through Cape Hatteras National Seashore and Pea Island National Wildlife Refuge. On the east side are wide sandy beaches; to the west are picturesque marshes, mud flats, and the expansive Pamlico Sound. Along the way are three lighthouses and numerous other historical sites. If you can ignore the fact that NC 12 can get mighty crowded in the tourist season, this drive is among the best there is along the entire Atlantic seaboard.

While you could drive this route in less than three hours, why would you want to? People come here to spend their entire vacations and hate to leave. So do yourself a favor and plan to spend as much time as you can. You should also study up before the trip so you don't miss any of the natural and historical features. Literature abounds about the Outer Banks and an Internet search will turn up more pages than you could read in a lifetime.

Route **25**

Start out in Nags Head. Drive south on NC 12 to the village of Ocracoke. *(47 miles)*

Morning twilight is often colorful at Bodie Island Lighthouse in Cape Hatteras National Seashore.

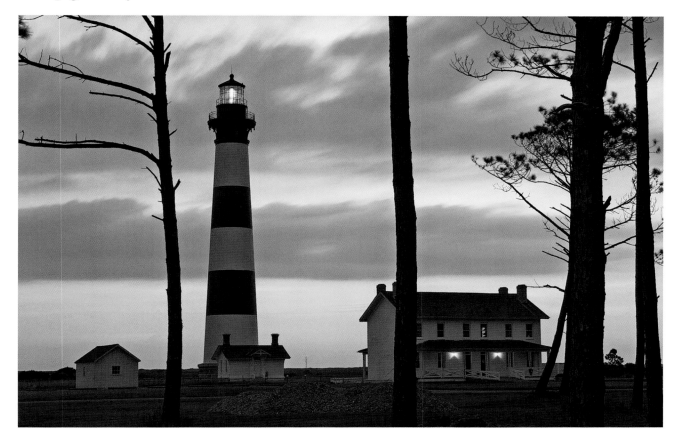

The setting sun casts a warm glow on the charter-fishing boats at Oregon Inlet Fishing Center.

The first stop for many visitors is Bodie Island Lighthouse, located about six miles south of Whalebone Junction. Pronounced "body," it makes a great photo subject because you can view it from so many different vantage points. In fact, one of the best views is from the main highway, where you can watch the sun setting beside the lighthouse. You can tour the keeper's house, but the lighthouse itself is presently closed due to structural defects. From the southwest end of the lighthouse loop road, a sandy path goes a short distance to the Pamlico Sound, providing a reprieve from the tourist crowds and an intimate view of the marsh system. The Bodie Island Dike Trail branches off from the sand road and follows an old dike to NC 12. Be sure to pick up the interpretive map from the visitor center before hiking this trail.

You might wonder why anyone would build a lighthouse so far from the water. The answer is that no one did. When constructed in 1872, Bodie Island Lighthouse stood beside Oregon Inlet. Since it

first opened, the inlet has moved some two miles toward the southwest. The best way to see this process is to drive the Herbert Bonner Bridge over Oregon Inlet. Notice how the first mile of the bridge spans sand flats and marsh and then ends abruptly on the opposite shore. The inlet wants to keep moving south, cutting into the north end of Pea Island, but rock walls built by the Army Corps of Engineers are halting it. The controversial efforts at controlling the inlet and maintaining the aging bridge are temporary at best. Plans are being considered for some type of new bridge, possibly bypassing Pea Island altogether on a route through Pamlico Sound.

If you're a birder, or have any notion of becoming one, you'll want to spend some time at Pea Island National Wildlife Refuge. Various species of shorebirds are seen throughout the year. During the peak autumn migration period (September and October), the refuge hosts impressive numbers of raptors and warblers. By November, the waterfowl take center stage, with snow geese a prominent species. In all, more than 360 bird species make the list for this small (5,834 acres) refuge. The North Pond Wildlife Trail begins from the refuge visitor center and makes a loop around the impoundment. It starts out at a small pond that is usually full of turtles and then follows the south end of the main pond to a couple of overlooks. Be sure to bring binoculars and a bird guide.

A few miles from the visitor center, you'll see the wooden remains of the bridge that once crossed New Inlet, which closed naturally in the 1930s. Inlets have been opening and closing along the Outer Banks as long as the islands have been here. Barrier islands are dynamic structures, constantly changing and shifting with winds and storms. Back in the 1930s, the government thought they could do something about that. The CCC constructed an artificial dune system from the Virginia line all the way south to Ocracoke Island. The shoreline dunes you see today are the result. Once the islands had been "stabilized," people gradually started building roads and houses. In the last few decades, this development has reached absurd proportions. The trouble is that the dunes haven't stabilized the islands; they have only altered the natural equilibrium of the ecosystem. In many circumstances, the dunes have increased the likelihood of greater storm damage.

The small villages of Rodanthe, Waves, and Salvo lie at the end of Pea Island National Wildlife Refuge. A good stop in Rodanthe is the historic Chicamacomico Life Saving Station. From Salvo, it's about twelve miles to the next small village, Avon. A few miles south of Avon, look out on the sound side for Haulover Day Use Area. Known locally as Canadian Hole, this section of Pamlico Sound is world-famous among windsurfers and kiteboarders, many driving down from Canada. The winds are best in spring and fall, but expect to see people here anytime the wind is blowing.

Just beyond Canadian Hole is the village of Buxton, carved out of Buxton Woods. The largest maritime forest in the state, Buxton Woods is a nationally significant natural area. Hike the Buxton Woods Nature Trail for an up-close view of this special place. Of course, the real reason everyone comes to Buxton is to see the Cape Hatteras Lighthouse. "America's Lighthouse," as it's often called, is possibly the tallest brick lighthouse in the world. Its exact height is a matter of debate. The oft-cited figure of 208 feet supposedly refers to the distance from mean sea level to the top of the beacon's lightning rod, which doesn't exactly seem like a fair measurement. The Coast Guard measures the distance from the high-tide line to the focal plane of the light. That measurement is 191 feet. Though modern navigational aids have rendered the lighthouse mostly obsolete, the Cape Hatteras Light once served an invaluable role in guarding ships from the treacherous Diamond Shoals off Cape Point.

It's a leisurely mile-long walk through soft sand to Cape Point— the Point, as the locals call it—or a quick ride if you have a four-wheel-drive vehicle. Diamond Shoals extends some ten miles out from the cape and separates the water of the cold Labrador Current from the north and the warm Gulf Stream from the south. Cape Point might be the most popular and well-known surf fishing spot on the East Coast. Come here in the fall or when the "blues are running," and you'll have to fight for elbow room to cast. Tangled lines are a common occurrence.

Surf fishers crowd the beach during sunset at Cape Point in Cape Hatteras National Seashore.

Between the villages of Frisco and Hatteras, you'll drive over a newly paved section of road where the island narrows and the vegetation on each side is sparse. In 2003, Hurricane Isabel came ashore and ripped a new inlet here. Coastal geologists warn that this spot is extremely vulnerable to experiencing the same thing during another storm.

THE MOVE OF THE CENTURY

IN A DRIVE ALONG North Carolina's Outer Banks, you don't require exceptional powers of observation to see that what the sea wants to do, it does. Any attempts on our part to control it work about as well as sticking the proverbial finger in the dam.

Fortunately, that's what the engineers were thinking when they decided that the best way to protect Cape Hatteras Lighthouse from the threatening sea was to move it out of the way. They studied many options, among them rock jetties, an encircling seawall (in which case the lighthouse would eventually sit on an island), and floating seaweed mats to control the surf. But the problem was that the lighthouse foundation sat on a short stack of yellow pine timbers constantly immersed in fresh water. When the sea won its battle, as it inevitably would, saltwater would seep to the foundation, causing the timbers to rot. Nothing could save the lighthouse once that happened.

So the National Park Service accepted the conclusion made by the National Academy of Sciences and prepared to move the lighthouse to a safe inland site. They hired International Chimney Corporation of Buffalo to make the move. The company excavated the foundation, separated the tower from its lower granite plinth, and inserted a temporary support system of steel beams, one hundred hydraulic jacks, and special rollers. They cleared a flat, level path and laid down a short row of steel I-beams for the rollers to move on. Hydraulic jacks pushed the lighthouse over the steel-beam mat, and once it had cleared a section of beams, workers moved them to the front of the line. In this manner, the steel mat was "leapfrogged" along the 2,900-foot path. Computers controlled the entire process.

At 3:05 p.m. on June 17, 1999, the Cape Hatteras Lighthouse began its journey to its new home, where it arrived safely at 1:23 p.m. on July 9. The move, expected to take up to six weeks, had been completed in only twenty-three days. District Ranger Steve Ryan wrote a citation to an official from the moving company for exceeding the posted speed limit for the lighthouse.

During the twenty-three-day voyage, Cape Hatteras Lighthouse became America's superhero. All the major networks covered the event, live webcams broadcast the progress, airplanes filled with photographers flew overhead, and thousands of visitors witnessed the event firsthand from viewing areas set up along the course. In the months that followed, books were written and videos were produced. In May 2000, NATIONAL GEOGRAPHIC covered the story. Moving America's Lighthouse truly was the Move of the Century.

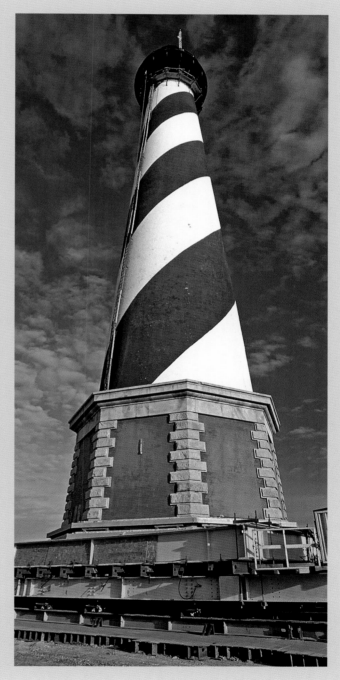

The setting sun illuminates Ocracoke Lighthouse in Ocracoke Village.

OPPOSITE: The beaches on Ocracoke Island provide the perfect getaway.

For many people, Hatteras is the favorite of the northern Outer Banks villages, with its relatively subdued development, picturesque marinas, and soundside views. At the south end of Hatteras, you have to board a ferry to finish the route. The free forty-minute ferry ride from Hatteras to Ocracoke Island is the highlight of the trip for many travelers. Be sure to bring something to toss to the gulls while riding the ferry. Gulls will eat anything you throw at them, so it's up to you to look out for their health. Shelled hard corn works well since it's a natural food and easy to throw. Leave the Twinkies in the car.

Once on Ocracoke Island, you have a twelve-mile drive to Ocracoke on the south end. Although not immune from modern development, Ocracoke is the quintessential coastal village, retaining much of the charm from its early days. The local people even have their own dialect, known as the "Ocracoke brogue." One particular characteristic of the dialect is the pronunciation of "i" as "oi," which has led Ocracokers to be referred to as "hoi toiders." The best way to explore the village is on foot. Walk the waterfront of Silver Lake (locals call it the Creek) and down the tree-lined sandy lanes off the main road. Be sure to visit Ocracoke Lighthouse, the nation's oldest operating lighthouse.

Except for the village, all of Ocracoke Island lies within Cape Hatteras National Seashore, so you have twelve miles of beach and soundside to explore. A sand road leads to the beach from the village area, but unless you have a four-wheel-drive vehicle, you would likely get stuck before you reached your destination. Several points between the village and the ferry dock provide beach access for those in regular vehicles. A few sand roads also lead to the soundside.

After exploring Ocracoke, you have two options. You can backtrack, or you can take one of two ferries across Pamlico Sound. One ferry takes you to Cedar Island and the end of Route 26. The other takes you to Swan Quarter, which is located along Route 23. For either ferry, it's a good idea to make reservations well in advance for a trip during the tourist season.

PART V

Diverse Nature and Scenery

The Southeast

Low tide exposes the sand flats on Shackleford Banks. The flats exhibit ripples that look like a miniature of the waves. Cape Lookout Lighthouse stands in the distance.

OPPOSITE: The carnivorous water sundew catches its prey with sticky secretions on its leaves.

Southeast North Carolina shares one defining characteristic with the northeast region: Outsiders are always in too much of a hurry to pass through the mainland on their way to the coast. From Cape Lookout National Seashore at the northern end to Sunset Beach at the South Carolina border, the barrier islands and beaches of the southeast are hugely popular. Two routes in this section take you to the beach, but they avoid the more crowded areas and give you options for solitude.

The mainland portion of southeast North Carolina is one of the state's little-known gems. Within this region are a national forest, two state forests, five state parks, a state and a national historic site, and numerous nature preserves. Blackwater rivers flow through the region, often leaving their defined banks and spreading out into sloughs and swamps that provide excellent wildlife habitat. We'll visit the most scenic of these areas on two of the routes.

ROUTE 26

Down East

BEAUFORT TO CEDAR ISLAND

The quintessential waterfront village, Beaufort, where we begin our route, lies just across the causeway from the port town of Morehead City. Once an important fishing and shipbuilding town, Beaufort has transformed into a tourist mecca with a maritime flair. Fortunately, the citizens of Beaufort have never given up their roots. The architecture and down-home hospitality remain much as they always have.

Route **26**

Start out at the drawbridge in Beaufort. Head east on U.S. 70. Drive 26 miles, then continue straight on NC 12. Follow it 12 miles to the Cedar Island ferry. (*38 miles*)

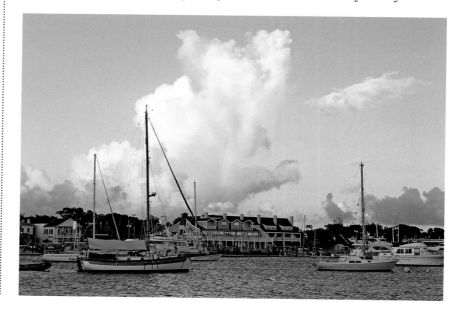

A rainbow enhances the beauty of Beaufort, a quaint waterfront village near Cape Lookout.

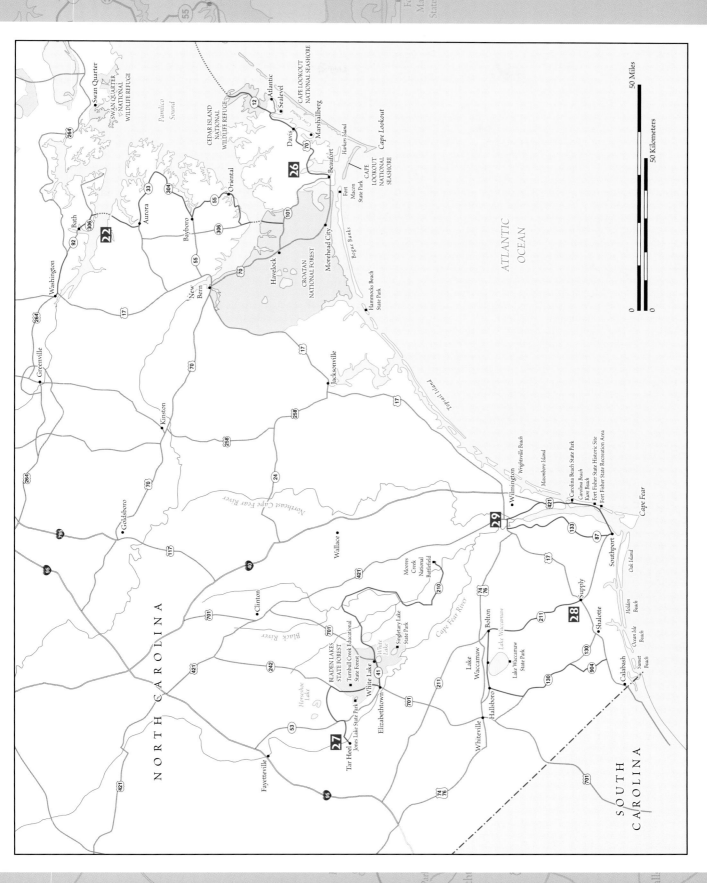

The first thing you need to know about Beaufort is how to pronounce its name. Say BEW-fert, and people will think you're from South Carolina—that's how they pronounce their town of the same name—and ask you to go back. Say BOW-fert, and you'll fit in just fine.

One person who fit in well in Beaufort was Rachel Carson, who came here in the late 1930s for coastal studies. Carson's 1962 book *Silent Spring* is credited with starting the modern environmental movement. Seven years earlier, Carson wrote a book about seashore life called *The Edge of the Sea*, gathering much of the material for that book during the time she spent in the Beaufort area. Today you can visit the Rachel Carson National Estuarine Research Reserve, named in honor of her contributions to the environment.

While in Beaufort, you can also visit the North Carolina Maritime Museum, browse the waterfront shops, rent a kayak, fish, stroll the streets, look at the historical architecture, and eat in the many fine restaurants.

From Beaufort, we're heading "Down East" to the slice of North Carolina's sound country stretching from Beaufort to Cedar Island. Locals have been calling it by that name for as long as anyone can remember, and they might get a little riled if you ask them about other areas along the coastal plain being called that. This is the original, the ONLY Down East.

Down East's charm lies in the fact that it has managed to avoid the late-twentieth-century transformations that characterize many other areas. For the most part, a drive to Cedar Island today is not a lot different from one made in the 1950s. The roads and bridges are better, and some of the houses are a little nicer, but Down Easters maintain a lifestyle tied to the sea, the marshes, and the farmland that surrounds them.

You'll pass through more than a dozen villages between Beaufort and Cedar Island. Most of them are tiny, and what you see from the main road is all there is. But a few communities beg for more exploration. A highly recommended side trip is to Harkers Island. Be sure to drive out to the end of the island and visit the Core Sound Waterfowl Museum and the Cape Lookout National Seashore visitor center. Other villages worth a detour are Gloucester, Marshallberg, Davis, Sealevel, and Atlantic.

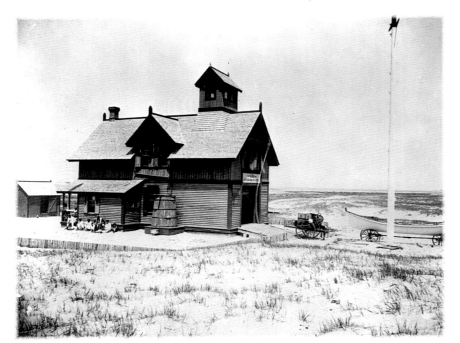

The original Cape Lookout Life Saving Station went into operation in the late 1800s. Today, the North Carolina Maritime Museum in Beaufort utilizes the facility as a marine educational center. *North Carolina State Archives*

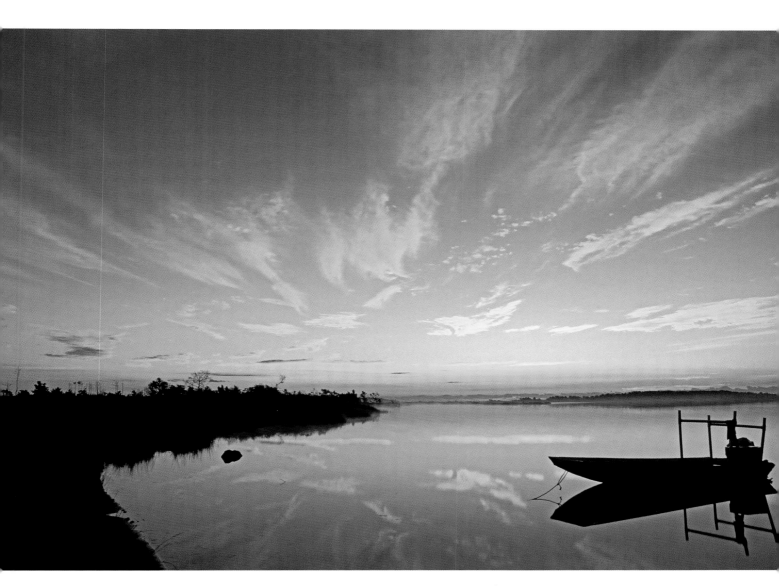

Up until the 1980s, fish houses thrived in the Down East region, with fishermen bringing in boatloads of shrimp, oysters, crabs, clams, and various species of fish. Sadly, most of the houses have closed their doors, unable to make a go of it in today's economic environment. Everywhere you go on this route, you'll find old abandoned fish houses, many of them falling into the water.

While this entire route is picturesque, a particularly scenic section is Cedar Island National Wildlife Refuge, where the road passes through a seemingly endless expanse of marsh. The best view is from the top of Monroe Gaskill Memorial Bridge in the middle of the marsh.

The road and our route end at the northern tip of Cedar Island. From here, you have only two choices. You can turn around and go back the way you came, or you can take a two-and-a-half-hour ferry ride across Pamlico Sound to Ocracoke Island at the end of Route 25. Reservations are recommended for the ferry, even in winter.

A shad boat rests in Jarrett Bay at sunrise. The bay is on Core Sound in the "Down East" section of the state.

Bright and variably colored coquina clams live in the intertidal zone on North Carolina's beaches.

CAPE LOOKOUT NATIONAL SEASHORE

THE DRIVE FROM BEAUFORT TO CEDAR ISLAND features exceptional views of bays and little inlets off the east side of the road. All of them are part of Core Sound, the long and shallow body of water created by the barrier islands of Cape Lookout National Seashore. Called Core Banks, these islands stretch from near Ocracoke to the north to Cape Lookout at the southern end, not far from Harkers Island. Also part of the national seashore is Shackleford Banks, a nine-mile island near Cape Lookout famous for its population of wild horses.

Cape Lookout became a national seashore in 1976, much to the chagrin of some of the local people. They didn't like the "government" telling them how to act on land they had been using for generations. They had built fish shacks on the islands and had brought over thousands of old cars and trucks to drive on the beach. When a vehicle became stuck in the sand or quit running, they just left it there and brought over another one. Of course, one of the first orders of business for national seashore officials was to remove these old fishing shacks and vehicles and let the people know that a new sheriff was in town.

The main appeal of Cape Lookout National Seashore is that you can't get there by road. Four-wheel-drive vehicles are still allowed in some places on the beach and sand

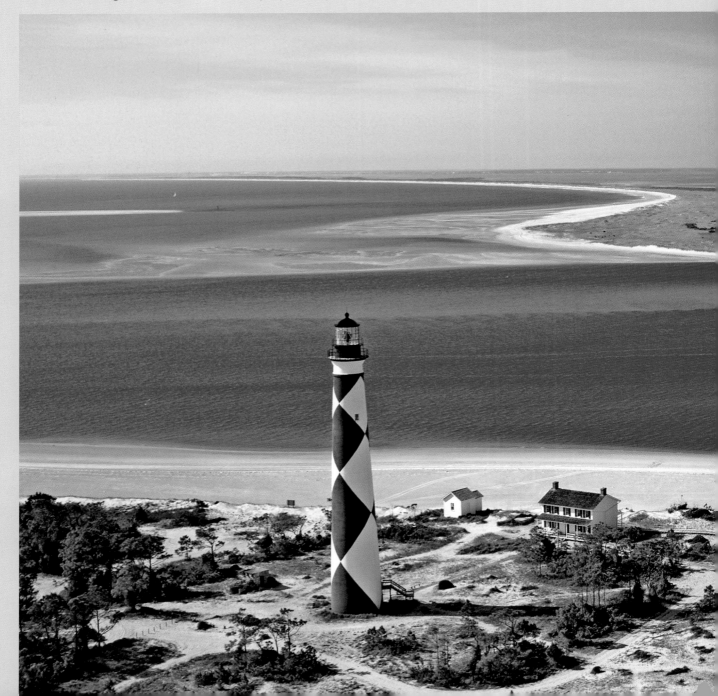

backroads, but you have to ferry them over. Unlike Cape Hatteras National Seashore to the north, Cape Lookout has very few visitor services. Concessionaires operate two small fishing camps, but mostly the islands consist of miles and miles of undeveloped barrier islands and associated soundside marsh.

The national seashore preserves two historic villages. Portsmouth Village lies at the northern end, across the inlet from Ocracoke. Cape Village lies at the southern end, near the lighthouse. The most well-known landmark is the Cape Lookout Lighthouse near Cape Point (not to be confused with the cape of the same name in Cape Hatteras National Seashore). Over 160 feet high, Cape Lookout Lighthouse has been guarding the treacherous shoals off Cape Lookout since 1859.

You can get to Cape Lookout National Seashore by private boat or commercial ferry service. Passenger ferries for the lighthouse area and Shackleford Banks operate out of Morehead City, Beaufort, and Harkers Island. Passenger ferries for Portsmouth Island operate out of Ocracoke. Vehicle ferries operate out of Davis for South Core Banks (lighthouse area) and Atlantic for North Core Banks (Portsmouth Island area).

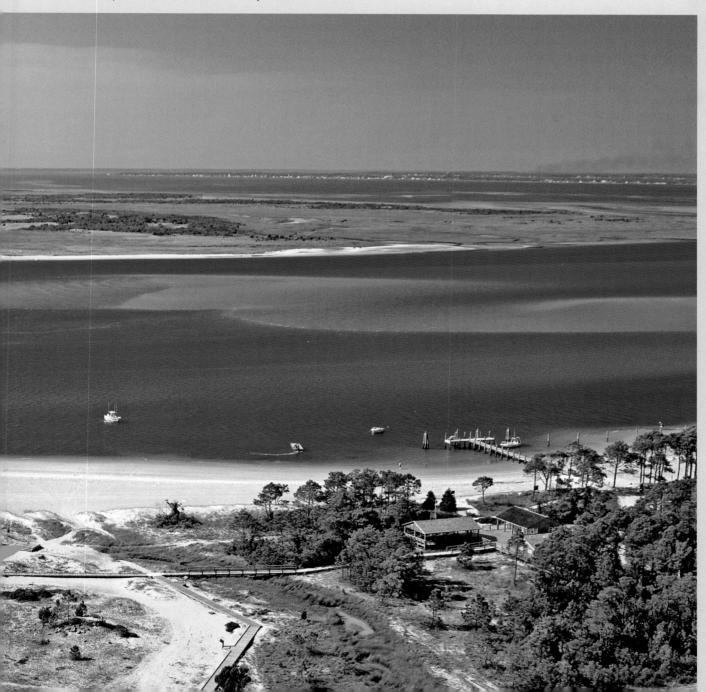

Period furniture and accessories furnish the upstairs bedroom at Harmony Hall, a late-eighteenth-century plantation on the Cape Fear River.

Extraterrestrials and Flowing Tea

CAROLINA BAY COUNTRY AND THE BLACK RIVER

Natural beauty and rich biological diversity characterize the route through this little-known region of North Carolina. But you have to work for it. Viewed through a windshield, Carolina bay country, while unquestionably scenic, is not particularly special in the coastal plain. To get the most out of this route, you really need to hike some trails and, ideally, paddle a canoe or kayak.

Our route begins at an increasingly rare site in North Carolina. The steel truss bridge over Cape Fear River is one of only a handful of its type remaining in the state. It is also among the largest. A few miles from the bridge you come to another relic, Harmony Hall, maintained by the Bladen County Historical Society. The exceptional plantation home, built in the late 1760s, has a unique exterior staircase leading to the second floor. On the grounds are other historical buildings of varying ages that have been moved from other locations.

After you drive through the community of White Oak and turn onto Gum Spring Road, look for Live Oak Methodist Church Road on the left. Take a side trip off our main route by driving down this road less than a mile and turning right at the sign for Suggs Millpond. Follow the unpaved road for two miles to the millpond. At first glance, the pond isn't very exciting. But slip a canoe in it and explore its two arms and you will find yourself in a watery world of stark beauty. Also known as Horseshoe Lake, Suggs Millpond is a Carolina bay

Route 27

Start out on the bridge over Cape Fear River, east of Tar Heel. Head east on Tarheel Ferry Road. Drive 1 mile, then turn right onto River Road. Drive 4 miles, then turn left onto NC 53. Go a quarter mile, then turn right onto Gum Spring Road. Drive 7 miles, then turn right onto NC 242 south. Drive 9 miles, then turn left onto NC 41. Drive 17 miles, then bear left onto Cannady Road. Drive 2 miles, then continue straight through the intersection onto NC 411. Drive 4 miles, then turn right onto Melvin Road. Drive 1 mile and cross over onto Belvin Maynard Road. Drive 2 miles, then turn right onto Wildcat Road. Drive 1 mile, then turn left onto Ivanhoe Road. Drive 9 miles, then turn right onto Beattys Bridge Road. Cross Black River and after half a mile turn left onto NC 210. Follow it 18 miles to Moores Creek National Battlefield. (*78 miles*)

MYSTERIOUS CAROLINA BAYS

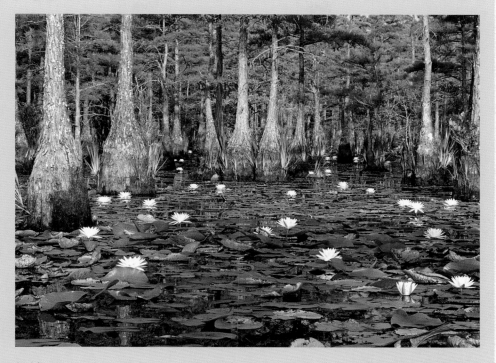

SCATTERED ALL OVER THE MID-ATLANTIC COASTAL PLAIN are mysteries. Some half million of them. Most are located in the Carolinas, hence the name Carolina bays. "Bay" comes from the types of shrubs usually found growing within them—red bay, sweet bay, and loblolly bay. Elliptical in shape and ranging in size from a few acres to several miles across, Carolina bays are shallow depressions surrounded by a slightly raised sandy rim. All are oriented in a northwest-to-southeast direction. Most hold water at some point, though they can be dry for several years in a row; some of them hold water year-round. Phelps Lake (Route 21) and Lake Waccamaw (Route 28) are examples of the latter that we visit in this book.

One interesting thing (out of many) about Carolina bays is that scientists can't tell us how they got here. Numerous theories have been proposed—some logical, some laughable. After viewing the first aerial photographs of bay country, scientists thought they had it figured out. The bays made the land look like the cratered surface of the moon, so they concluded that the bays were the result of an enormous meteor shower. Some even suggested that it was the same event responsible for the extinction of the dinosaurs. But meteor impacts are nearly always circular, even those where the meteor strikes obliquely. Plus, no impact evidence has ever been found to support the theory. Perhaps the most convincing evidence against the meteor theory (or a similar one involving a comet explosion) is the age of the bays. Radiocarbon dating of peat deposits shows ages ranging from 30,000 to 5,000 years. That would have been some meteor shower to last for 25,000 years! No wonder the dinosaurs became extinct. Oh, wait a minute, the dinosaurs died out some 65 MILLION years ago!

Other theories presented over the years provide more comic relief than matter for serious study. Of course, the person who suggested that Carolina bays are dinosaur footprints was purposely trying to be funny. (One hopes, anyway.) And whoever implied that aliens had a hand in it had obviously spent too many nights camped out in crop circles. But the prize must go to the person who, in all seriousness, proposed that it was fish who created the Carolina bays. The theory goes that back when the sea covered this part of the land, this was their spawning ground. The fish congregated in huge schools and the motion of their fins caused the water to scoop out the shallow depressions.

Fanciful postulations aside, scientists do have a working theory that does a fairly good job of explaining how the Carolina bays came into existence. The explanation requires at least six years of postgraduate geology study to comprehend fully. The layperson's explanation goes something like this: When the sea receded, it left behind pools of water. Strong winds churned up the water, causing it to carve out the depressions.

Either that, or all the fish left stranded by the receding water started flailing around in a panic attack, digging out the bays in the process!

A pond cypress reflects on the water at Suggs Millpond during sunrise.

that is partially filled with water. Along the shoreline float unique vegetation beds that support large populations of yellow pitcher plants. The pond also contains extensive mats of water lilies and lily pads, and, of course, the requisite cypress trees with swollen buttresses.

Suggs Millpond lies near the northeast end of a group of Carolina bays in Bladen County known as the Bladen Lakes. The most visitor-friendly of the Bladen Lakes, Jones Lake, is next up on our route. Jones Lake is a state park, which means it has the usual amenities, such as picnic grounds, campground, and trails. What makes it popular among the locals, though, is its sandy beach. You can also rent canoes and paddleboats in season. The three-mile Lake Trail encircles the lake, providing wonderfully scenic views and an intimate experience with the shoreline ecosystem. Chances are good you'll have most of the trail to yourself any time of year. A short side trip from Jones Lake is Turnbull Creek Educational State Forest, which features exhibits interpreting the history of forest use in the Carolina bay region.

From Jones Lake, our route passes very close to another Carolina bay named White Lake. White Lake is somewhat unusual among Carolina bays in that its water is crystal clear, not tea-colored like most. Its white-sand beaches and clear water have attracted visitors for generations. Some early efforts were made to protect all or part of the lake, but none were successful. Today, the entire shoreline is heavily developed. Its worthiness for exploration is only as an educational juxtaposition to the largely pristine lakes surrounding it.

We make our first of three Black River crossings at the tiny community of Clear Run. But before you cross, pull off to the side of the road and walk onto the bridge. The first thing you notice is that the river is appropriately named—black as tar when viewed on the surface. Scoop up a glassful and it looks like iced tea. The color comes from natural tannins that have leached into the water from vegetable matter. If the water level is not too high, you can

see the remains of the steamer *A. J. Johnson* on the left bank a few yards downstream. From the mid-1700s into the early twentieth century, the Black River served as an important transportation artery. Cotton, naval stores, lumber, and a few other commodities were floated downstream to the port at Wilmington. Early vessels were canoes and rafts. Shallow-draft steamboats began plying the river in the late 1800s.

Amos J. Johnson operated his steamer business from his home base here in Clear Run. In its heyday, the town consisted of a shipyard (where the steamer was built), a cotton gin, a turpentine distillery, a sawmill, and several general mercantiles. With the decline of forest resources in the early twentieth century and the advent of the automobile, traffic on the Black River ceased. The *A. J. Johnson* sank in 1914, and Clear Run became a ghost town. Remarkably, the cotton gin and several buildings still exist and remain largely unchanged. The general store from the 1870s sits by the road, with original merchandise still waiting on its shelves.

We can thank the descendants of Amos Johnson for the preservation of so much of Clear Run's rich history and for placing the site on the National Register of Historic Places. The McLamb and Norris families have been caring for the land for more than century. While the site is not open to the public, you can see the general store and another mercantile as you drive by. Please respect the rights of the owners by staying in your car.

At our second crossing of the Black River, a large antebellum house with expansive porches overlooks the river. Laura Dern, playing the promiscuous Rose, graced this house with her seductive antics in the 1991 film *Rambling Rose*. The bridge over the river is shown in the film several times—minus the guardrail and covered with dirt to hide the asphalt.

Between the *Rambling Rose* home and the NC Highway 53/11 bridge downstream, the Black River flows through a wild, hauntingly beautiful section called Three Sisters Swamp. Here the river has no main channel and fans out through the cypress swamp in numerous small braids. The swamp is home to a rich diversity of reptiles and amphibians, mammals, birds, fish, and mussels. Somewhere tucked

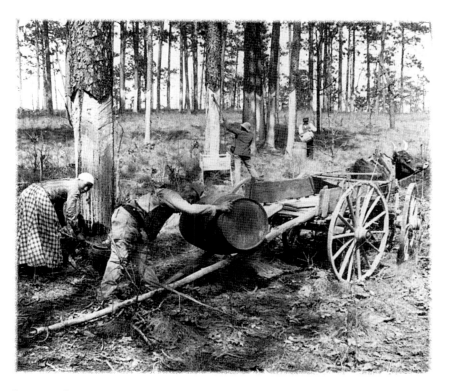

Workers gather crude turpentine from the great longleaf pine forests of eastern North Carolina in 1903. *Library of Congress*

Three Sisters Swamp on the Black River takes on a golden hue during a foggy sunrise.

in the heart of the swamp is a cypress tree sporting a small metal tag bearing the numbers BLK69. If you happen to find this tree while canoeing the Black, pause for a moment and consider that this tree germinated around the time Constantine the Great established Constantinople. Yep, this tree is well over 1,600 years old, officially making it the oldest living thing known in the eastern United States. Dr. David Stahle, the University of Arkansas scientist who dated the tree, believes there are other trees on the Black that were here when Christ walked the earth!

You can see a few old-growth cypress trees from the NC 53/11 bridge, but the only way to experience the river fully is from the water. You can put a canoe or kayak in at most of the road crossings. Just be forewarned that it's mighty easy to become twisted around in Three Sisters Swamp. People have been known to wander around in it for days before finding their way back out. But then, as writer Lawrence Early says, there are worse fates than getting lost in a cypress swamp.

Our third Black River crossing is on the NC Highway 210 bridge. A few miles farther down, the route ends at Moores Creek National Battlefield. The first battle of the American Revolution to take place in North Carolina occurred here on February 27, 1776. A force of about 1,000 Patriots soundly defeated the 1,600 Loyalists who were attempting to cross Moores Creek. The battle marked the end of permanent British control over the North Carolina colony.

ROUTE 28

Land of the Longleaf Pine

THROUGH THE GREEN SWAMP

Everyone is familiar with the Venus flytrap. Schoolchildren throughout the world recognize the famous plant. It's a favorite among plant collectors. It has been the inspiration for everything from a television sitcom character (the disc jockey Venus Flytrap on *WKRP in Cincinnati*) to the title of a Stevie Wonder song ("Venus Flytrap and the Bug"). The movie *Little Shop of Horrors* featured a Venus flytrap named Audrey II that looked like it had overdosed on steroids. The list of flytrap references could fill a book. However, as well known and popular as the Venus flytrap is, few people realize that the plant is native only to a small radius around Wilmington, North Carolina, and grows naturally nowhere else in the world. That's right, the Venus flytrap is a purebred Tarheel.

Among the best places in the state (which means the world) to see the Venus flytrap is in the Green Swamp, through which our route passes. The Nature Conservancy owns a preserve here, protecting

Early-morning sunlight glistens on the wiregrass at Big Island Savanna in The Nature Conservancy's Green Swamp Preserve.

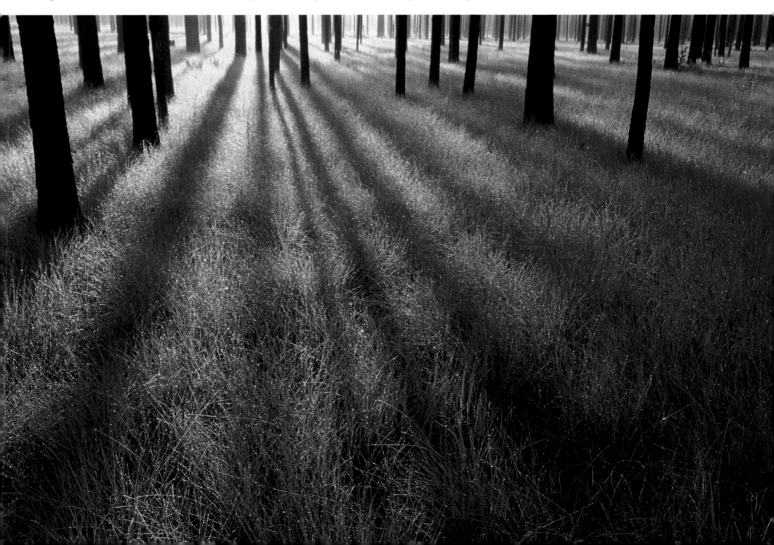

Grass pink, a member of the orchid family, grows on the longleaf pine savannas of the Green Swamp.

Route 28

Start out from U.S. 17 in the community of Supply, north of Southport. Head north on NC 211. Drive 24 miles, then turn left onto NC 214. Drive 11 miles, then turn left onto Hallsboro Road. Drive 7 miles, then turn left to remain on Hallsboro Road. Drive 3 miles, then turn left onto NC 130 east. Drive 11 miles, then turn right onto Longwood Road. Drive 4 miles, then continue straight on NC 904 south. Follow it 5 miles to U.S. 17. (*65 miles*)

more than 15,000 acres of superb pocosin and pine savannas. Of the most botanical interest are the savannas, on which grow the flytrap and other types of carnivorous plants such as pitcher plants, sundews, and butterworts, along with a rich variety of other plants. One study found more than fifty species of plants growing within a square meter of pine savanna. The savannas are dominated by North Carolina's official state tree, the longleaf pine. Pine savannas once covered a huge swath of land that ran from extreme southeastern Virginia to Texas, but very few acres remain. The Green Swamp Preserve protects possibly the finest remaining example in the nation, earning its distinction as a National Natural Landmark.

A little less than six miles north of U.S. Highway 17 you will see a small "borrow" pond on the right. Borrow ponds are created when road builders dig dirt for use on the roadway, leaving a depression in the ground that eventually fills with water. Beside the pond is a small parking area, from which a trail leads through the preserve. Keep in mind that it can get mighty hot and buggy here during the summer.

Timber companies have built canals and drained most of the original 200,000 acres of Green Swamp to create tree plantations. That's mostly what you'll be driving through between the Green Swamp Preserve and Lake Waccamaw. Lake Waccamaw is name to both a small village and a large body of water. The village consists mostly of shady lanes and charming mature homes on the northwest shore of the lake. The old train depot, now a museum, evokes the bygone days of the town's importance on the railroad line for shipping forest products out and lake vacationers in.

The northwest and west shores of Lake Waccamaw are lined with private homes, but the northeast and south shores, and all of the lake itself, are part of Lake Waccamaw State Park. The park features camping, picnicking, hiking trails, and a popular swimming area. Exhibits in the modern visitor center interpret the biological diversity of the park. Lake Waccamaw is a Carolina bay (see Route 27), but it is a unique one. Most water-filled Carolina bays have tannin-rich water that is highly acidic. A natural limestone outcrop on the northern shore of Lake Waccamaw neutralizes its water, causing it to have more life-sustaining nutrients. As a result, Lake Waccamaw supports a diverse population of fishes, mussels, snails,

The carnivorous northern pitcher plant, a common inhabitant of the Green Swamp, traps its prey by drowning it.

Carnivorous sundews secrete a gooey substance that sticks to insects, trapping them on the plant. Several species of sundew grow in the Green Swamp.

and other aquatic life. In fact, several of the lake's fish and mollusk species are found nowhere else in the world.

It is a straight shot along the railroad line to Hallsboro, where our route turns south. From here we follow near the western edge of Green Swamp all the way to U.S. 17. Most of the countryside is sparsely populated with farm fields and occasional glimpses of the swamplands. However, that is all changing rapidly, as Brunswick County counts among the fastest growing of North Carolina's counties. This will be all too evident when you reach the end of the route if you decide to explore the nearby coastal areas of Calabash, Ocean Isle Beach, or Sunset Beach. If you do, a couple of good places to take a break from the beach crowds are the Museum of Coastal Carolina at Ocean Isle Beach and Ingram Planetarium at Sunset Beach. And the best way to end the day is to sit down at a gluttonous plate of fried popcorn shrimp, Calabash style.

ROUTE 29

Battles, Boats, and Beaches

CIRCLING THE CAPE FEAR RIVER

Route 29

Start out at Cape Fear Memorial Bridge in Wilmington. Head south on Front Street (U.S. 421 Truck). Drive 1 mile, then turn right onto Burnett Boulevard. Drive 2 miles, turn right, then make a quick left onto River Road. Drive 12 miles, then turn right onto U.S. 421 south. Drive 1 mile, then turn right onto Dow Road. Go a quarter mile to Carolina Beach State Park. Visit the park, then backtrack to Dow Road and turn right. Drive 4 miles, then turn right onto U.S. 421 south. Drive 3 miles to the Southport-Fort Fisher Ferry. Take the ferry and proceed from the landing on NC 211. Drive 3 miles, then turn right onto NC 87. Drive 3 miles, then turn right onto NC 133 north. Drive 7 miles, then turn right onto Orton Road. Drive a quarter mile to Plantation Road. Orton Plantation is just across the road to the left. Brunswick Town is to the right, and then left on St. Phillips Road. To complete the loop, continue 12 miles on NC 133 to U.S. 17 and then 3 miles to Wilmington. (*60 miles*)

At first impression, this route hardly qualifies as a backroad. After all, Wilmington, which comprises a good portion of the route, is the state's ninth-largest city and its metropolitan area is ranked twentieth in the nation in growth rate. And along the developed beaches of Pleasure Island, you can't squeeze a playing card between the hotels and condominiums. But by taking roads that only the locals know about, we're going to bypass most of the horrific congestion along the major routes through Wilmington and Pleasure Island. Also, if you make this trip in winter, you'll still get to see most of the attractions without battling the typical tourist crowds. Regardless of when or how you take this route, do take it. The combination of historical sites, recreational opportunities, and scenic beauty is tough to beat for such a small area.

From the mid-nineteenth to the early twentieth century, Wilmington was North Carolina's largest city and by far its most important port. Ideally situated at the confluence of the Cape Fear and Northeast Cape Fear rivers, some thirty miles from the ocean, the city has served a principal role in the commerce and history of North Carolina. Merchants exported great quantities of lumber, cotton, fertilizer, rice, and other cargo while importing the goods needed for a growing state. The port served as a crucial supply point for the Confederacy during the Civil War. Nearly a century earlier, British troops disembarked at its docks during the Revolutionary War. Wilmington remains important in North Carolina, one of only

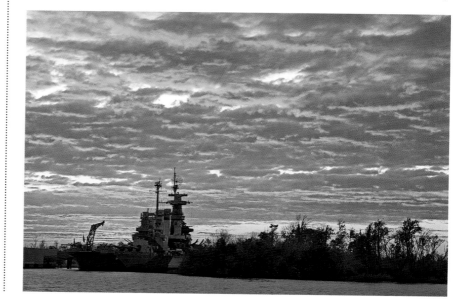

A "sailor's delight" sunset lights the sky above the USS *North Carolina* in Wilmington.

two significant seaports in the state (Morehead City being the other one). But ships no longer handle goods at the foot of Water Street. Today's seaport is located downstream at a large industrial site that we will drive by. Water Street and Wilmington's waterfront now play host to sightseers and history buffs.

Across the river from Wilmington's waterfront is the USS Battleship *North Carolina* Memorial. The USS *North Carolina* represents the first in a new era of fast, powerful battleships. At her commissioning in 1941, she was regarded as the greatest sea weapon ever built. Seeing action during every major naval campaign of World War II, the USS *North Carolina* earned fifteen battle stars. When the navy decided to dismantle the ship for scrap in the late 1950s, a statewide grassroots effort (including schoolchildren donating coins) raised the money required to build a berth and display the ship. Even if war machines are not your thing, a tour of the venerable battleship is highly recommended.

We take the back way from Wilmington to the bridge over the Intracoastal Waterway at the head of Pleasure Island. The twelve miles of this route that follow River Road might surprise you. A few miles to the east is the congested and heavily developed U.S. Highway 421. Our route, however, passes through undeveloped woods along the eastern shore of the Cape Fear River. Just before we get back on U.S. 421, there is a county park on the right called Snows Cut Park. Snows Cut is the name of the canal that runs beside the park, dug to permit boat travel between the Cape Fear River and the Atlantic Ocean. Although this section of the Intracoastal Waterway is not natural, the "island" created to the south of it is known as Pleasure Island.

Shortly beyond the bridge over Snows Cut, our route turns off to the right and escapes the full-blown beach-resort mania of Carolina Beach. Carolina Beach State Park is next up. Occupying the southern shore of Snows Cut directly opposite Snows Cut Park, as well as along a portion of the Cape Fear River shoreline, the park features a campground, picnic area, hiking trails, a marina, and relative solitude from the masses back at Carolina Beach.

Continuing on the backroads behind Carolina Beach, Wilmington Beach, and Kure Beach, we rejoin U.S. 421 at a local landmark. The Kure Beach Fishing Pier is said to be the oldest continuously operating pier on the North Carolina coast. The first pier built at this location was in 1923. Storms and modernization have necessitated many rebuilds over the years, but the pier still maintains its fisherman motto: "Man, you should have been here last week."

A couple of miles from the Kure Beach Fishing Pier we leave the condos behind us for good. Fort Fisher State Historic Site (river side) and Fort Fisher State Recreation Area (beach side) make it difficult to choose what to do first. Built by the Confederacy to protect

the critical port of Wilmington, Fort Fisher fell to Union forces on January 15, 1865. Despite numerous efforts to preserve the historical site, Fort Fisher remained unprotected for nearly a century. During this time, the fort fell victim to treasure hunters, severe erosion, the U.S. government (the military built a base over part of the fort and constructed an airfield on it during World War II), and the construction of present-day U.S. 421, which bisects the ruins. Today, the state historic site designation protects what remains, although erosion from the sea remains a threat.

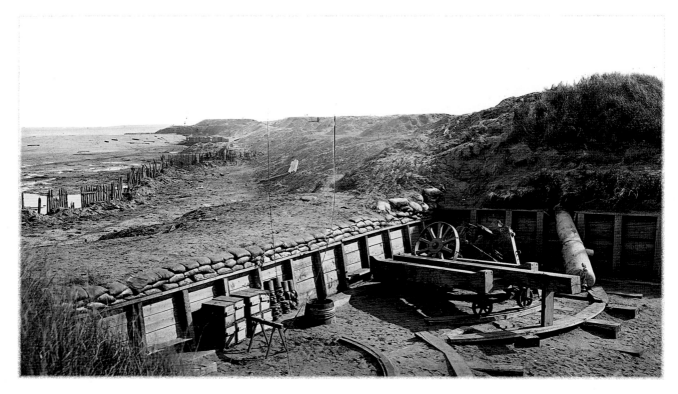

Built by the Confederacy to protect the critically important port of Wilmington, Fort Fisher fell to Union forces in 1865. In the second gun chamber of Shepherd's Battery, we see a toppled Barbette gun carriage and an 8-Columbiad tube leaning against the parapet wall, stark reminders of the fierce battle. *Timothy H. O'Sullivan, Library of Congress*

OPPOSITE: Coquina Rocks at Fort Fisher State Recreation Area is the only natural rock outcrop along the North Carolina coast.

If you choose the beach-side recreation area, park in the parking area across the street from the Fort Fisher visitor center and walk back up the beach to the condos, where you'll discover a unique rock outcrop on the beach. Called Coquina Rocks, it is the only natural rock outcrop on the North Carolina coast. Down the road a little bit from Fort Fisher is one of three state aquariums: the North Carolina Aquarium at Fort Fisher.

Be extra careful if you drive in this area in the morning or evening. White-tailed deer are everywhere around here and they have the bad habit of jumping in front of vehicles.

A short distance beyond the aquarium is the Southport-Fort Fisher Ferry that we're going to board. But before we do, let's continue another quarter mile to the end of the road. That grass-covered pile of sand on the right is Battery Buchanan, which guarded the mouth of New Inlet and represented the first line of defense for Fort Fisher. Once an imposing structure, the bastion has suffered from

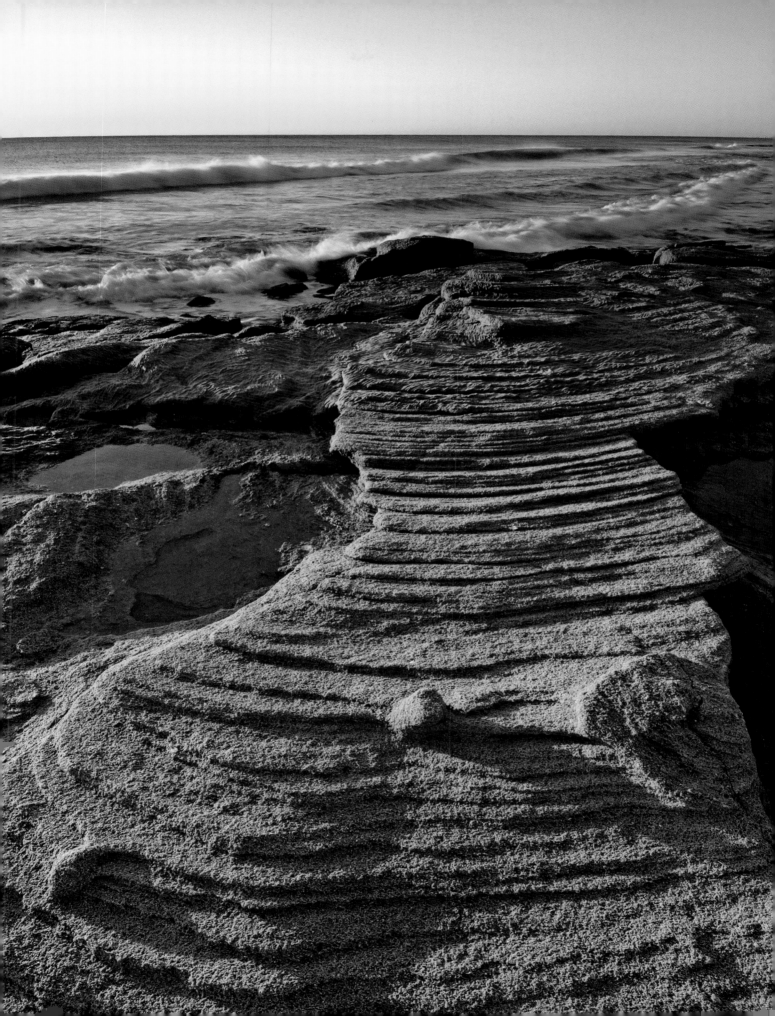

Morning twilight silhouettes the live oak trees at Fort Fisher State Historic Site.

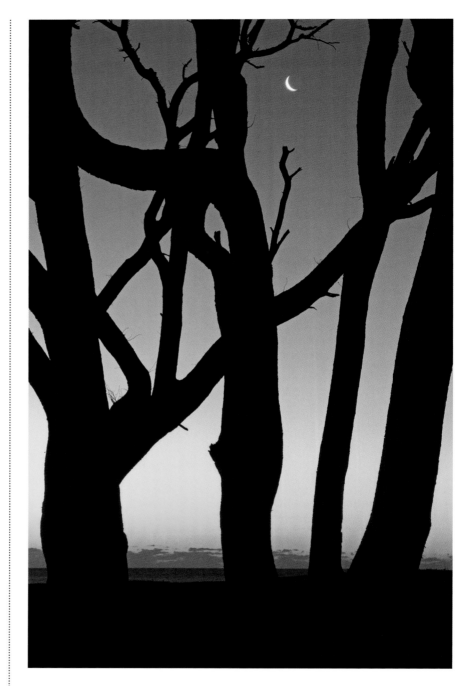

143 years of erosion. If not for the interpretive signs, the average visitor would think this pile of sand was just another sand dune.

To the left at the end of the road is a body of water called the Basin. It is extremely popular among fishers, boaters, kiteboarders, and windsurfers. The Basin exists as the result of one of the biggest engineering projects of the nineteenth century. Built in the 1880s, the Rocks is a breakwater extending about a mile to Zekes Island and, from there, another two miles to Bald Head Island. The first section stretches more than one hundred feet wide at the base and nearly forty feet thick. It doesn't sound like such a big deal until you

stand at the end of it and see it fade in the distance. Why did the government build such a massive structure? The plan was to block New Inlet, which had opened during a storm in the 1700s. The inlet caused water flow and depth problems in the Cape Fear River, the route used by ships heading to the port at Wilmington. The breakwater successfully corralled the inlet, and it remains largely intact today. You can walk across the Rocks at low tide, but be forewarned that algae makes the surface extremely slippery. Also, pay careful attention to the tides. At high tide, the Rocks can be covered by several feet of water, making it impossible to cross.

Let's head back up the road now and board the ferry. Just before the ferry reaches the dock at Southport, it passes by Prices Creek Lighthouse. Built in 1849, the lighthouse is the only one remaining from a series of range lights located along the Cape Fear River from Oak Island to Wilmington. Range lights worked by allowing river pilots to line up the lights from two beacons, steering them in the correct direction through the channel. Prices Creek Lighthouse is owned by the Archer Daniels Midland Corporation, which has steadfastly refused public access to the lighthouse, even for maintenance and historical research. Enjoy the view from the ferry, because that's all you're going to get.

For many people, Southport is the quintessential coastal village, retaining all its charm from the late-nineteenth and early-twentieth centuries yet somehow managing to avoid the gaudiness of the typical beach resort. Stately live oaks line the streets, shading the large historic homes overlooking the Cape Fear River. Southport's postcard-pretty waterfront wonderfully blends salty local fishermen plying their trade and businesses catering to the tourists who come to watch the fishermen at work.

From Southport we turn north and head back to Wilmington on a wide parallel of Cape Fear River's western banks. Two sites along the way are worth exploring. First is Brunswick Town State Historic Site. Established in 1727, Brunswick Town was one of the colony's earliest ports. It also had the distinction of being seat to two different counties: New Hanover and Brunswick. Brunswick County was created from a portion of New Hanover County in 1764. Surpassed in population by Wilmington, Brunswick's prominence had diminished by the time of the American Revolution and fell into ruins in the early 1800s. During the Civil War, the Confederates built Fort Anderson over the town site. The fort joined Fort Fisher, Fort Johnston in Southport, Fort Caswell on Oak Island, and Fort Holmes on Bald Head Island as a seemingly formidable line of defense for the

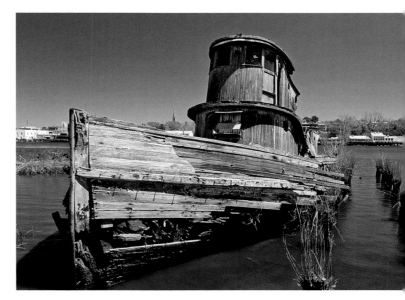

An abandoned tugboat slowly falls to pieces on the Cape Fear River at Wilmington.

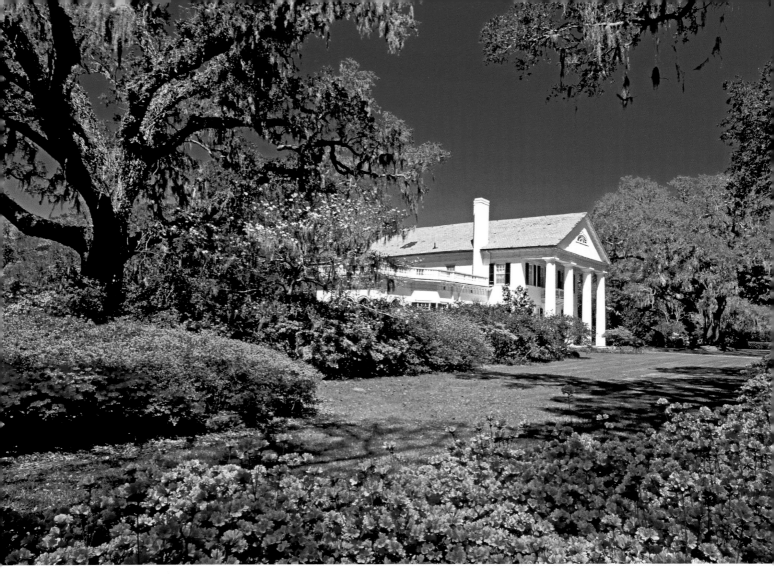

Azaleas bloom in the gardens at Orton Plantation on the Cape Fear River.

vital port of Wilmington. Fort Anderson fell to Union troops soon after the fall of Fort Fisher.

In the 1720s, rice plantations began sprouting up along the Cape Fear River in the Wilmington region. Nearly thirty were established by the time the Civil War began. By the end of the nineteenth century, however, rice cultivation in North Carolina had been abandoned. Today, most of the old rice fields are unrecognizable and only one of the original plantation houses remains. Orton Plantation, adjacent to Brunswick Town, stands proudly on a sandy bluff overlooking the Cape Fear River. Originally constructed as a one-and-a-half-story structure around 1725, the home has undergone a number of changes, resulting in the magnificent Greek Revival mansion that exists today. The rice fields have also experienced a makeover. At Orton and a few other old plantation sites along the lower Cape Fear, the owners have transformed the former rice fields into prime bird and wildlife sanctuaries. Orton Plantation Gardens is famous for its spring flowers, including spectacular displays of azaleas and camellias. Visitors can tour the gardens at leisure, but the home serves as a private residence for the owners and is closed to the public.

FURTHER READING

Adams, Kevin. *North Carolina Waterfalls*. Winston-Salem, NC: John F. Blair, 2005.

——. *North Carolina's Best Wildflower Hikes*. Englewood, CO: Westcliffe Publishers, 2004.

——. *Our North Carolina*. Stillwater, MN: Voyageur Press, 2005.

Barefoot, Daniel W. *Touring the Backroads of North Carolina's Lower Coast*. Winston-Salem, NC: John F. Blair, 1995.

——. *Touring the Backroads of North Carolina's Upper Coast*. Winston-Salem, NC: John F. Blair, 1995.

Biggs, Walter C., Jr., and James F. Parnell. *State Parks of North Carolina*. Winston-Salem, NC: John F. Blair, 1989.

Bishir, Catherine W., and Michael T. Southern. *A Guide to the Historic Architecture of Eastern North Carolina*. Chapel Hill, NC: University of North Carolina Press, 1996.

——. *A Guide to the Historic Architecture of Piedmont North Carolina*. Chapel Hill, NC: University of North Carolina Press, 2003.

Bishir, Catherine W., Michael T. Southern, and Jennifer F. Martin. *A Guide to the Historic Architecture of Western North Carolina*. Chapel Hill, NC: University of North Carolina Press, 1999.

Duncan, Barbara R., and Brett H. Riggs. *Cherokee Heritage Trails Guidebook*. Chapel Hill, NC: University of North Carolina Press, 2003.

Frankenberg, Dirk, ed. *Exploring North Carolina's Natural Areas*. Chapel Hill, NC: University of North Carolina Press, 2000.

Frankenberg, Dirk. *The Nature of North Carolina's Southern Coast*. Chapel Hill, NC: University of North Carolina Press, 1997.

——. *The Nature of the Outer Banks*. Chapel Hill, NC: University of North Carolina Press, 1995.

Fussell, John O., III. *A Birder's Guide to Coastal North Carolina*. Chapel Hill, NC: University of North Carolina Press, 1994.

Lord, William G. *Blue Ridge Parkway Guide: Grandfather Mountain to Great Smoky Mountains National Park*. Birmingham, AL: Menasha Ridge Press, 1981.

——. *Blue Ridge Parkway Guide: Rockfish Gap to Grandfather Mountain*. Birmingham, AL: Menasha Ridge Press, 1981.

Manuel, John. *The Natural Traveler Along North Carolina's Coast*. Winston-Salem, NC: John F. Blair, 2003.

McCullough, Gary L. *North Carolina's State Historic Sites*. Winston-Salem, NC: John F. Blair, 2001.

Mills, Joseph, and Danielle Tarmey. *A Guide to North Carolina's Wineries*. Winston-Salem, NC: John F. Blair, 2007.

The Nature Conservancy. *North Carolina Afield*. Durham, NC: The Nature Conservancy, 2002.

North Carolina Atlas & Gazetteer. Yarmouth, ME: DeLorme, 2008.

North Carolina Scenic Byways. North Carolina Department of Transportation, 1997.

Sakowski, Carolyn. *Touring the Western North Carolina Backroads*. Winston-Salem, NC: John F. Blair, 1995.

Simpson, Marcus B., Jr. *Birds of the Blue Ridge Mountains*. Chapel Hill, NC: University of North Carolina Press, 1992.

Stewart, Kevin G., and Mary-Russell Roberson. *Exploring the Geology of the Carolinas*. Chapel Hill, NC: University of North Carolina Press, 2007.

INDEX

ABOUT THE AUTHOR/PHOTOGRAPHER

Kevin Adams has had a lifelong love affair with nature and the outdoors, particularly in his home state of North Carolina. A naturalist, writer, teacher, and photographer, Kevin is the author and photographer of eight books, including *Our North Carolina*, published by Voyageur Press. He also writes magazine articles, and his photographs appear in books, magazines, calendars, and advertisements across the country. He has traveled extensively in the Tarheel State where, in addition to photography, he enjoys hiking and kayaking. When he's not camping in the great outdoors, Kevin lives in High Point, North Carolina, with his wife, Patricia.

Photograph courtesy of Carl Galie